Lanchester Library

D0301597

Lanchester Library

WITHDRAWN

P.O 2172

JOHN HOYLAND

Mel Gooding

John Hoyland

John Taylor
in association with Lund Humphries London

Coventry Polytechnic
Art and Design Library

Author GOODING

Class 709.719 HOYL

First published in 1990 by

John Taylor Book Ventures
7 Cranborne Road
Hatfield Herts AL10 8AW
in association with
Lund Humphries Publishers Ltd
16 Pembridge Road
London W11 3HL

Text Copyright ©1990 John Taylor Book Ventures
Illustrations Copyright ©1990 John Hoyland

ISBN 0-85331-564-7

British Library Cataloguing in Publication Data

Gooding, Mel
 John Hoyland
 1. Paintings, English—Hoyland, John, 1934-
 I. Title
 759.2

 ISBN 0-85331-564-7

International distribution by Lund Humphries Publishers Ltd

Designed by Herbert Spencer

Typeset by Nene Phototypesetters Ltd, Northampton
Colour processed by Columbia (UK) Ltd, London
Made and printed in Great Britain by
BAS Printers Ltd, Over Wallop, Hampshire

Jacket illustrations
Front:
Quas 23.1.86
acrylic on cotton duck 96 × 96 in/243.8 × 243.8 cm
Back:
Kumari 28.7.86
acrylic on cotton duck 100 × 100 in/254 × 254 cm
Frontispiece:
John Hoyland in 1990 (photo: Bridget Jones)

Acknowledgements

The publishers wish to acknowledge the careful and enthusiastic
participation of the artist in the preparation of this volume. They
would also like to thank Mel Gooding who took on the
assignment of writing the text at very short notice. Finally, they
would like to acknowledge the support of Waddington Galleries
and to thank Sarah Shott for her meticulous and cheerful
attention to detail in providing material from the archives and
arranging photography of the paintings.

Photo acknowledgements

Rodney Todd-White & Son, London and Prudence Cuming
Associates, London were responsible for colour photography.
Bridget Jones, Hugh Kelly, Jorge Lewinski and Jacqueline
Mitelman were among those who kindly provided other
photographs.

CONTENTS

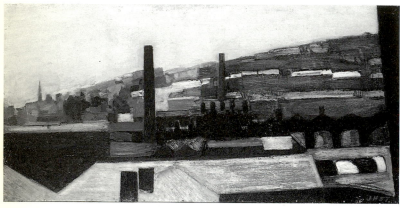

Midland Station, Sheffield 1957

What I am after, above all, is expression. Sometimes it has been conceded that I have a certain technical ability, but that all the same my ambition is limited, and does not go beyond the purely visual satisfaction such as can be obtained from looking at a picture. But the thought of a painter must not be considered as separate from his pictorial means, for the thought is worth no more than its expression by the means, which must be more complete (and by complete I do not mean complicated) the deeper is the thought. I am unable to distinguish between the feeling I have about life and my way of translating it. The entire arrangement of my picture is expressive: the place occupied by the figures, the empty spaces around them, the proportions; everything has, at the painter's command, to express his feelings. In a picture every part will be visible and will play its appointed role, whether principal or secondary. Everything that is not useful in a picture is, it follows, harmful. A work must be harmonious in its entirety; any superficial detail would replace some other essential detail in the mind of the spectator.
Matisse (from *Notes of a Painter* 1908)

Like the cubists before them, the abstractionists felt a beautiful thing in perceiving how the medium can, of its own accord, carry one into the unknown, that is to the discovery of new structures. What an inspiration the medium is. Colors on the palette or mixed in jars on the floor, assorted papers, or a canvas of a certain concrete space – no matter what, the painting mind is put into motion, probing, finding, completing. The internal relations of the medium lead to so many possibilities that it is hard to see how anyone intelligent and persistent enough can fail to find his own style.
Robert Motherwell (*Beyond the Aesthetic* Design, April 1946)

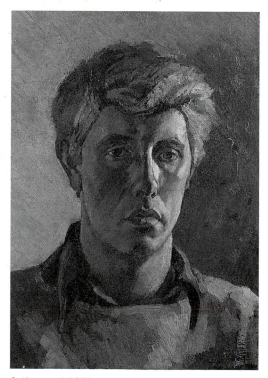

Self-portrait 1954

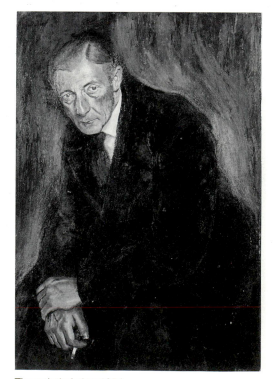

The artist's father 1954

1. Sheffield to the Academy

A view over Sheffield, 1957. It is a painting made by a student artist: its narrow range of sombre tonalities, off-whites, pale ochres, greys and blacks, are at one with the reductive simplicity of the townscape, which transforms his native city into a composition of horizontal rectangles and triangles rhythmically interrupted by dark verticals – church spires and foundry chimneys. It is painted with a deliberate and self-conscious discipline, as if the structuring of the picture, and the low-key wintry colour, are means to the curbing of any sentimental expressiveness that might be encouraged by the subject. The rectangular slabs, poised against each other, like building blocks, recall the manner of the late de Stael, whose retrospective the student had seen the previous summer at the Whitechapel Gallery, during his first months at the Academy Schools. With this modest painting, thoughtfully composed, coolly emphatic of its materiality, John Hoyland can be seen to be launched on the voyage of a lifetime.

Hoyland was twenty-three. He had been studying for several years at Sheffield School of Art, where he was taught to draw in the limited academic manner, encouraged in his painting of landscape and portraits, and kept in near-perfect ignorance of the existence of modern, not to say abstract, art. His friend Brian Fielding was also at the School; from the beginning, they had walked the streets of the dour city, discussing with the absolute passion of youth the great questions of Art, sharing their enthusiasms. After Fielding's untimely death in 1988, Hoyland remembered those early days: 'After evening classes we would take the tram to the "Green Cafe" in Norfolk Street, and there we would drink tea and discuss Art with a capital A. Afterwards we would walk around the town, much of it still débris from the wartime bombing, and continue our conversation until the last buses were about to leave. We talked of our heroes, Van Gogh, Chagall, Roualt, etc., and as we walked we would see Van Gogh's "starry night" together with Roualt's judges at every corner. . . .' When Fielding had gone ahead to London, on a scholarship to the Royal College, he had sent back reports of art and life in the capital, and coming back on visits he brought catalogues and books, including on one occasion a booklet on de Stael which had helped prepare Hoyland for the revelatory exhibition at the Whitechapel.

The work he had made during his later years at Sheffield was not especially remarkable, but what has survived indicates

without doubt that Hoyland was talented and committed. A **Self-Portrait** of 1954 is painted with a decisive vitality and lacks the self-dramatisation that might be expected of its subject; a **Portrait of the Artist's Father** done in the same year is a remarkable painting, intense and searching, and absolutely direct and unsentimental in its portrayal of character. These are nevertheless exercises in a straightforward and conventional naturalism, discreetly painterly, tonal and contained in the English way. The move to London was essential to Hoyland's further development, and in 1956 he finally secured a place at the Academy Schools, where he was able to take advantage of a benign neglect by the teaching staff and begin the real business of finding himself as an artist.

1956 saw the first arrival of the new American painting in this country, in the final rooms of the 'Modern Art in the USA' exhibition at the Tate Gallery. The sight of the grand abstract paintings of Pollock, Still, Newman and, above all, Rothko, aroused a profound excitement in Hoyland. It would take time for this response to make itself felt in his own work, but the scale and colour, and the philosophical grandeur of New York painting, the magnitude of its concerns, made a powerful impression upon him. The delay in reaction is characteristic of Hoyland: his best painting comes always out of deeply assimilated experience – of art and of life – critically transformed at levels of working beyond the conscious grasp. A succession of impressive one-man exhibitions at the American Embassy through the late 1950s, and the magnificent follow-up to the '56 show, 'The New American Painting', which came to the Tate in early 1959, confirmed for Hoyland (as it did for many others) the importance of American painterly abstraction in its multifarious manifestations. For his last two years at the Academy Schools he moved through a flurry of abstract experiments, including sub-Pollock serpentine linearity, and Rothko-influenced colour cloud painting, these latter taking him for the first time beyond an abstraction based upon landscape or still-life.

If the new American painting was of crucial significance for Hoyland and others of his generation, it should not be forgotten that there were important and influential non-figurative developments in European and British painting throughout the 1950s. These were efforts in various ways to reach out of the dark moral and political complexities of the post-war years and reassert the primacy of inner experience and of imagination. Artists were insisting on the validities of

autonomous 'plastic languages' of space, form and colour, independent of the word, beyond the capabilities of speech. It was as if the moral enormities of the European war and the spiritual desolation of the decade that followed had demanded and called forth new means of expression, purer and more direct than the worn-out conventions of representation. (The stark and joyless 'realism' that had enjoyed a critical if not a popular vogue in the early years of the decade, and which had occupied the British Pavilion at Venice in 1956, now seemed sentimental and banal.) In the catalogue to an exhibition in 1955 introducing artists of a senior European generation to American audiences, 'The New Decade: 22 European Painters and Sculptors', the artists' statements have a remarkable consistency of tenor. Alberto Burri's is perfectly representative:

Words are no help to me when I try to speak about my painting.
It is an irreducible presence that refuses to be converted into any other form of expression.
It is a presence both imminent and active.
This is what it stands for: to exist so as to signify and to exist so as to paint.
My painting is a reality which is part of myself, a reality that I cannot reveal in words.

It was impossible to come to a mature artistic consciousness in the late 1950s without being affected by these ideas and presences. It was not so much that Hoyland closely followed the complex developments in European abstraction as that his growing awareness of American trends was necessarily accompanied by a sense of the achievements of certain artists on this side of the Atlantic. After the 1958 retrospective of his work at the Whitechapel, Jackson Pollock became, understandably, a powerful temporary model; but it was in the same year that Antonio Tapies won a double prize at the Venice Biennale, and he too has been admired by Hoyland since those early years. Poliakoff, Fautrier, Fontana, Hartung, and, of course, de Stael were among European artists whose commitment and largeness of vision were important to the young artist as he came towards the end of his years of training. What mattered most was not so much specificities of individual style – *informel, tachisme, materia* – as of seriousness of purpose; not so much *manner* as *stance*. His consciousness of a European achievement at the frontiers of non-figurative painting was to be essential to his maintenance of poise in the intensively self-regarding competitive hurly-burly of the New York scene ten years later.

The enormous challenge of non-figurative painting lay in the awesome freedom it conferred on the artist: 'The vastness and diversity of the problems confronting a painter when he departs from traditional representation of figures result in as many different solutions as there are artists, and all of these solutions are equally valid', wrote Marcel Brion in 1958. It was a challenge that Hoyland felt was hardly being met in English art, or confronted in English art schools. Instead of a grand adventure into vast and diverse regions, British abstract art seemed to consist largely in a domestication of

earlier modernisms, assimilating them to the lyrical empiricism of the native landscape and still-life traditions. With certain great exceptions (particularly those mentioned above), and in spite of the more exalted critical language in the claims made for it, much of the prevailing abstract art in Europe seemed slight and formless, and above all, mannered and formularised. About the scale of the problems confronting the non-figurative artist, Brion was undoubtedly right; about the universal and equal validity of the solutions, Hoyland would have considered him to be unduly optimistic, if not plain wrong.

The poverty of discourse in the art schools (in the case of the Academy Schools the complete absence of it), and the general anti-intellectualism of the art establishment were alleviated for Hoyland by conversation with gifted artist-friends of his own generation, notably Paul Huxley, Basil Beattie, and Brian Fielding. The explosion in art publishing, of books and especially of international magazines, was yet to take place, and intellectual and artistic stimulus had to be sought out with persistence. In 1957 Hoyland spent time at a Summer School at Scarborough set up by Victor Pasmore with Harry Thubron and Tom Hudson. Influenced by the Bauhaus preliminary course and the pedagogics of Klee, the work there was concentrated on the basic properties of form, line and colour, and in developing a coherent framework within which those fundamental elements of painting could be comprehended and harnessed to expression. From Pasmore, Hoyland learnt for the first time of deep and shallow non-perspectival space in painting, and of how these might be related to colour and form on the plane.

During this period Hoyland had also begun to travel, spending time painting Cézannesque landscapes in the bright light of Provence, conscious of the poignant presence of Van Gogh, and, more sharply, of de Stael, who just three years before had committed suicide in his studio at nearby Antibes. In Italy he visited the shrines of Quattrocento art in Florence, Arezzo and Assissi. The hard-edged contrasts of reflected light and deep shadow in the Arezzo town square, between bleached wall and dark colonnade; the everyday brilliance of Mediterranean sunlight, the violet resonance of Southern darkness; wine and good bread in the open: these had stronger effect upon the sensibility of the young artist than the great and pious art in the cool interiors of churches and museums. This predisposition to the sensuously immediate in experience, to high intensity excitement and extremes of feeling, is characteristic of Hoyland's personality. It has profoundly affected his work: at times it has been the admitted subject; at others its suppressed and disguised energies make the coolest Hoyland canvas seem to harbour a kind of dark tension.

Hoyland joined William Turnbull's evening class at the Central School in London in 1958, after hearing that something out of the ordinary was happening there. Turnbull was an artist of ambitious achievement; he had been to the States, and met and known the already legendary painters of the New York School. A man of considerable

sophistication and knowledge, he was an inspiring teacher, inventive of creative situations, and genuinely interested in what the students made of them. In Turnbull, Hoyland found a teacher who recognised that he was trying to move beyond representation and a simple abstraction from perceived objects, and who provided valued encouragement at a crucial moment. During the following year Hoyland also attended the evening colloquies organised by the critic Lawrence Alloway at the ICA Galleries in Dover Street, at which developments in European and American art were discussed by intelligent and sympathetic speakers. From divers sources he was gathering with characteristic energy and curiosity the components of a knowledgeable sophistication. His direction was becoming clear.

2. Situation to New Generation

Abstract Composition 1958 (plate 1) is one of a very small number of paintings to survive from Hoyland's later years as a student. It is a work of considerable accomplishment. The painstaking construction, block by block, of the Sheffield townscapes of a year before, each horizontal and vertical rectangle fitted against the next in a willed pattern derived from observed actuality, is abandoned for an irregularly placed series of rectangles of brilliant colour (some free-standing, some vaguely attached to others) related ambiguously to an atmospheric ground. The painting has no subject but that of colour and form, and its composition is not based upon something seen directly in the world. If the blue and green verticals across the centre remind us at one moment of the bottles in a de Stael still life, they are just as likely the next to be perceived as apertures through the red. The blurred edges of the larger pink rectangles inevitably recall Rothko's floating lozenges of colour, but they appear more like windows than clouds, and the painting as a whole has nothing of a Rothko's resolved hieratic dignity, being busily organised and obviously experimental.

In this painting certain problems of colour and tone are tackled with a remarkable rigour and verve. The intensification of darkness that we expect in colour as it moves through the spectrum towards violet can be reversed in a picture by virtue of the fact that pigment is matter and not light, and that, in painting, white and black can be used to modify the natural disposition of colours towards dark or light. This is something Hoyland had learnt from Harry Thubron, who termed the effects achieved in this way 'colour discordance'. By this rule, the pale rectangles, being actually crimson reduced by white, belong in a naturally darker register than the surrounding scarlet, which is itself painted over a still-visible orange: the outcome is an optical vibration, not unlike that of an after-image, caused by the propensity of the eye to correct the reversal. By a closely related procedure, which Thubron called 'discordant opposition', the yellow of the small rectangle to the centre right of the picture is perceived as darker than the violet which surrounds it, which in nature is its complementary, lying at the darkest extreme of the spectrum, as yellow lies

next to white light. In a student work we might expect little more than a systematic exploration of these effects; **Abstract Composition 1958** manages to be both interesting and beautiful. Hoyland is declaring a vocation, and demonstrating a talent equal to its most difficult and demanding requirements.

It was not a talent universally recognised at the time. The President of the Royal Academy refused to allow Hoyland's Diploma presentation, which consisted entirely of abstract paintings, to be put into the Diploma exhibition. Hoyland was awarded his Diploma largely through the intercession of Peter Greenham, the Academy's Acting Keeper, who recalled the Sheffield landscapes as indication of his ability to paint properly. Others who had seen his work in progress showed a more positive interest, most notably Maurice de Sausmarez, who shortly before term began in the Autumn of 1960 offered him a part-time teaching post on the basic design course at Hornsey College of Art. Hoyland was in good company at Hornsey; others on the staff included Alan Green, Bridget Riley, and his close friend and comrade in art, Brian Fielding. But little was to come of these connections. Hoyland's teaching career in the early 1960s was chequered and of little significance to his development. Teaching was a necessity, for Hoyland had been married for two years, and was father to a young son. Annual holidays in his wife's native Finland were partly paid for by landscapes and portraits painted there to commission and with a thoroughly professional facility.

What was of much greater importance to his career was Hoyland's involvement with the Situation exhibitions of 1960 and 1961. The first of these was held at the RBA Gallery in Suffolk Street in September 1960. Hoyland was a late addition to the group, and one of its youngest members. Peter Coviello had seen some of the pictures he was making, and recognised his affinities with the others. Among these were William Turnbull, Richard Smith, Robyn Denny, Gillian Ayres, Henry Mundy, and Bernard and Harold Cohen. Situation artists had in common a commitment to large-scale abstraction, to the production of paintings that would dominate the space around them, holding the spectator in an environmental field of energy generated by colour. Influenced by the American painters, especially those who exploited the visual dynamics of the large colour field, 'Situation painting' was primarily about scale and colour. It was about direct experience rather than about ideas or objects. The Situation artists were never a tightly organised group cohering round a shared theory or 'philosophy'; as the name implies, the major impulse was to create a dynamic state of affairs within which a particular kind of art, with its own diversities, could be shown and appreciated for what it was.

Turnbull, writing of his own work in 1960, invoked the spirit of the enterprise:

My recent paintings in no way relate to the geometric abstracts of the thirties. They are neither platonic nor geometric.

I'd like to be able to make one saturated field of colour, so that you wouldn't feel you were short of all the others.

In an earlier piece, dating from 1958 (at just the time when Hoyland was studying with him at Central School), Turnbull had written what might have been a manifesto for Situation painting:

We can no longer reject that which will not fit itself neatly into triangles and squares as being formless ... familiarity breeds form which is total not partial.
... these large canvases are the banners carrying the ideogram of our time; not creating a familiar illusionistic space that takes us into a world of perspective and chiaroscuro, but acting outwards into our own world, large environmental shields changing our lives but leaving us in its centre; provocative to contemplation and action. They behave on many levels ... demanding your commitment in the act of looking, with little comfort from the usual frame of reference ... We are all out of apples.
The situation is, as they say, 'fluid'. There is more to come.

Hoyland contributed two paintings to the first Situation exhibition, both of which employed a similar visual tactic. These were handsome upright pictures, consisting of parallel horizontal bands of alternating colours (in **Situation 1960** these were purple and green) which become progressively wider as they move towards the top of the canvas. The relation between the colours in both cases is 'discordant', and the slightly irregular increase in scale of the ascending steps of the parallel bands increases the optical unease that the paintings induce. What is at first sight a quietly ordered statement of monumental simplicity, as of blocks placed squarely one on top of the next, begins to shimmer, and the dominance of one colour over the other oscillates without resolution. That element of visual disturbance characteristic of all Hoyland's painting is created in these works by remarkably simple means; things are not quite what they seem. The paintings engaged with a genuine conviction with the Situation painters' concerns with questions of perception, and effected the required active entry, *by purely visual means*, into the 'real' space of the immediate environment.

Situation was important to Hoyland because it gave him experience of a truly professional *milieu*, showing with artists who were tough-minded and uncompromising, and who had consciously broken with the British tendency to landscape-derived abstraction and disguised figuration. The exhibition at the RBA was poorly attended, but it attracted some critical attention, and it has acquired over the years a legendary status as a kind of declaration, a *manifestation* of a kind unusual in this country, the more significant in that it was organised by artists. The second exhibition in 1961, at the Marlborough New London Gallery, to which Hoyland again contributed, was smaller and less open than the first. It was especially significant for the inclusion of **Sculpture 1** by Anthony Caro, whose work was to become for Hoyland a touchstone of authenticity and originality, a model of invention.

Caro had recently returned from the United States, where his approach to sculpture had undergone a revolution under the direct influences of David Smith, of younger American painters such as Kenneth Noland, and of the critical lucidity of Clement Greenberg. This ability in Caro to renew himself as an artist, to shift ground decisively and fearlessly and come at the process from new and unexpected directions, to invent not merely new forms but new procedures, has been a constant inspiration to Hoyland. Caro's work at that time was entirely consistent with the programme (if it can be so termed) of Situation: placed directly on the floor it occupied the real space of the onlooker; cleanly painted in pure colour, the hard edges, odd angles and openness of its figures played ambiguous perceptual games with the ground and space against which they were seen. Above all, his sculptures asserted their own existence as free-standing objects, not imitations of something else (unless it be something intangible and 'unpicturable' like the sensation of dancing, or of surprise): they 'made explicit' in Greenberg's words, '... that which was unique and irreducible' to sculpture itself, determining 'through operations peculiar to itself, the effects peculiar and exclusive to itself'. Caro's work has continued to demonstrate for Hoyland a mode of integrity, a rigour of intention, and the possibilities of diversity.

When his paintings in the second Situation exhibition were referred to by the painter-critic Denis Bowen as 'exquisite and refined', Hoyland was slightly bothered. Such a note was not in key with the prevailing intellectuality of Situation, its preoccupations with retinal perception and the objective self-sufficiency of painting, which were reinforced by an abrasive toughness of tone in the talk and writing of those

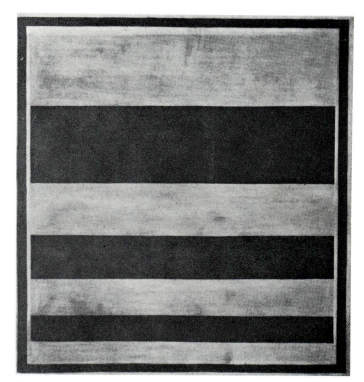

Situation 1960 72 × 66 in/183 × 168 cm

critically supportive of the group. But pictures like **Painting November/December 1960** (plate 2) and **10.11.61** (plate 3), for all the apparent premeditation of their optical concerns, rely greatly in fact on touch and intuition for effect. The non-mathematical irregularity of the stripes, their inexactitudes of dimension, the imprecision of the alignments where they apparently 'bend' in concert, the tonal variations in their colour, combine to create a moody atmosphere, and there are even suggestions of a pictorial space of recessions and enclosures of a kind at odds with the ambiguous figure/ground openness and flatness favoured by other painters in the show.

Nor has the impulse behind these paintings anything much in common with the theoretical refinement and exactitude of artists like Bridget Riley or Vasarely. Even Hoyland's final and most carefully devised 'stripe' painting, made in March 1962 (plate 4), with precisely aligned hard-edge chevrons, and carefully-drawn Stella-like convergent pinstripes, has a complexly veiled ground (put down in multiple thin stains), and the sinuous line of intense blue, free as a river on a Japanese screen, is shadowed its length by a darker stained penumbra, which determines at once a mood and atmosphere and an optical sensation. This complication of effect, compromising a purely visual programme with emotive hints and implications, loading a picture with intimations and allusive possibilities, is an abiding characteristic of Hoyland's work. It is an aspect of which he has spoken rarely, and which at times he has seemed to desire to keep in check, going for a grand economy of means, a magisterial simplicity of effect.

For most of 1962 and into the following year Hoyland suffered a prolonged crisis, working without certainty of direction, seeking a way to break with the somewhat formulaic structures of the band and stripe paintings of the previous two years. The arbitrary limitations of that mode on his own practice, however they might concentrate the researches of others, came home to him with especial keenness at the magnificent Rothko exhibition mounted at the Whitechapel in the late Autumn of 1961. Here were absolute non-figurative paintings that used the resources of pure colour and engaged the act of perception to openly emotional and spiritual ends, holding the spectator enthralled by what Robert Goldwater called 'their enigmatic, gripping presence'. Characteristically, it was to be some time before the impact of that experience was to be reflected in Hoyland's work, and then indirectly and with the true originality that is the outcome of deep assimilation.

In the meantime Hoyland may have unconsciously recognised that his various disruptions of the ordered linear field, by diagonals that struck across the centre like horizontal lightning, or by serpentine diagonal verticals, signalled a creative temperament disinclined to be governed by the restrictions of a static symmetrical format. From that time on, his work has been persistently characterised by a dynamic compositional assymmetry, sometimes with a play of forms wittily poised in momentary imbalance, sometimes with a dramatic momentum towards a dangerous disorder.

Against the Apollonian disposition to geometric clarity and order is opposed the impetuous Dionysiac impulse to darkness and disequilibrium: out of that opposition *within* the work comes much of Hoyland's most characteristic imagery. Chaos is ever-imminent; Hoyland's art seems always to acknowledge that terrible fact even as it hubristically attempts to outface it.

During this period of change, by his own account, Hoyland experimented unsuccessfully with Arp-like biomorphic forms, and 'difficult' and 'anti-pretty' colour. No work has survived from those months of crisis, but some residue of these inconclusive researches can perhaps be found in **22.6.63** (plate 5), in which vaguely biomorphic truncated shapes, like the parts of a dismembered American football helmet, float on a pale roughly circular form that oddly anticipates the circular 'plate' and 'mask' paintings of twenty years later. In a closely related but even bigger painting, made two months after this, a yellow ground which extends to the picture edge invades the helmet shape and sets up a more disconcerting ambiguity of relation between the floating form and the ground itself, inviting speculation as to what actually is laid upon what.

These paintings, dating from the Summer of 1963, show the beginnings of an interest in the enigmatic possibilities of a kind of picture in which ambiguous organic forms, purely abstract but susceptible to various readings, usually in some way evocative of water, of pool and ripple and things that float, are placed in an open pictorial space created of pure artificial colour. The high-key acid and candy colours of these paintings, as in **28.12.63** (plate 6), indicate a wry awareness of the current ascendancy of Pop art, as does their playful, even jokey, visual trickery. They also have a close affinity with paintings made during the same period by Hoyland's friend Paul Huxley, which similarly play with organic liquid forms and enigmatic space, though Hoyland's lack the epistemological sharpness of focus of these latter. Both artists were selected by Bryan Robertson for his brilliant 'New Generation' exhibition at the Whitechapel Gallery in the Spring of 1964. In a general atmosphere of confident youthful celebration, Hoyland's statement for the catalogue sounds a note of philosophical uncertainty, and suggests something of the psychological and emotional pressures behind his painting at this time:

The shapes and colours I paint and the significance I attach to them I cannot explain in any coherent way. The exploration of colour, mass, shape is, I believe, a self-exploration constantly varied and changing in nature: a reality made tangible on the painted surface.

3. Theatres of Colour: Theatres of Form

Bryan Robertson was to play a continuing and often decisive role in Hoyland's career, featuring him in *Private View*, the indispensable panorama of British art in the 1960s that was the outcome of his collaboration with Lord Snowdon and John Russell, and in the same year, 1965, selecting him for 'The English Eye', a personal anthology of modern British art chosen with Robert Melville, for the Marlborough Gerson Gallery in New York. **21.2.66** had been purchased by the Peter Stuyvesant Foundation from the New Generation show, which it had sponsored, and Hoyland had won a travel bursary awarded by the Foundation. With this he travelled, for the first time, to New York, where he visited studios and talked with a number of artists of the great Abstract Expressionist generation (Newman and Frankenthaler he had already met, through Bryan Robertson, in London, and he was later to become friends with Motherwell), as well as meeting Clement Greenberg and several of the artists – Noland, Feeley, Olitski – that Greenberg was currently championing as 'post painterly abstractionists'.

In London he was spending time with sculptors rather than painters, especially those, like Philip King, Tim Scott and David Annesley, who were associated with the exciting developments, largely inspired by Caro, at St Martin's School in London. William Tucker, the theoretical leader of the group, he had known for a couple of years. Hoyland was greatly stimulated by the work and conversation of these artists, whose own epochal 'New Generation' exhibition Robertson was to put on in the Spring of 1965. Their experiments with reductive abstract forms and arrangements, with undifferentiated non-referential colour, and with new spatial dispositions within sculpture, and their theoretical emphasis on the pure *objecthood* of their works, suggested to Hoyland an alternative to the adeptly playful visual ambiguities with which his painting had become preoccupied. There was a cerebral formalist coolness that typified the approach of the 'New Generation' sculptors, aspects of which Bryan Robertson identified, with a hint of misgiving, in his catalogue preface as 'the "anonymity of touch", the "non-association" of colour, the elementary formal pursuits, experiment as opposed to genuine exploration ...'.

Even so, their insistence on the object itself, and on a Greenbergian 'modernist reduction' to the basic properties of the medium, whether painting or sculpture, were challenging, exemplary notions for Hoyland. And certain simple formal ideas, especially to do with the possibility of constructing the image in a painting in the same manner as an abstract sculpture out of elementary components like building blocks, can be traced to his sympathetic association with the St Martin's sculptors. But something of a wider perspective must be attributed to his personal encounters with the older generation of the New York painters, which confirmed his long-standing respect and admiration for their achievements, and reinforced his conviction of the dignity of painting, and of the gravity of its

significance. What he found in Motherwell, Newman and Rothko was the quality of feeling that Bryan Robertson had suspected might be missing from much (though by no means all) of the 'New Generation' sculpture: 'Great painting and great sculpture can only come from feeling. This alone produces a true vision'.

His other important New York connection, with Greenberg and the 'post painterly abstractionists' (most of whom, incidentally, were considerably older than Hoyland), indicated that there were non-figurative ways forward from the overwhelming examples of the established New York masters. These included the greater pictorial 'clarity and openness' that Greenberg had recognised as characterising the reaction to the 'painterly' mannerisms – the dense loading of the canvas and the 'Tenth Street touch' – typical of the second-division Abstract Expressionists. That very clarity, of intention and of utterance, was precisely what Caro's work exemplified, and what had moved Hoyland so deeply at the Whitechapel exhibition of his work in September 1963, just at the moment when he was beginning again to find a voice of his own.

30.8.64 (plate 7) is one of a number of paintings made late in that year which use colour and abstract shape in the purest way to assert the reality of the picture itself as a visual event. It is something to be encountered in the world for itself, vibrantly assertive of its own objective existence, its apparently simple organisation offering a complex pleasure to the eye, a self-sufficient visual experience. The scale of this painting is crucial to its effect: the action takes place in a vast green space (six and a half feet high/ten and a half feet long) that occupies the entire field of vision as the spectator moves close. The blocks of colour proceed sculpturally across the field, levitating to the left in a movement complicated by two distinct and contradictory spatial operations, one involving the abutment of *shapes*, the other the contiguity of *colours*. The first has to do with the alternating up and down placement of the blocks, which makes a lively lateral stepping pattern, flat like a decorative frieze, though its intervals are inconsistent; the second is a function of colour relations, by which the pink at centre left recedes as the strong royal blue in the centre advances, an effect repeated by the blue in relation to the mid-green on its right, and which is complicated by the fact that the pink at extreme right in overlapping the green appears to occupy a space *in front* of the green, and on the same plane as the blue. What is proposed by this relation is a *recessive* space within which the colour blocks are 'flats' placed in front of or behind one another. There are other problematics: the enigmatic blue downward stroke to centre right seems at one moment intent to assert the flatness of the ground, at the next to float in a space behind the arrangement of colour flats; the vivid red and dark green at the left are ambiguously related, themselves enacting in detail the bi-axial dynamic of the whole sequence; and the bridge-like span of the blocks, which at first sight seems to connect one edge of the canvas with the opposite across a finite space, is actually free-floating in an implicitly infinite space, stopping short of the canvas edge at either end.

30.8.64 is a virtuoso performance in which the sparest of means is deployed to achieve an extraordinary complication of expressive affect. We are present at a spectacular visual balancing act, at a moment of dangerous poise. Other paintings in this series use simpler arrangements of even fewer components. These are the most severely minimal paintings Hoyland has ever made, and his titles for them are intended to draw our attention to their extreme economy: **25.6.64 green, with two reds; 30.8.64 lime green, with two blues, red, green and pink.** They offer an astringent excitement, like that of the most austere modern music, foregoing almost every resource in order to concentrate the senses upon the most basic elements, to bring us back to beginnings.

In these works we can see Hoyland clearing the decks, finally reaching towards an abstract mode that will be equal to the passionate imperatives of his temperament, the insistent demands of his creative ambition. For the next three years he was engaged upon an astonishing body of work, an achievement in scale, sharpness of definition and expressive power that is unmatched by any of his contemporaries, and unparalleled in modern British art. By the time of his first retrospective, at the Whitechapel Gallery in the Spring of 1967, Hoyland had established himself as one of the finest artists of his generation, and was poised at the beginning of an international career.

In 1964, Hoyland was living in Kingston-upon-Thames, where he built himself a large garden studio. This gave him the space he needed for the big paintings he now felt impelled to make. The works from this period are remarkable for their formal grandeur and absoluteness. They are triumphantly self-sufficient, great machines built to convey a powerful charge of visual energy. They carry all that Hoyland had learnt from the great post-war generation of American abstract painters, but have an unmistakable identity of their own, a startling originality and clarity of utterance. Their expressive force has to do with the intensity and conviction of their engagement with the history of art, especially, *but not only*, with Abstract Expressionism, rather than with any expression of personal feeling. They are informed and activated by the pressures of what Eliot, talking about poetry, called '*significant* emotion' – 'emotion which has its life in the poem and not in the history of the poet'. 'The emotion of art,' he continued, 'is impersonal. And the poet cannot reach this impersonality without surrendering himself wholly to the work to be done.'

During that period of the mid-1960s Hoyland indeed 'wholly surrendered himself to the work to be done': he dedicated himself to painting with an absolute concentration and enormous energy. The paintings of these years have a magisterial impersonality, an authority that derives from their total objectivity, their freedom from any referential burden. Their emotive power is contained and immanent, not a matter of evocation and reminding; their colours and their forms are neither symbolic nor analogical. They offer no commentary on the world. These paintings are themselves their own subject, each one taking its place in the world as an undeniable *fact*, demanding a response as might any natural phenomenon, a fall of light, a stretch of water, a rainbow. In this respect, although the idea must be entered here with proper caution, and its implications carefully delimited, they aspire to the category of the 'sublime'. Their scale, and their grand simplicity, invite that thought, and remind us of Hoyland's English and Northern European antecedents, as well as, inevitably, Rothko and Newman. But their success in those terms is a function of their expressive power and an answering response; it is not an outcome of artistic ambition or intention.

Indeed, Hoyland's concerns were ostensibly formal and technical. His own discussion of his paintings has always been diffidently low-key and unpretentious, concentrating on the problems and pleasures of their making, and the achievement of effects, rather than on the more portentous matters of meaning, the imponderables of affective and spiritual communication. Speaking in 1979, he recalled critical response to the Whitechapel exhibition: '... everyone went on about the colour. In fact I really hadn't thought about colour very much: it had been the least of my preoccupations. I wanted brilliant, full, unmixed colour, but basically it was reds, greens and oranges. I was much more preoccupied with shape, *where* to locate colours, what kind of shapes to use, and so on. This was all in the wake of Rothko, etc. – it was trying to come to terms with those paintings of his, but knowing that one couldn't go on making them that simple. I just happened to like those colours, and I still do. But the ways edges met, how colours impinged upon one another, and the way that that affected the space was much more of a problem.'

The arbitrariness of the colour and its relation to structural concerns in those paintings was picked up with particular insight by Norbert Lynton in his review of the 1967 show in *Art International*: 'One could, in fact, itemise Hoyland's pictures from the point of view of colour to show that the hues and tones ... especially his red and green ranges', but we may find between one of his expansive green grounds and one of his red grounds do not, curiously, relate to their being red or green. This does not mean that they carry no emotional charge but that this is an integral part of the total experience, acting inseparably with the other commanding factors: size of painting, scale of members, their positions within the field and in relation to each other.' In fact it is hardly surprising that Hoyland's use of colour should have attracted the attention it did. Lynton went on to remark that his 'colours have a commanding presence such as I have rarely seen before', and to quite properly locate that 'presence' not only in Hoyland's 'extraordinary range of hues and tones ... especially his red and green ranges', but also in the scale of the fields, and in his ability to set up sonorous contrasts. Colour may not have been Hoyland's primary concern, but one feels that is so only because his consummate colourism enabled him to concentrate upon what he found more difficult.

The thrilling expanses of colour, sometimes pure and undifferentiated as in **12.8.65** (plate 8), sometimes fading

into light, thickening into darkness as in **2.1.66** and **14.9.66** (plates 9, 11), are, of course, a central element in his 'coming to terms' with Rothko, just as the floating forms, often soft-edged and subtly haloed, can be seen to take off from those of that acknowledged master. But the iconic centrality and symmetry of Rothko's paintings, and their upright format, has been replaced by a kinetic play of asymmetric elements across a horizontal field. These often have a dramatic sculpturality, either as solid blocks or attenuated into linear features (**14.5.66**, plate 10), and bring into the pictures a tough structural dynamic that can clearly be traced to the example of Caro. The anti-gravitational propensity of these forms to 'float' free of the side and bottom edges of the canvas – as with the dark triangle in **3.2.67** (plate 12) – in no way compromises this observation of their innate sculpturality: it was precisely this paradox, that a ground-based structure might appear to fly and leap capriciously free of the ground on which it stands, that Caro had introduced into sculpture.

The device of intervalled verticals, again soft-edged and slightly shimmering as a consequence of a slight, almost subliminal, shadowing of the forms ('like a veil of smoke' in Lynton's evocative simile) (**14.9.66**, plate 11) recalls Morris Louis's poured images, and Newman's 'zip'; but Hoyland's deployment of these forms is characteristically more agitated and disquieting, suggesting neither the majestic natural flow of the one, nor the monumental symbolic stillness of the other. Again, the forms are made independent of the vertical and horizontal axes of the canvas edge, and stand free, like columns of fire or shadow, connecting nothing with nothing, characters in their own right in a pictorial drama.

The high-key 'un-natural' colour in these paintings is an aspect of their essential theatricality, acting like artificial lighting on the stage or screen suggested by the wide horizontal format. It also counters any suggestion that we are being presented with disguised landscape painting, abstraction of the kind Hoyland was most at pains to avoid. That escape from allusion and evocation was precisely what Hoyland admired most about Rothko and Newman; their inspired leap from nature into art was what made their example seem the ultimate challenge, and what distinguished their case from that of Pollock, whom Hoyland admired without reserve, and from that of his friend Motherwell, whose political, historical and literary interests, as expressed in his painting, did not concern him. Of course, there is no such thing as 'pure art', only degrees of distance from nature, alienating devices, strategies of escape from likeness and suggestion. Colour is a phenomenon whose occurrence *in nature* is the basis of its *symbolic* power.

Hoyland was well aware of this, just as he knew that formal relations were not ultimately what concerned Rothko and Newman. His conversations with both of them had explored the deeper issues underlying their life enterprises. (He had visited Rothko while he was making the Houston chapel paintings.) 'I am not interested in relationships of color or form or anything else ...' Rothko had said in 1957. 'I am interested only in expressing the basic human emotions – tragedy, ecstasy, doom, and so on ... The people who weep before my pictures are having the same religious experience I had when I painted them. And if you, as you say, are moved only by their color relationships, then you miss the point!' Hoyland has pointedly avoided the exalted utterance that was a feature of abstract expressionist discourse, but we should not think that his reserve in this respect signals concerns any less profound; it is rather an English disguise, continuing a tradition of understatement that goes back at least to Turner. His earlier habit of giving his paintings no other title than the date on which they were completed is at one with this.

His single-minded concentration on problems of structure and of form, and his deliberate and arbitrary use of particular colour relations, were in fact the ways by which he kept his eye on the ball, maintained control of the game. They were components of a deeper game plan by which he could curb intentional ambitions that might trap him into epigonal exercises, mere acts of homage to the masters, attempts at their themes rather than the discovery of his own. His sure assimilation of their modes and techniques was an indication of his own originality. The artist 'is not likely to know what is to be done,' Eliot goes on to say in the passage from which I have already quoted, 'unless he lives in what is not merely the present, but the present moment of the past, unless he is conscious, not of what is dead, but of what is already living.' With a creative determination akin to obsession, at a pace and prolificity that was astonishing, Hoyland was making it new with a vengeance: in those three years he had succeeded in making his first major contribution to the progress of abstract painting.

Something of the hidden programme in Hoyland's work, that dynamic of oppositions and contradictions which gives everything he has painted an edge of unease, was detected by the critic Robert Melville in the emphatic theatricality of the paintings of this period. Adept at such sightings of the oddly individual element in an artist's work, Melville added Hoyland's name to the 'secret list of the surrealist underground': 'just as the small blocks of colour which represent the "figure" in his "figure-ground" schema seem to have equivocal reasons for being there, as if they had just alighted to start a reconnaissance, so the ground assumes the appearance of a curtain suspended from somewhere above the canvas, and the deliberate shifts of tone in the colour invite the surmise that they may be determined by something moving on the other side of the canvas. One will not find such an effect in American abstraction.' This surrealist note, the more effective for being minimal, even subliminal, and outside conscious intention, is persistent in Hoyland's painting.

4. To New York and Back

We are where we think we are, neither time nor distance makes any difference. Diderot

It is a mark of the best painters that however radically they change direction and manner, their work maintains an unmistakable identity; however surprising a new body of work may look at first sight, in retrospect it comes to be seen as an inevitable and necessary development. Hoyland's career is marked by periodic shifts in manner and changes of formal preoccupation, though each series can be seen to grow out of the last, being anticipated in later paintings of the earlier phase. Each new series of work begins with a formal element in pictures already made, which, like a minor character in a play or novel, is taken up in a sequel as the central protagonist. And each series takes its place in a coherent project of research and discovery, a lifetime's enterprise animated by a passionate imagination and an inventive wit.

The opportunity which the Whitechapel exhibition gave him to review his own work was bound to have a major effect on Hoyland's practice. The sheer scale of the paintings made at Kingston had made it impossible for him to see many of them together at a time. Each new canvas was attacked as a new challenge, a new variation within a thematic programme strictly constrained by self-imposed limitations of means. Brought together in what was Hoyland's second one-man exhibition (and he could have repeated the show with the amount of work he had available) their power and completeness as a statement was confirmed. Whitechapel was a watershed; it was time for a move.

The circumstances of Hoyland's life were also undergoing changes which would affect his work. In 1967 he began to spend time working in New York, and the frequency of his visits and the length of his stays there were to increase over the next four years. The competitive ambience in New York was a given: Hoyland went to America to test himself in a legendary arena, but he carried with him to the New World a vital consciousness of his European antecedents, most particularly a sense of the importance of *feeling*. The typical 'cool' of post painterly abstraction, and the knowing formalism of the painters who looked to Greenberg and his disciples for critical leadership, were aspects of the situation in New York which he found unsympathetic, and before long had rejected. The enormous achievement of the Kingston paintings gave him the confidence to go his own way, not least because those works of the previous three years had exemplified the very 'clarity and openness' that Greenberg had seen as defining the best painting of the 1960s, and done it with a splendour of ambition that was beyond most New York painting at that time.

In 1968 his marriage came to an end. Hoyland bought himself a disused chapel in the Wiltshire village of Market Lavington for use as a studio, and the rundown stables behind it he converted into living quarters. The distractions of teaching and of a hectic social life in London were left behind for long weekends of undisturbed and concentrated painting. When in 1969 he began to spend as much as half the year in New York or travelling in the States, it was to Wiltshire that he would return. When the New York scene finally palled for Hoyland in the early 1970s, and for a while he suffered a crisis of confidence, the beginning of a triumphant recovery was effected in the rural quietude of Market Lavington. By that time he was also renting a studio in London's Primrose Hill, where he made the majority of the later paintings that were shown at a second retrospective exhibition at the Serpentine Gallery in 1979. But this is to anticipate the story.

In the paintings of the period following the Whitechapel show, free-standing blocks of opaque colour expanded to occupy greater expanses of the picture surface. This had been anticipated, as in **12.8.65** (plate 8), but always as a part of ambiguous figure-ground dynamics. In the paintings of late 1967 and 1968 these larger rectangles take on the character of screens or fences. The translucent aerial spaces of the earlier work, the product of an all-over acrylic staining that often gave the colour in those paintings an atmospheric 'breathing' quality, are shut out by these stark walls of hard colour, as in **9.11.68** (plate 13) and **12.12.68** (plate 14). These squarely cut hard-edge features, like theatrical flats, reflect or dully absorb the light and are increasingly thickly painted, often with the palette-knife. The effect is to create a claustrophobic space at the very forefront of the picture that seems to extend from the picture into the real space of the spectator. In some cases, as in **9.11.68**, an angle at the base of one of these features proposes a shallow recession. In any case, we are this side of an impenetrable wall of colour behind which there is a veiled space, potentially infinite.

The distinctive device of a thickly painted, hard-edged opaque rectangle, though undergoing many transmutations, diminishing at times from screen-like dimensions in the paintings just described to the status of a small figure on a complex ground, becomes for the next ten years a major structural element in Hoyland's painting, an unmistakable personal motif. The recurrence of this device has led to a persistent over-estimation of the importance of Hofmann's influence on Hoyland, based on superficial similarities in their deployment of seemingly blank rectangular elements against expressively textured areas of free painting. The tendency to exaggerate this, besides ignoring the history of Hoyland's encounters with Hofmann's work in the crucial period of his own development after Whitechapel 1967, fails to take proper critical account of deeper and more significant affinities between the two artists.

Hoyland had his first sight of Hofmann's painting in the company of Clement Greenberg in the course of his visit to New York in 1964. At the Kootz Gallery two small canvases were brought out of store. Hoyland, who had been looking, with Greenberg, at paintings by Noland and Louis, was immediately impressed by the painterly richness of the Hofmanns. At a time when American abstract painting was

exploiting the 'thin' clarities of poured and stained acrylic, Hofmann was persisting with the thick opacities of oil. Although Greenberg had written a short monograph on his work, Hofmann was still regarded primarily as a teacher; he had not, for example, been represented in either of the Tate exhibitions of American painting in the late 1950s. Of course it is true that Hofmann had not arrived permanently in the States until he was over fifty years old; he was in truth a European painter.

And what Hoyland had immediately responded to in Hofmann's painting was its 'Europeanness': in the rich variety of his late painting Hofmann was taking on aspects of the European traditions of both figurative and abstract painting with a profound and inward knowledge of Abstract Expressionist painting in all its forms. As his knowledge of Hofmann's work increased, and as he found himself, as a painter, increasingly out of sympathy with what seemed the cool aridities of second-generation New York stain painting, Hoyland came to recognise Hofmann as a kindred spirit, working within the colouristic ambit of Matisse and the Fauves, and of the Northern expressionists, coming to terms with the discoveries of de Stael and of Mondrian. Hofmann was effecting a synthesis that was at times somewhat willed and teacherly, but was exemplary in its freedom from the arbitrary constraints of the critical theoretics that dominated New York artistic practice.

This meant that Hofmann was also prepared to admit into an avowedly principled non-figurative painting aspects of the seen, and this was salutory at a time when Hoyland was himself moving towards a more richly allusive and evocative abstraction. Hofmann's pictures teem with references to the objects of the perceived world, and continually suggest spatial relations that are analogical with those in real space, sometimes in terms of colour, sometimes in terms of form and texture, always pulled in and subordinated to the demands of the painting as an object with its own objective integrity, its communicative charge generated by the tensions between its own irreducible material and formal elements. It is with those aspects of his work that Hoyland discovered the deeper affinities to which I have referred. These were acknowledged in a generous act of homage, when Hoyland selected and introduced an exhibition of Hofmann's late paintings at the Tate Gallery in 1988. By then it was plain to see that Hofmann's wilful and programmatic introduction of precise rectangles into the hectic fields of gesture had little at all to do with Hoyland's own compositional disposition of squared-edged blocks of thick paint.

In **7.8.69** (plate 15) and **6.11.69** (plate 16) this feature powerfully dominates the paintings as long horizontal blocks, the thick impasto an aspect of their presentation of themselves as objective, substantial, real. There is no getting round them, in more ways than one. The assertive blankness and solidity of the rectangles in these paintings insist on their materiality, and the multiplicities of textual incident on their surface, created by palette knife and by thrown gobbets of paint, are emphatic of their modernist

'flatness', defying allusive or associational readings. In this and in other aspects Hoyland is moving away from the neutrality of saturated staining towards a greater complication of the picture surface: the aerial fields above and around the impasto of the blocks is becoming increasingly complex and rich. The referential potentialities of the painting in these areas of the canvas multiply even as the solid walls of thick colour close down on such possibilities for themselves. It is a contradiction intensified by the inescapable division of the anterior real space fronting the 'flat' blocks from the deep pictorial space 'behind' them.

Thus in **7.8.69** the poured flow of yellow over the darker ground billows like curtains parting as if about to disclose some further and deeper space, though any suggestion that the dark blue horizontal might be a platform is countered by the thick ooze of reds and oranges around its edges, and the space between its base and the lower canvas edge. In **6.11.69** the colours – green and yellow – of the pyrotechnic splashings and pourings above the top edge of the orange rectangle have a range of natural references, and hint at something of a screened garden. In both paintings the intense *theatricality* of Hoyland's imagery, which has been remarked as characteristic of his paintings of the mid-1960s, is again evident. But the drama that takes place in these great arenas is of colour, form and texture, and of dynamic contradictions of effect, whereby what is proposed in terms of space and pictorial reality in one part of the painting is denied in another.

So persistent are these oppositional dynamics, and so central are they to the psychic charge that the paintings carry, that they appear to be the irresistible outcomes of creatively contradictory psychological pressures. These push towards an impetuous expression of a Dionysiac vision of frantic or euphoric disorder on the one hand and an Apollonian imposition of order and control on the other. A tumultuous atmospheric exuberance, such as we find in the upper section of **5.9.70** (plate 17), which seems created out of an automatic *furore* of pouring, splashing and flicking, and which in its middle section has a succession of distinctly recessive layerings, like banking clouds or a range of hills, is visually repudiated by the implacably frontal rectangle of heavily knifed Venetian red at the base of the picture, itself held firmly in place by a frame of marginally lighter reds. The severely dense and weighty blankness of this block is mitigated by dashes of flicked paint, which appear to fly in front of it, and to compromise its flatness. These flakes of paint are a vital recurrent feature of the New York poured paintings of this period, and of the more pale-toned pink, ochre and bleached yellow paintings mostly executed in Wiltshire. They flicker and flash with the chromatic brilliancy of fish, birds, and insects against the broken light of impasto and coagulation: bright figures of fire and air against grounds of pigmented earth.

Hoyland is significantly emphatic about the control he exercises over the making of his paintings, and it is truly the case that he has always been preoccupied with formal and

technical problems. **8.10.70** (plate 18) was, like **5.9.70**, painted in New York. Hoyland was in regular contact with Larry Poons, and spending time with other younger painters, especially John Griefen and Ronnie Langfeldt, as well as maintaining contact with Noland, Motherwell and Frankenthaler. Unlike Poons and other New York artists, who were at this time pouring and paddling paint on unstretched canvases on the studio floor, and cropping the canvas at will, Hoyland was, as always, working with stretched canvases, and achieving effects with the greater deliberation that tipping and turning a taut canvas allowed.

The middle sections of **5.9.70** and **8.10.70** are the result of multiple pourings and coagulations of thick paint, carefully built up to the richly textured cracked and crazed surfaces that give those paintings their intensely physical presence. The wild emotional and psychic weather of these paintings is then the premeditated outcome of controlled procedures, its emotional expressiveness *significant* in Eliot's sense of the term. Whatever may be the psychological compulsions that lie behind the complex paintings of the late 1960s and the 1970s, they are mediated through a consummate technique. Testing himself to the limits in the competitive crucible of the New York art world, Hoyland was making himself a master of the medium.

It was a period of great freedom and many changes. As well as being divorced, Hoyland had given up teaching and had started out upon an international career. Over these years he lived a life of contrasts and excitements. For nearly four years from 1969 to 1973 he intermittently lived and travelled with Eloise Laws, the American singer. It was a relationship which brought him into close contact with the jazz he loved and the musicians who made it. He was painting prolifically in bursts in New York, returning between times for periods of quiet in Market Lavington, vacationing in the Caribbean, crossing the States with Eloise. It was a way of living which ultimately took its toll: the competitiveness of New York palled, and the issues that animated artistic discourse there began to bore him; constant travel and the nocturnal life of jazz clubs and concert halls got in the way of painting. In 1973 Hoyland returned to live and work more or less permanently in London.

There is a marked difference between the paintings he made during the early 1970s in New York and those he painted in Wiltshire. These latter tend to a lighter palette and more open surfaces, and for all their busy-ness of surface they breathe more freely, admit more light. They are paintings, like **8.2.71** (plate 19), that seem to reflect the experience of nature in daylight. By contrast, **30.8.72** (plate 20), with its artificial pastel colourism and obligatory pouring, is very much a New York painting. Both pictures exhibit Hoyland's tendency during this period to work with 'difficult' achromatic colour, in line perhaps with the Greenbergian directive in force at the time, that new colour was the only thing left for painting to explore.

In one highly significant aspect, however, Hoyland's paintings from the early 1970s depart from the fashionable New York practice: the knifed blocks of solid colour, no longer truly rectangular, are shaped into step-like forms, and begin to declare themselves as figures against a ground. The break up of the geometry of the rectangle inevitably invites possibilities of associative connotation: these blocks might be highly stylised reclining figures, the sides of a building, de Stael-like ships, or whatever. The American painters with whom Hoyland was associating did not approve. This looked too much like a return to old-fashioned abstraction from nature, evocative figure-on-ground 'picture making'. In a certain respect they were right. Hoyland was aware of those English painters who 'had confronted the problem … of how one could make paintings which were both abstract and figurative at the same time'; and beyond them of the example of the great European modern masters: he was re-thinking his aesthetic.

The paintings of the late 1960s and early 1970s, for all their differences and variety, represent a rigorously progressive movement away from the 'walls of light' that were Hoyland's earlier response to colour field painting and the minimal sublime. Hofmann, as we have seen, was exemplary to this endeavour; the impure, committed abstract figuration of Motherwell was also an important clue to other possibilities than the 'cold objects' of the later Noland, the airless programmatic aridities of Stella, and the conceptual and spiritual minimalisms towards which Newman and Rothko had pointed the way. In the light of a deep engagement with the discourse of American painting, Hoyland was reconsidering structure, texture and colour as aspects of *expression*.

5. Equivalents to Nature

Painting, like passion, is a living voice, which, when I hear it, I must let speak, unfettered. Barnett Newman

Hoyland was determined to move towards a complex structured non-figuration which was open to associative readings, that might admit allusion to natural objects and analogy with natural processes, and yet maintain something of the expansiveness and openness of American painting. It was a programme that would meet with little sympathy in New York. And the competitive atmosphere there was especially irksome at a time when he was not entirely clear about the direction his painting would take. Hoyland's return to England in 1973 was the beginning of a testing time. After the heady excitements of New York, and of travels with Eloise, the mid-1970s began with something of a hang-over. Everywhere it was proclaimed that painting was dead.

In New York, Hoyland had been enormously prolific, sometimes finishing several paintings in a few days. In the solitude of Market Lavington in the Spring of 1973 the work did not come so easily. Paintings like **27.4.73** and **4.6.74** (plates 21, 22) are thickly painted and over-painted several times, and took up to three months to complete. Compositionally, they can be seen to have taken the

rectangular block and expanded it to fill virtually the entire picture plane. The effect is claustrophobic, even oppressive. We are confronted by a dumb centre, a blank screen of hard high colour and dense texture; a golden door firmly closed. There is a great deal of surface incident but it is the outcome of reworking the knifed impasto, of pouring over a ground already thickly painted, of *adding* to things already there. What is visible at the edge is no less impenetrable, though there may be odd gaieties of colour, bright pinks, glimpses of pure red and green.

It is possible to read the sharp-edged area at the off-centre of these paintings not as a figure (a block, a flag, a shield, a mask) but as a ground – a framed field of colour; in this case we may fancy that we are looking through a window or an aperture, or perhaps into a mirror. Even in those cases where a light seems trying to break through from behind, as in **22.8.74** and **Verge 12.10.76** (plates 23 and 25), there is still little to see: it is as if the pane has been crudely painted over, the window is a blank; the mirror is dusty; we look as through a glass darkly. Hoyland has said of this group of works that 'every painting was a struggle'. These were difficult paintings to make, and they carry the travail of their making. For all the brilliancy of their high-key colours, they are sombre and intractable monuments; the tensions in them are those of a dammed exuberance.

Hoyland's colour becomes progressively more brilliant and variegated through the 1970s and its interrelations within the paintings more complex and thrilling. It is impossible to discuss it adequately without at the same time considering structure and texture, for it is the colour and its edge or edgelessness which in these paintings define form or formlessness, and it is itself defined and complexified by conditions of facture. 'The structure of form,' Hoyland said, 'is meant to be a container for colour, a container of feeling. Structure or colour alone could never be an answer in itself.' The personality and potency of presence of the colour is determined by the thickness or thinness of the paint that carries it, by its pureness of application, or by the manner of its disclosure – in the scraping down of an over-painted layer, or as a survival glimpsed beneath or beside later deposits. The colour in paintings like **Saracen, Wotan, Devilaya** and **Pact** (plates 26, 27, 28, 29) is spectacular and dynamic: cold is set against hot; chromatic against tonal; fractured against pure.

The forms also become looser and more various, and the relations between them increasingly ambiguous and suggestive. The rectangles break down at their edges, are lopped at their corners to become trapeziums or cut across diagonally from corner to corner to become triangles. The climax of this manoeuvre is the diagonal division of the picture as in **Devilaya** 1977 and **Pact** 1978. The spatial play in both of these paintings is particularly complicated, proposing multiple planes and regressions in a constant condition of dynamic contradiction.

In places, deep space is created purely by colour relations, as in the emerald green behind the yellows, pale greens and

pinks at the top of **Devilaya**, and the deep green of the top right half of **Pact** against the steps of red, bottle green, mauve, at top left. Elsewhere formal relations of linear edge and contiguous fields suggest a masking or overlapping of a recessed space, as in the lower diagonal edge of the triangular ochre curtain which occupies the centre right of **Devilaya**, or the sharply sculptured shelving of rectangles and triangles in **Pact** which seems to propose the ground to its right as a dark green sea stretching to a steep horizon. The crimson ripple at the centre of this green expanse seems indeed to exist in *perspectival* space. This sea of khaki green reasserts itself as a flat field of paint, a physical fact without pretensions to illusion, at the extreme right of the canvas, where at its ragged edge we can glimpse the red underpainting, and a further staining of green. This stained green re-emerges at the opposite side of the canvas in order to confound the claims of the piled forms to any sort of sculptural or terrestrial solidity.

In all the paintings of this period in the late 1970s, the forms, colours and textures concatenate into rich patterns of overlap and interplay, piling up and pressing against each other, now tense, now relaxed, in a curbed turbulence that affects the eye like a complex visual music, now a rich chord, now a dissonance, now harmonic, now discordant. At Hoyland's second major retrospective, at the Serpentine Gallery in 1979, they succeeded each other in sonorous grandeur, like the movements of a magnificent symphony. It was clear that Hoyland was not only a great colourist, but a master builder, an engineer of great machines.

That word may justly remind us of Constable's majestic orchestrations of the multiple diverse effects of nature into symphonic arrangements, and of Turner's tumultuous analogies, his awesome enactments of natural process. For Hoyland's painting in the late 1970s draws unmistakably upon the English tradition of the painterly landscape sublime which reached its climax in the work of those masters. Its high-key chromatic colour derives just as surely from the Northern expressionist landscapists, Nolde and Munch, and from van Gogh and Matisse. (Hoyland's brilliance in this regard serves to remind us that the great tradition of colourism is a phenomenon of Northern European painting.) And there are strange presences and mysteries in these paintings, odd maskings and occlusions, that recall Robert Melville's inclusion of Hoyland on the secret list of covert surrealists.

It seems inevitable that Hoyland would at some point tumble the square forty-five degrees on its axis, and discover the disconcerting capacity for visual instability and imbalance of the diamond. **Voyeurs Voyage** 1981 (plate 31) is an early instance of this, with its three tipped rectangles not so much underpinning as undermining the carriage-like structure that dominates the top half of the painting. The whole configuration floats freely in a dark cloud against an atmospheric ground that is characteristic of Hoyland's painting in the early 1980s, and which is first visible in **North Sound** 1979 (plate 30), where the piled building blocks are still four-square. Their freedom from anchorage to the

canvas edge, and the aerial openness of the field within which they turn, spiral or tumble (though it is often dark, like a night sky), gives the forms in these paintings a new found freedom of relation to each other. There is a playful lightness about paintings such as **Tiger Walk** 1981, **Singwara** 1981, and **Hoochy-Coochy** 1982 (plates 32, 33, 34). It is as if that predisposing pressure in Hoyland's work towards closure and constriction, towards the damming of natural flow and flux, has relaxed at last, and the anarchic tendencies in his temperament are finding unfettered expression. The grand Romantic architectonics of the late 1970s give way to free-form caprice; their rotating movement and spiral overlapping (which irresistibly recalls Matisse's great *papier collée* snail in the Tate – a favourite picture of Hoyland's) is the figure of a dance.

That compositional figure, and the title of **Hoochy-Coochy**, remind us of another potent influence upon Hoyland's art, that of dance music and jazz: the forms in that painting and in **Tiger Walk** turn within their space with the insistence of drumbeats, the emphatically gestured marks within them like the complex inner rhythms of jazz drumming. Behind the title of **Hoochy-Coochy** lies a misremembering of the statement Newman had made for the 1959 Tate exhibition, but not a misrepresentation of Newman's essential point: that the geometric as the expression of a deathly and willed order must be contended with (as Blake had fought with the spirit of Newtonian physics) and that 'a new image based on new principles' must be discovered, which will unlock our access once more to the natural sublime – 'only an art of no-geometry can be a new beginning'.

Hoyland's own words about his painting are invariably more down to earth, emphasising the spectator's perception of the work as a visual event, something 'enjoyed by the senses; felt through the eye'. He has always avoided the rhetorical statement, the moral or philosophical *rationale*, just as he has said nothing of spiritual *programme* and premeditation. Close to his notebook record of **Tiger Walk** and **Hoochy-Coochy** he has inscribed a quotation from Jean Renoir: 'One discovers the essence of a work of art after the work exists, not prior to its existence; as with a meal, not in the cooking but in the tasting'. Hoyland has himself referred to matters of handling and technique as the 'cuisine' of painting. His characteristic modesty of utterance disguises a profound seriousness of purpose.

'From the beginning of the sixties I aligned myself with what seemed to me the most advanced painting of the day. Since then non-figurative imagery has for me possessed the potential for the most profound depth of feeling and meaning.' A brief series of observations written in 1978 concludes with an understated indication of the true scale of his ambition: 'Paintings are not to be reasoned with, they are not to be understood, they are to be recognised. *They are an equivalent to nature, not an illustration of it*; their test is in the depth of the artist's imagination' (my emphasis). This seems to contain a memory, no doubt unconscious, of a passage emphatically marked by Robert Motherwell in a book on Turner he gave to Hoyland in 1973, and which has an

increasingly direct relevance to Hoyland's paintings from the late 1970s on: 'Natural forces, both those he had inherited from the Sublime as images of horror, such as fire and storm, and those of light and colour, that he had discovered for himself, became the very essence of his art, embodying in their forms alone the emotions he wished to communicate. The former, fire and storm, conveyed his sense of the insignificance in the face of the immensity and destructiveness of nature; the latter, light and colour, were hymns of praise to the life-giving essences of the physical world.' Just below this passage, even more emphatically marked, is this. 'He came to realise that the *forms of movement* were what he wanted to define, and that nature consisted, not of separate objects in mechanical relations to one another, but of fields of force. Hence the deep tensions that entered into his forms and colours.'

The artist's imagination can work on any material, transforming it to expressive purposes. Through the 1980s Hoyland's work becomes increasingly overt in its reference to its imaginative sources. **Singwara**, for example, openly acknowledges memories of islands glimpsed in the radiant blue of the South China Sea during Hoyland's journey home from Australia in mid-1980. A greener landscape is evoked by the title **Kilkenny Cats** 1982 (plate 36), with its suggestions of Irish mountains and coasts. But Hoyland's titles are never to be taken as descriptive, and are attached to the paintings after their completion, as means to identification rather than as indications of subject matter. His adoption of titles in the early 1970s, as opposed to the simple dating of his earlier practice, is concomitant with a more open acknowledgment of sources of inspiration in the natural world and in personal experience, but they are often discovered purely by chance, or chosen capriciously with a private reference.

The sail-like forms in **Kilkenny Cats** and **Broken Bride** 1982 (plate 35) are derived, in part, from post-cards of crowded boats in Hong Kong harbour, but they are, of course, essentially abstract forms, and their abutments and overlaps are components of a pictorial dynamic of forms, colours and space, just as the manner of their painting and the arbitrary dispositions of colour patches are elements in a drama of textures and surface tensions. The handling in these paintings is coarser, and there is a speed of execution evident in the brushwork that suggests in places an automatic quickness, a spontaneous discovery *in the action of painting* of vital relations. These paintings strike the spectator as compositionally unpremeditated, their odd balances moments of tricky poise before an incipient collapse into chaos. The central triangle in **Broken Bride** depends upon the square form at its bottom left remaining improbably static, just as the square beneath the triangle to the lower right floats without support in a shadowy space: the whole central ensemble is as unstable as a house of cards. In **Kilkenny Cats** the central triangle is balanced on the brown as on a fulcrum (the brown itself being an isosceles triangle fallen on its side), and the long green triangle at the top is precariously poised in its turn. This uneasy stasis is contradicted by the right to left movement

irresistibly suggested by the sloping backs of the solid forms, which seem to push leftwards like scudding clouds, or yachts at the start of a race, and also by the free-wheeling spiralling tumble of the coloured shapes within the large green triangle.

This kinetic vitality, a function of colour, form and handling combined, is the outcome of an intention to discover in painting an equivalent for the dynamism of nature – those 'forms of movement' that are the aspects of the 'fields of force' – in the living world. Hoyland had conducted his research towards these paintings with a deliberation that seems belied by these forms, their spontaneous headlong arrangements, their look of having *arrived* unbidden, as marvellously unpredictable and hectic as the natural forces and forms to which they allude. 'I tried gradually to break from the rectangle and its relationship to the framing edge, and at the same time tried to bring physicality and tactile feeling to the surface. I worked in a kind of open-ended series, moving from the rectangle to the stressed rectangle and eventually to the dynamic of the diagonal, the form with the greatest potential to suggest movement. This led me to the diamond and the use of the triangle.' In **Kilkenny Cats** the axle around which these triangular forms are implied to move is the centre of a grey circle, the first appearance in Hoyland's work of this motif.

The structural dynamic of the paintings just discussed was of course spiral, the movement of their forms inscribing a notional circle within the rectangle of the canvas. That is not quite the case with **Maverick Days** 1983 (plate 37), in which the great beak-like shape which dominates the painting, and which might have been derived from the form of a New Guinea sculpture owned by the artist, is stolidly static like a black mountain around which heavy clouds are banking up. Within its stillness, at the dynamic centre of the painting (though not its actual centre) spins a blue circle on a paler blue patch, the centre of a wider invisible arc which spins out of the rectangular frame altogether, and whose leap to freedom may have given Hoyland the idea for the painting's title. Inevitably, the circle which is at first compositionally implicit, and becomes visible as a crucial axial element in **Kilkenny Cats** and **Maverick Days**, comes into its own in the next series of paintings, and remains in one way or another a recurrent element in Hoyland's paintings for the rest of the 1980s.

6. Improbable Planets, Passionate Infinities

You higher men, what do you think? Am I a soothsayer? a dreamer? a drunkard? an interpreter of dreams? a midnight bell? a drop of dew? a haze and fragrance of eternity? Do you not hear it? Do you not smell it? Just now my world became perfect; midnight too is noon; pain too is a joy; curses too are a blessing; night too is a sun – go away or you will learn: a sage too is a fool. Nietzsche

Hoyland embarked upon the 'circle paintings' in 1983 in the spirit of an adventurer, and with a sense of extreme risk.

Those paintings are like the reports from deep space of a solitary astronaut concerning his encounters with strange and unanticipated worlds, improbable planets. Each one reminds us of something seen, something known; each one seems utterly strange and without a precedent in our experience. They are beautiful and monstrous; they spin in our sight from the banal to the metaphysical, from the comic to the cosmic. These capacious circles contain anything and everything, fruit, fish, beast and fowl, dark vegetation, brilliant blossoms, animals; they concatenate the elements, being like worlds composed of fire, air, earth and water spinning in an infinite darkness, an absolute emptiness; they enact dramas of food and sex and intoxication. They are visions and nightmares, heavens and hells.

These paintings confound respectable aesthetics. They are painted with the offensive coarseness of the new spirit 'bad painting', adopting the broken multiple tonalities of much German painting of the early 1980s, as in the unpleasant green/yellow/black streaks that define the form to the left of the circle in **Turn Turn** 1983 (plate 38), and the brown/white/red smearing of the inner circle in **Street of Kisses** 1985 (plate 40). They are often painted with a glutinous thickness of application that recalls the passionate lubricity of late Picasso, and their freedom from the constraints of conventional design remind us of his magnificent denial of premeditation: 'I do not seek, I find'. These are truly *found* images; discovered in the dark spaces of the imagination by a voyager untrammelled by inhibiting considerations of good taste. It looks like a bowl of fruit? a breakfast plate? a head? a womb? a primitive mask? a ram's head? a strange moon? a burning sun? a cosmogony? Very well, as Walt Whitman might say, it looks like those things; these images are large, they contain multitudes.

The circle paintings were made with a consciousness that the most recent 'major' use of the circle motif was to be found in the un-engaged and decidedly un-Whitmanesque emptiness of American post-painterly abstraction, in the repetitive stained circles of Noland and in certain early 1960s paintings of Olitski; it was also a cosmic presence in the early paintings of Newman, and in the later paintings of Gottlieb: one way or another, it was a potent presence in the modern painting to which Hoyland had paid most attention. There were also the sparely reductive round plate still lifes of de Stael. In all those cases, and others, the circle is always used as a minimal cipher, a simple uncomplicated motif. The circle in Hoyland's paintings, on the contrary, is – to borrow a phrase from de Kooning – 'wrapped in the melodrama of vulgarity'; deliberately over-loaded with allusions and referential ambiguities. **Street of Kisses**, for example, refers to a novel by Marques; **The Ark** 1985 (plate 41) is crowded with vaguely zoological morphologies; **Burning** 1985 (plate 42) contains a strange ideograph beside a bright yellow sun. They may have a portmanteau devil-may-care air about them, but they are much more than *jeux d'esprit*. Hoyland was keenly aware of the history of the circle, as image and symbol, aware of its archetypal resonances; the problem was how to make it new, how to take an ancient sign and re-make its significances. Where others had made it empty,

a cosmic symbol of an absolute perfection, he made of it an image of abundance, a container of the multifarious, the variegated and the heterogeneous.

The magisterial *insouciance* of his treatment of the theme, his cramming and crowding of the image and his admission of free associative materials into its making, are indications of a relaxing of those tensions in Hoyland's approach to picture-making which had demanded always a check on Dionysiac impetuousity, an element of control manifested in pictorial terms. It is important to emphasise that it is matters of design and device that are under consideration here: those *formal* features, characteristic of Hoyland's paintings, which act to stem expressive abundance and to oppose to it order and control. Hoyland's *technical* control is never in question; he is a consummate maker, a master of the craft of painting in all its aspects of colour, texture, formal design. The outcomes of automatic techniques – pouring, staining, flicking, throwing – have always been modified when his intention has required it. Things may arrive in his paintings by the manipulation of accident and chance, but nothing in the paintings is *left* to chance.

The astonishing prodigality of the paintings of the late 1980s is all the more extraordinary in this light. For if the strange and exotic moons of the circle paintings potentially contain everything, including Rimbaud's *l'informe* – that which has *no form* – they are themselves circumscribed and contained: the circle is itself a perfect form. In **Kumari** 1986 (plate 43), **Gadal** 1986 (plate 46) and **Tracks** 1987 (plate 49) it is a form which spins in a chaotic universe: it is as if the lonely astronaut had taken off into the deep space glimpsed behind and beyond those planets whose images he had transmitted in the circle paintings, and found there galaxies and systems in a passionately potential infinity. There is no longer any boundary or confine to the free play of the visionary imagination, no curbing devices, no edge, no angles.

These paintings are acts of enthralled witness, to what is seen in the mind's eye, remembered from childhood, dreams and drunkenness, felt in the spirit, and experienced in the flesh. They are images of joy: **Kumari, Quas** 1986 (plate 45) and **Moon Dance** 1987 (plate 51) are explosive images of plasmic matter, of ecstatic liquefaction and deliquescence, of the melt-down of the individual personality into oceanic formlessness in dance, in sexual passion, in the diver's moment of immersion. They also bring up from Rimbaud's *la-bas* the images of bad dreams and nightmares: the dark angels of **Gadal**, of **Helel: Fallen Angel** 1988 (plate 52) and of **Drakon** 1988 (plate 55) free-fall into vision in monstrous and dreadful shapes. They conjure visions like those seen from the drunken boat:

I've touched, you know, fantastic Floridas
Mingling the eyes of panthers, human-skinned, with flowers!
And rainbows stretched like endless reins
To glaucous flocks beneath the seas …

and phantasmagoria from a season in Hell:

… one see's one's own Angel, never the Angel of another …

And they report too on more immediate experience, of Hoyland's sojourns in the Caribbean, of moonlit and starry nights, glad days, music and drink, sea, coast and forest. They evoke at times the observations and reflections of the great St Lucian poet Derek Walcott on the moon over the ocean:

Black is the beauty of the brightest day,
black the circumference around her rings
that radiate from black invisibly,
black is the music which her round mouth sings,
black is the blackcloth on which diadems shine
black, night's perfection. …

They are images drawn from a life of sharpened sight and generous receptivity. Hoyland has made his own wonderfully undiscriminating and inclusive list of subjects: 'Shields, masks, tools, artefacts, mirrors, Avebury Circle, swimming underwater, snorkling, views from planes, volcanoes, mountains, waterfalls, rocks, graffiti, stains, damp walls, pavements, puddles, the cosmos inside the human body … food, drinks, being drunk, sex, music, dancing, relentless rhythm, the Caribbean, the tropical light, the northern light, the oceanic light. Primitive art, peasant art, Indian art, Japanese and Chinese art, musical instruments, drums, jazz, the spectacle of sport, the colour of sport, magical realism. … Borges the metaphysical, dawn, sunsets, trees, flowers, seas, atolls. … The Book of Imaginary Beings, the Dictionary of Angels, heraldry, North American Indian blankets, Rio de Janiero, Rotterdam!'

These are images, nevertheless, that reach beyond the personal experience; they are representations of ideas that cannot be considered independent of their factual realisation. They are summoned into spectacular being by the exercise of a technical wizardry, like the tempest willed into fury by Prospero's magic art. For of course these teeming pictures are the outcome of a controlled craft, of a furious and tense *invention*, of a capricious trickery. If titles like **Off You Sail** 1987 (plate 50) and **Wandering Awhile** 1987 (plate 47), **Swift Days, Moons and Suns** 1987 (plate 48) recall the ecstatic Rimbaud of *Le Bateau Ivre* and *Les Illuminations*, they should also remind us of the marvellous technique by which those visions were carried into a verse that transcends the maker's personality.

The terrible tension of **Gadal**, for example, is a function of the dynamic between the three circles, *as abstract features*, pushed to the extremes of the picture, each one in oddly asymmetric relation to the others, unstable elements in an uncertain space. The black form, amorphous and yet vaguely suggestive (a falling human form? a crow-like bird?), occupies a space, like the circles, in front of a darkly diaphanous curtain, behind which a wildly agitated deep space, visible at the top of the picture, is proposed. There is a continuous shift, then, between the purely abstract dynamics of the painting – configurations of colour, texture and form in uneasy unstable relations – and the elusive and unsettling spatial and formal analogies that its physical and visual properties suggest. Every one of these tumultuous

paintings could be subjected to this sort of visual-interpretative analysis; in every one there are contradictions and tensions of that kind, depths and shallows, currents of movement and points of stillness, brilliancies and darknesses.

In **Moon Dance** 1987 (plate 51) a snaking spontaneous line of squeezed paint whips across from centre right to the lower centre, and this device is to be found again in **Drakon** 1988 (plate 55) and **Helel**. As we have observed so often in Hoyland's work, a minor feature enters as a subsidiary formal element, and becomes the clue to a major formal development. These eccentric calligraphic linearities are the first signs of the ideogrammatic arabesque which is the principal formal protagonist in the most recent paintings of 1988 and 1989. We can trace the development of this motif as it struggles to release itself from the general matrix of forms and textures, and individuate into a main player at centre stage of the pictorial drama. In the grandly sexual **Spirit of Venus** 1988 (plate 63), and in several other paintings of 1988 – **Paramaribo**, and **Isda** and **Over the Edge** (plates 64, 65, 66) – it metamorphoses through complexities and complications until it reaches the quick and elegant simplicity of the arabesque in the magisterial **Siren** 1989 (plate 71), in **Sorcerer, Aerial Animal** and subsequent paintings (see plates 72, 74, 75, etc.). In these latest magically beautiful paintings of Hoyland this whiplash ideogram enters into animated and imperious dialogue with each of the other features and forms, a line of pure helical energy, a vital image of the individuating life force in the cosmic chaos. Describing the sweep of the sorcerer's arm, commanding form to emerge from the oceanic matrix, it is an image of the artist's creative gesture, a signature, a sign.

Barnes April 1990

Notes and References

1

'The New Decade: 22 European Painters and Sculptors' was at the Museum of Modern Art, New York, from May to August 1955, and subsequently toured to three other cities.
Marcel Brion is quoted from *Art Since 1945* (Thames and Hudson 1959).

2

William Turnbull's statements can be found in *Uppercase 4* (Ed. Theo Crosby) 1960.
Robert Goldwater was writing in the catalogue to Rothko's retrospective exhibition at the Whitechapel Gallery, October-November, 1961.
'Post Painterly Abstraction' was the title of an exhibition selected by Greenberg for the Los Angeles County Museum of Art in April 1974. There were thirty-one artists in the show, including Gene Davis, Sam Francis, Helen Frankenthaler, Al Held, Morris Louis, Kenneth Noland, Jules Olitski, and Frank Stella. In the catalogue essay Greenberg wrote: 'By contrast with the interweaving of light and dark gradations in the typical Abstract Expressionist picture, all the artists in this show move towards physical openness of design, or towards linear clarity, or both.'

3

T. S. Eliot's 'Tradition and the Individual Talent' was written in 1919; it can be found in *Selected Essays* (Faber).
Hoyland is quoted from an interview with Adrian Searle in *Artlog 3* 1979.
Norbert Lynton's review of the Whitechapel exhibition was in *Art International* Summer 1967.
Rothko is quoted from Selden Rodman's *Conversations with Artists* (New York 1957) in Robert Rosenblum's *Modern Painting and the Northern Romantic Tradition* (Thames and Hudson 1975) p. 215
Robert Melville's observations are to be found in the introduction to the catalogue of 'The English Eye' exhibition in New York, 1965.

4

The epigraph from Diderot is a favourite quotation of Hoyland's.

5

The epigraph and the quotations from Barnett Newman are from a statement in the catalogue of 'The New American Painting' at the Tate Gallery, February to March 1959.
'From the beginning of the sixties ... etc.' comes from a note written by Hoyland for the author; 'Paintings are not to be reasoned with ... etc.' comes from Hoyland's statement for the catalogue of the Serpentine exhibition in 1979.
Jack Lindsay quotes Rothenstein and Butlin's *Turner* (1964) in his own study of the painter, *Turner His Life and Work* (Icon Editions NY 1966)
'He came to realise etc ...' are Lindsay's own words.

6

The epigraph is from part 10 of 'The Drunken Song' in *Thus Spoke Zarathustra: The Fourth Part* (trans. Walter Kaufmann in *The Portable Nietzsche:* Viking 1954).
Whitman's lines are in *Song of Myself*:
'Do I contradict myself?
Very well then contradict myself,
(I am large, I contain multitudes.)'
de Kooning speaks of himself as 'wrapped in the melodrama of vulgarity' in the catalogue of the 1959 Tate exhibition. His statement opens: 'Art never seems to make me peaceful or pure'.
Rimbaud's famous letter to Paul Demeny of 15 May 1871 contains the seminal line: 'If that which he [the visionary seer] brings back from *down there* has form, he gives form; if it is formless, he gives formlessness'.
Le Bateau ivre and *Une Saison en Enfer* are texts of sharp relevance to a consideration of Hoyland's paintings in the late 1980s. (The translations are by Louise Varese.)
Derek Walcott's 'Oceano Nox' is in *The Arkansas Testament* (Faber 1987). *The Dictionary of Angels (Including the Fallen Angels)*, by Gustav Davidson (The Free Press NY 1971) has provided Hoyland with many of his recent titles.

1934	Born in Sheffield, 12 October
1946	Enrolled at junior art department of Sheffield College of Art, instead of following grammar school education
1951–56	Studied at Sheffield College of Art; figurative painting, no awareness of abstract art; academic draughtsmanship, but no sense of possibilities of drawing; Eric Jones excellent teacher of drawing. Read Auden, Eliot, etc. Affected by Turner watercolours in Graves Art Gallery and Paul Nash's monochromatic 'Winter Sea' with abstract horizontal planes. Long conversations about art with Brian Fielding, also at Sheffield College of Art
1956	Visited St Cyr, South of France, near de Stael's Cassis; made many topographical paintings Influenced by Rothko's painting in 'Modern Art in the USA' at the Tate Gallery, London
1956–60	Studied at Royal Academy Schools, London; began to draw seriously from the model; interest in early Matisse 'brown and white' pictures; and painting figures Friendship with Paul Huxley, Basil Beattie, Keith Arnatt, Oliver Bradbury
1957	Painted landscapes in Sheffield area, influenced by de Stael Experimented with colour in isolation, at Scarborough summer school, where Pasmore, Tom Hudson and Thubron taught colour, structure and form. Before this, had started to abstract from still life paintings Visited South of France and Adriatic Coast, painted landscapes between Marseille and Toulon; also Italy – Milan, Arezzo, Florence, Assissi; greatly affected by quality of life and light in Italy and France after greyness of Sheffield; painted landscapes and portraits
1958	Joined evening class at Central School of Art, London, under William Turnbull; worked mainly from still life but with expanded references – the possibilities of extending or abstracting from still life Marriage to Airi Karkainen Birth of son, Jeremy
1959	American art in Tate Gallery exhibition made a great impact Entire Diploma show of abstract paintings taken down from wall by order of President of Royal Academy, Sir Charles Wheeler, but Diploma allowed ICA series of 'Talk' sessions: artists' meetings and discussions with Lawrence Alloway and others
1960	Began teaching basic design at Hornsey College of Art, London, teaching with Alan Green, Bridget Riley and Brian Fielding under Maurice de Sausmarez; also taught at Oxford School of Art Visited Finland, and annually thereafter for some years
1961	Studio at Primrose Hill, until 1965 Taught at Luton College of Art and Hornsey College of Art until end of 1962
1962	Began teaching at Croydon School of Art and Chelsea School of Art, London Met William Tucker; saw Paul Huxley regularly until his departure for USA in 1965
1963	Calouste Gulbenkian Foundation Purchase Award Greatly stimulated by Caro exhibition at Whitechapel Art Gallery, London
1964	Visited Italy and South of France; saw Matisse chapel at Vence, and Leger Museum at Biot Travelled to New York with Peter Stuyvesant Bursary; visited studios, saw unexhibited canvases by Morris Louis; met Noland, Feeley and Olitski in Vermont; also met Clement Greenberg, who showed him two small Hofmann's at Kootz Gallery, New York International Young Artists Award, Tokyo

John Hoyland, aged 6

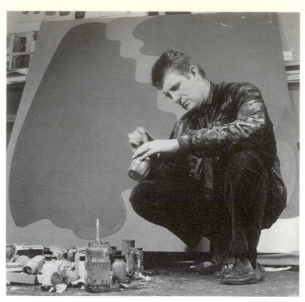

Oppidans Road Studio 1963

Sheffield 1952

In New York 1971

RA Schools 1958

The artist with Eloise Lawes at Studio La Citta, Verona 1973

24

1964–65	Built studio in garden of home in Kingston-upon-Thames
	Principal Lecturer at Chelsea School of Art, London; occasional teaching visits to Royal Academy Schools
	Prizewinner at John Moores Liverpool Exhibition, 1965
1966	Prizewinner at Open Paintings Exhibition, Belfast
1967	Made first works in New York, in Peter Stroud's studio
1967–69	Frequent visits to New York; in summer of 1968 worked in studio of John Griefen; spent time with Larry Poons and Ronnie Langfeldt
1968	Separated from wife; subsequently divorced
	Moved to new studio, Market Lavington, Wiltshire
	Made lithographs with Curwen in London and with Wolfensberger in Switzerland
1969	Travelled to Brazil and Caribbean with Anthony Caro; worked summer in New York
	Met Eloise Laws, black American singer, in Trinidad; shared apartment in New York until 1973; contact with Hubert Laws, flautist and composer, and Ronnie Laws, saxophonist and composer; travelled extensively in America with Eloise Laws' engagements in jazz clubs
	Resigned principal lectureship, Chelsea School of Art
	First Prize (with Robyn Denny) Edinburgh Open 100 Exhibition
	Made series of screenprints with Chris Prater at Kelpra Studio, London
1970	Resigned from Chelsea School of Art
	Second studio at Primrose Hill, London
1970–71	Made prints with Ian Lawson, Kelpra Studio and Chris Betambeau at Advanced Graphics; also made an etching at the Royal College of Art
1971	Frequent trips to New York; continued to see Noland, Frankenthaler, Motherwell and Greenberg
	Worked in New York, including work on a series of nine screenprints
1972	Charles A. Dana Professor of Fine Arts, Colgate University, Hamilton, New York
	Studio in Hamilton, produced much work; started to work on smaller scale, building more tactile surface
	Vacation in Barbados, and frequent visits from this time on to Caribbean in Winter
1973	Travelled to Provincetown with Robert Motherwell
	Returned to work in London
1974	Made a series of three lithographs with Ian Lawson and another series in Verona
1974–77	Visiting teacher, St Martin's School of Art, Royal Academy Schools and Slade School of Art, London
1975	Rome Scholarship Committee (printmaking)
	First Prize, Chichester National Art Exhibition
1975–79	Worked periodically on paintings in New York
1977	Selector and exhibitor, Royal Academy Silver Jubilee Exhibition
1978	Artist in Residence, Studio School, New York (Summer); painted many small works on paper
	Made a lithograph at Slade School
1979	Artist in Residence, Melbourne University, from December until April 1980; visited Bombay en route with Patrick Caulfield; contact with Caulfield in Australia; visited Hong Kong and Thailand
	Selector and Curator for Hayward Annual, London
	Arts Council of Great Britain Purchase Award
	Rome Scholarship Committee (printmaking), until 1989
	Worked on two etching/aquatints with James Collyer and John Crossley at J.C. Editions and on a further series with Nigel Oxley at Kelpra Studio
1980	Moved to new studio in Charterhouse Square, London
	Visiting teacher, Slade School of Art, London
1980–81	Made etchings and aquatints at Kelpra Studio and a large screenprint at Advanced Graphics
1982	Worked in Los Angeles
	First Prize, John Moores Liverpool Exhibition
1982–83	Worked on a series of monotypes with Alan Cox at Sky Editions

1983	Visiting Teacher, Slade School of Art
	Made prints and monotypes with Atelier Lacourière et Frélaut, France; screenprinted monotypes with Advanced Graphics, London; and etched monotypes with Jack Shirreff at 107 Workshop, Wiltshire
1984–85	Made ceramics in Tody, Umbria, invited by Piero Dorazio
1984–89	Continued to make monotypes at Sky Editions
1986	Joint First Prize in Korn Ferry International Award Exhibition (with William Scott)
	Set designs for 'Zansa', Sadler's Wells; choreography by Richard Alston, music Nigel Osborne, lighting Peter Mumford
	Worked on two series of etchings at 107 Workshop
1987	First Prize, Athena Art Awards Exhibition
	Travelled to Trinidad, Antigua and Jamaica
1988	Travelled in United States selecting and curating Hans Hofmann exhibition for Tate Gallery, London
	June, travelled to Jamaica; sailing trip in eastern Mediterranean with Patrick Caulfield, Janet Nathan and Beverly Heath
1989	Travelled to Minorca with Ken Draper, Joan MacAlpine and Beverly Heath; to Jamaica and Italy with Beverly Heath; made etchings in Milan with Giorgio Upiglio at Grafica Uno
	Resigned from Slade School of Art, London

In Australia 1980

John Hoyland in his studio 1983

John Hoyland in his studio 1990

ONE-MAN EXHIBITIONS

1964 Marlborough New London Gallery, London
1965 Chelsea School of Art, London
1967 Whitechapel Art Gallery, London
 Galerie Heiner Friedrich, Munich
 Robert Elkon Gallery, New York
 Nicholas Wilder Gallery, Los Angeles
 Waddington Galleries, London
 Waddington Fine Art, Montreal
1968 Robert Elkon Gallery, New York
 Waddington Fine Art, Montreal
1969 Andre Emmerich Gallery, New York
 Waddington Galleries, London
 Leslie Waddington Prints, London
1970 Waddington Galleries, London
 Andre Emmerich Gallery, New York
 Galleria dell'Ariete, Milan
1971 Waddington Galleries, London
 Andre Emmerich Gallery, New York
 Waddington Fine Art, Montreal
1972 Andre Emmerich Gallery, New York
 Harcus Krakow Gallery, Boston
 Picker Gallery, Colgate University, Hamilton, New York
1973 Waddington Galleries, London
 Galleria l'Approdo, Turin
1974 Studio la Citta, Verona
 Waddington Galleries, London
 Nicholas Wilder Gallery, Los Angeles
1975 Kingpitcher Contemporary Art Gallery, Pittsburgh
 Galleria E. Bolzano, Italy
 Rubiner Gallery, Detroit, Michigan
 Waddington Galleries, London
 Waddington Fine Art, Montreal
1976 Waddington Galleries, London (paintings 1966–68)
 Galleria La Bertesca, Milan, Genoa and Turin
 Studio la Citta, Verona
1976–77 Galeria Modulo, Lisbon
1978 Waddington Galleries, Montreal
 Waddington and Tooth Galleries, London
1979 Andre Emmerich Gallery, New York
 Waddington Fine Art, Toronto
 Bernard Jacobson Gallery, New York (works on paper)
 Art Contact, Coconut Grove, Florida
1979–80 Serpentine Gallery, London (retrospective); touring to Birmingham City Art Gallery;
 Mappin Art Gallery, Sheffield
1980 University Gallery, University of Melbourne; touring to Art Gallery of South Australia,
 Adelaide; Macquarie Galleries, Sydney
 Galerie von Braunbehrens, Munich
 Galerie Kammer, Hamburg

1981	Gump's Gallery, San Francisco
	Waddington Galleries, London
1982	Jacobson/Hochman Gallery, New York
	Bernard Jacobson Gallery, Los Angeles
	Compass Gallery, Glasgow
1983	Waddington Galleries, London
	Waddington Graphics, London
1983–84	Hokin/Kaufman Gallery, Chicago
1984	Castlefield Gallery, Manchester
1985	Waddington Galleries, London
1986	Waddington & Shiell Galleries, Toronto (ceramics and paintings)
1987	Waddington Galleries, London
	Oxford Gallery, Oxford
	Lever/Meyerson Gallery, New York
1988	Erika Meyerovich Gallery, San Francisco
	Edward Thorden Gallery, Gothenburg
1990	Austin/Desmond Fine Art, London (prints)
	Waddington Galleries, London

TWO-MAN EXHIBITIONS

1969	Hoyland/Anthony Caro, X Biennal de Sao Paulo, Brazil
1972	Hoyland/Jules Olitski, Leslie Waddington Prints, London
1979	Hoyland/Gordon House, Waddington Graphics, London
1980	Hoyland/John Walker, Van Straaten Gallery, Chicago
1981	Hoyland/Joe Tilson, Hokin Gallery, Miami

GROUP EXHIBITIONS

1956	'Royal Academy Summer Exhibition', Royal Academy, London
1957	'Royal Academy Summer Exhibition', Royal Academy, London
1958	'Royal Academy Summer Exhibition', Royal Academy, London
1959–60	'Young Contemporaries', RBA Gallery, London
1960	'Situation', RBA Gallery, London
	'Summer Exhibition', Redfern Gallery, London
	'Summer Exhibition', AIA Gallery, London
1961	'Nine Painters from England', Galleria Trastevere, Rome
	'Neue Malerei in England', Stadtisches Museum, Leverkusen, West Germany
	'New London Situation', Marlborough New London Gallery, London
1962	'Hoyland, Plumb, Stroud and Turnbull', New London Gallery, London
	'British Painting', Stone Gallery, Newcastle
	'Nine Painters from England', Galleria Trastevere, Rome
1962–63	'British Art Today', San Francisco Museum of Art; touring to Dallas Museum of Contemporary Art; Santa Barbara Museum of Art
	'Situation', Arts Council Gallery, Cambridge; touring to Aberdeen Art Gallery; Hatton Gallery, Newcastle; Bradford City Art Gallery; Kettering Art Gallery; Walker Art Gallery, Liverpool
1963	'7th Tokyo Biennial', Tokyo
	'Critic's Choice', Arthur Tooth & Sons, London
	'One Year of British Painting', Arthur Tooth & Sons, London
	'John Moores Liverpool Exhibition', Walker Art Gallery, Liverpool
	'British Painting in the Sixties', Whitechapel Gallery, London
1964	'The New Generation: 1964', Whitechapel Gallery, London
	'Contemporary British Painting and Sculpture', Albright–Knox Art Gallery, Buffalo, New York
	'1954–64: Painting and Sculpture of a Decade', Calouste–Gulbenkian Foundation Collection, Tate Gallery, London
1965	'4th Biennial Exhibition of Young Artists', Musée d'Art Moderne de la Ville de Paris
	'John Moores Liverpool Exhibition', Walker Art Gallery, Liverpool
	'The English Eye', Marlborough–Gerson Gallery, New York
	'Peter Stuyvesant Foundation – A Collection in the Making', Whitechapel Gallery, London
1966	'London Under Forty', Galleria Milano, Milan
	'Open Paintings Exhibition', Ulster Museum, Belfast
	'Six Sheffield Artists', Mappin Art Gallery, Sheffield
1966–67	'Aspects of New British Art', Arts Council exhibition touring to New Zealand; Queensland; New South Wales; Tasmania
1967	'Pittsburgh International', Carnegie Institute, Pittsburgh
	'Recent British Painting', Peter Stuyvesant Foundation Collection, Tate Gallery, London
	'Works on Paper', Waddington Galleries, London
	'Jeunes Peintres Anglais', Palais des Beaux Arts, Brussels
	'First Edinburgh Open 100 Exhibition', David Hume Tower, Edinburgh University
	'John Moores Liverpool Exhibition', Walker Art Gallery, Liverpool
	'Drawing Towards Painting 2', Arts Council Gallery, London
1968	'Junge Generation Grossbritannien', Akademie der Kunste, Berlin
	'Documenta IV', Kassel, West Germany
	'Britische Kunst Heute', Kunstverein, Hamburg

'The New Generation: 1968 Interim', Whitechapel Gallery, London

'Leicestershire Collection: Part II', Whitechapel Gallery, London

1968–69 'New British Painting and Sculpture', selected by Herbert Read and Bryan Robertson, University of California Art Galleries, Los Angeles

'European Painters Today', Musée des Arts Decoratifs, Paris; touring to New York; Washington; Chicago; Atlanta; Dayton

1969 'Marks on a Canvas', organised by Tate Gallery and selected by Anne Seymour, Museum am Ostwall, Dortmund; touring to Kunstverein, Hannover; Museum des 20. Jahrhunderts, Vienna

'Edinburgh Open 100 Exhibition', Edinburgh

'John Moores Liverpool Exhibition', Walker Art Gallery, Liverpool

1970 'Exhibition of Contemporary Art', Kansas State University, Manhattan, Kansas

'Contemporary British Art', National Museum of Modern Art, Tokyo

1970–71 'British Painting and Sculpture 1960–1970', National Gallery of Art, Washington DC

1971 'Junge Englander: Monro, Hoyland, Tucker, Caulfield, Smith', Kunstudio Westfalen, Bielefeld, West Germany

'Art Spectrum South '71', Arts Council exhibition touring to Southampton City Art Gallery; Folkestone Arts Centre; Royal West of England Academy, Bristol

'Pittsburgh International', Carnegie Institute, Pittsburgh

'Three Painters' (with Patrick Caulfield and Ivon Hitchens), Bear Lane Gallery, Oxford

1972 'Britisk Maleri 1945–70', British Council exhibition touring to Kunstnerforbunder, Oslo; Trondhjems Kunstforening; Bergens Kunstforening

'John Moores Liverpool Exhibition', Walker Art Gallery, Liverpool

1973 'La Peinture Anglaise Aujourd'hui', Musée d'Art Moderne, Paris

'I Paint a Painting', Studio la Citta, Verona; touring to Turin; Rome

1974 'Some Significant British Artists 1950–70', Rutland Gallery, London

'British Painting '74', Hayward Gallery, London

'Works on Paper', Andre Emmerich Gallery, Zurich

'John Moores Liverpool Exhibition', Walker Art Gallery, Liverpool

1975 'Britanniasta '75', Helsingin Taidehalli, Helsinki; touring to Alvar Aalto-Museo; Tampereen Taidemuseo, Tampere

'Chichester National Art Exhibition', Chichester

'British Exhibition Art 6 '75', Basel

'Color as Language', Museum of Modern Art, New York; touring to Arte Fiera 75, Bologna

1975–76 'Peter Eveleigh, Michael Garton, John Hoyland, Paul Mount', South West Arts exhibition, Royal West of England Academy, Bristol; Plymouth City Museum & Art Gallery

1976 'Arte Inglese Oggi', Palazzo Reale, Milan

'Royal Academy Summer Exhibition (Peter Blake's Choice)', Royal Academy, London

'John Moores Liverpool Exhibition', Walker Art Gallery, Liverpool

1977 'Tolly Cobbold/Eastern Arts National Exhibition', Fitzwilliam Museum, Cambridge; touring to Ipswich Museums; Graves Art Gallery, Sheffield; Camden Arts Centre, London

'Hayward Annual', Hayward Gallery, London

'ROSC 1977', Dublin

'Color en la Pintura Britanica', British Council exhibition touring to Rio de Janeiro; Brazilia; Curitba; São Paulo; Buenos Aires; Caracas; Bogota; Mexico City

'British Painting 1952–1977', Royal Academy, London

'British Art Mid-70's', Leverkusen, West Germany

'Englische Kunst Der Gegenwart', Kunstlerhaus, Bregenz

1978 'Groups', Waddington & Tooth Galleries, London

'Critic's Choice', Institute of Contemporary Arts, London

1979 'British Drawings since 1945', Whitworth Art Gallery, Manchester

'John Moores Liverpool Exhibition', Walker Art Gallery, Liverpool

1979–80 'The British Art Show', Mappin Art Gallery, Sheffield touring to Laing Art Gallery, Newcastle; Hatton Gallery, University of Newcastle; Arnolfini Gallery, Bristol; City Museum & Art Gallery and Royal West of England Academy, Bristol

1980 '6 Modern Artists', Poole Arts Centre, Poole, Dorset

'John Moores Liverpool Exhibition', Walker Art Gallery, Liverpool

1981	'Groups IV', Waddington Galleries, London
	'3rd Tolly Cobbold/Eastern Arts National Exhibition', Fitzwilliam Museum, Cambridge; touring to Christchurch Mansion, Ipswich; Castle Museum, Norwich; Institute of Contemporary Arts, London; Mappin Art Gallery, Sheffield
	'Peter Moores Liverpool Project 6; Art into the '80's', Walker Art Gallery, Liverpool
1982	'Aspects of British Art Today', Tokyo Metropolitan Art Museum; Tochigi Prefectural Museum of Fine Arts, Utsunomiya; Hokkaido Museum of Modern Art, Sapporo
1982–83	'John Moores Liverpool Exhibition', Walker Art Gallery, Liverpool
1983	'Groups VI', Waddington Galleries, London
	'Recent Acquisitions in Contemporary Art, Part 1', Carnegie Institute, Pittsburgh
	'Pintura Britanica Contemporanea', Museo Municipal, Madrid
	'Maclaurin Collection', Maclaurin Gallery, Rozelle, Ayr
1984	'Groups VII', Waddington Galleries, London
	'English Expressionism', Warwick Arts Trust, London
	'Royal Academy Summer Exhibition', Royal Academy, London
	'The Forgotten Fifties', Graves Art Gallery, Sheffield; touring to Norwich Castle Museum; Herbert Art Gallery & Museum, Coventry; Camden Arts Centre, London
1984–85	'British Art Show', City Art Gallery and Ikon Gallery, Birmingham; Royal Scottish Academy, Edinburgh; Mappin Art Gallery, Sheffield; Southampton Art Gallery
1985	'Groups VIII', Waddington Galleries, London
	'Printmakers at the Royal College of Art', Barbican Art Gallery, London
1986	'Retrospective', Castlefield Gallery, Manchester
	'Royal Academy Summer Exhibition', Royal Academy, London
	'Forty Years of Modern Art, 1945–1985', Tate Gallery, London
	'Hidden Landscape', Juda Rowan Gallery, London
	'Into View: British Paintings from Private Collections', Gainsborough's House, Sudbury
	'Waddington Graphics: Publishers of Contemporary Prints', Waddington Graphics, London
1987	'British Art in the 20th Century: The Modern Movement', Royal Academy, London; touring to Staatsgalerie, Stuttgart
	'Athena Art Awards Exhibition', Barbican Art Gallery, London
	'Inaugural Exhibition', Patricia Knight Fine Art, London
	'Biennale', Musée d'Art Moderne, Liège (prints)
	'Works on Paper', Waddington Galleries, London
1988	'Basil Beattie, John Hoyland, Albert Irvin', Northern Centre for Contemporary Art, Sunderland
	'Walia – A Memorial Exhibition of his photographs of artists and works by the artists photographed', Chelsea School of Art, London
1988–89	'Paintings and Sculpture', Francis Graham-Dixon Gallery, London
	'The Presence of Painting', Mappin Art Gallery, Sheffield; touring to Hatton Gallery, Newcastle; Ikon Gallery, Birmingham
	'100 Years of Art in Britain', Leeds City Art Gallery
1989	'Works on Paper', Waddington Galleries, London
	'Sun, Moon and Stars', Trelissick Gallery, Cornwall
	'Royal Academy Summer Exhibition', Royal Academy, London
	'Abstract '89', Cleveland Bridge Gallery, Bath
	'From Picasso to Abstraction', Annely Juda Fine Art, London
	'British Painting in the 1960's & 70's', Ramsgate Library Gallery, Ramsgate
1990	'Friends of Alistair Grant', Royal College of Art, London
	'The Compass Contribution – 21 Years of Contemporary Art', Tramway, Glasgow (anniversary exhibition organised by Cyril Gerber)
	'Great British Art Exhibition', McLellan Galleries, Glasgow

1976	'British Art in Milan', BBC Television
	'The London Programme', London Weekend Television
1977	'British Art 1952–77' (Royal Academy) BBC Television
	'Painting in the 50's and 60's', Open University, (BBC Radio interview with Bryan Robertson)
1979	'6 Days in September', BBC Arena
1989	'Signals', Channel 4 Television, 15 February

United Kingdom
: Arts Council of Great Britain, London
Birmingham City Art Gallery
British Council, London
Contemporary Art Society, London
Courtauld Institute, London
Government Art Collection, London
Calouste Gulbenkian Foundation, London
Laing Art Gallery, Newcastle-upon-Tyne
Leicestershire Education Authority
Maclaurin Collection, Rozelle, Ayr
Manchester City Art Gallery
Royal Academy of Arts, London
Royal College of Physicians, London
Peter Stuyvesant Foundation, London
Tate Gallery, London
Ulster Museum, Belfast
Victoria & Albert Museum, London
Walker Art Gallery, Liverpool
Warwick University
Whitworth Art Gallery, Manchester

Outside United Kingdom
: Art Gallery of South Australia, Adelaide
Melbourne University Art Gallery
Perth Art Gallery
Power Gallery of Contemporary Art, University of Sydney
Albright-Knox Art Gallery, Buffalo, New York
Carnegie Institute, Pittsburgh
Neuberger Museum, State University of New York, Purchase
Art Gallery of Ontario, Toronto
Phoenix Museum, Arizona
Picker Gallery, Colgate University, Hamilton, New York
Museum of Art, Rhode Island School of Design, Providence
Museum of Modern Art, Rio de Janeiro
Toledo Museum of Art, Ohio
Frederick R. Weisman Art Foundation Collection, Los Angeles
Art Museum of the Ateneum, Helsinki
Stadtisches Museum, Leverkusen, West Germany
Tehran Museum of Modern Art, Iran

SELECTED BIBLIOGRAPHY

1964 Read, Herbert: *Contemporary British Art*, Penguin Books, London
 Thompson, David: (introduction) *The New Generation*, catalogue, Whitechapel Gallery, London

1967 Robertson, Bryan: (introduction) *Paintings 1960–67*, catalogue, Whitechapel Gallery, London
 Bowness, Alan: (introduction) *Recent British Painting* catalogue, Peter Stuyvesant Foundation, London

1969 Brett, Guy: 'John Hoyland', *The Times*, 26 May
 Lucie-Smith, Edward: *Late Modern Art*, Praeger, New York
 Harrison, Charles: 'John Hoyland', *X Bienal de São Paulo Gra-Bretanha 1969*, catalogue, British Council, Lund Humphries, London
 John Hoyland: Paintings, catalogue, Waddington Galleries, London

1970 Alley, Ronald: 'The Sebastian Ferranti Collection', *Studio International*, January
 Arckus, Anthony Leon: 'Introduction to the Catalogue', *Pittsburgh International*, catalogue, Carnegie Institute, Pittsburgh
 Theriault, Normund: 'Hoyland: Je suis un reactionnaire', *La Presse*, Montreal, 7 February
 Heywood, Irene: 'John Hoyland', *Montreal Gazette*, 7 February
 Bardo, Arthur: 'Portrait of the Artist', *Montreal Star*, 7 February
 Seymour, Anne: 'Subtle Barriers', *Spectator*, 3 May
 Lucie-Smith, Edward: 'John Hoyland', *Sunday Times*, 7 May
 Gosling, Nigel: 'Visions off Bond Street', *The Observer*, 17 May
 Pincus-Witten, Robert: 'Reviews and Previews', *Art News*, October
 Kramer, Hilton: 'Art: Vitality in the Pictorial Structure', *New York Times*, 10 October
 Lynton, Norbert: 'British Art Today', *Smithsonian*, November, volume 1, no. 8
 Pincus-Witten, Robert: 'New York: John Hoyland', *Artforum*, December
 Robertson, Bryan: (introduction) *John Hoyland*, catalogue, Galleria dell'Ariete, Milan
 Lucie-Smith, Edward: *British Painting and Sculpture 1960–1970*, catalogue, National Gallery of Art, Washington DC
 John Hoyland: paintings, catalogue, Waddington Galleries, London

1971 Marle, Judy: 'Histories Unfolding', *The Guardian*, May
 Forge, Andrew: 'Andrew Forge Looks at Paintings of Hoyland', *The Listener*, July
 Kennedy, R. C: 'London Letter', *Art International*, (Lugano), 20 October
 John Hoyland: Recent paintings, catalogue, Waddington Galleries, London

1973 Russell, John: 'The English Conquest', *Sunday Times*, 11 February
 John Hoyland, catalogue, Waddington Galleries, London

1974 Findlater, Richard: 'A Briton's Contemporary Clusters Show a Touch of American Influence', *Free Press*, 27 October
 Maloon, Terence and John Edwards: 'Two Aspects of John Hoyland', *One*, no. 2

1975 Martin, Barry: 'John Hoyland and John Edwards', *Studio International*, May/June, p. 177
 McEwen, John: 'Hoyland and Law', *The Spectator*, 15 November
 Bowen, Denis: 'John Hoyland', *Arts Review*, 14 November

1976 Walker, John: 'John Hoyland and Bob Law', *Studio International*, January/February
 Spurling, John: 'Totems', *New Statesman*, 22 October
 McEwen, John: 'Momentum', *The Spectator*, 23 October
 Overy, Paul: 'Colour', *Art and Artists*, November
 Oille, Jennifer: 'John Hoyland', *Art Monthly*, November

Feaver, William: 'Painting Prose', *The Observer*, 17 October
John Hoyland, catalogue, Galeria Modulo, Lisbon

1977 Robertson, Bryan: 'Looking for Hoyland', *The Spectator*, 2 July
Prendeville, Brendan: 'British Painting in Common View', *Artscribe*, no. 8
Faure-Walker, Jaames: 'Painting at the Hayward', *Artscribe*, no. 8
Vaizey, Marina: 'British Painting: a Progress Report', *Sunday Times*, 25 September
Harrison, Charles: 'Two by Two they went into the Ark', *Art Monthly*, November

1978 Lehmann, Harry: 'Hoyland abstractions boldly pleasing as ever', *Montreal Star*, 30 March
McEwen, John: 'John Hoyland in mid-career', *Arts Canada*, April
Maloon, Terence: 'Nothing succeeds like excess', *Time Out*, September
Feaver, William: 'The Many Sides of Moynihan', *The Observer*, 10 September
Vaizey, Marina: 'John Hoyland', *Sunday Times*, 10 September
Wright, Barbara: 'John Hoyland', *Arts Review*, 15 September
Mackenzie, Andrew: 'Let's recognise city artist', *Morning Telegraph*, Sheffield, 18 September
Spurling, John: 'Curtained off', *New Statesman*, 22 September
McEwen, John: 'Abstraction', *The Spectator*, 23 September
Burr, James: 'Functionalism Humanised', *Apollo*, September
Robertson, Bryan: 'John Hoyland, Bridget Riley, Paul Huxley', *Harpers and Queen*, October

1979 Russell, John: 'New Paintings by John Hoyland', *New York Times*, 9 February
McEwen, John: '4 British Artists', *Artforum*, March
Hoyland, John: 'Painting 1979: A Crisis of Function', *London Magazine*, April/May
Searle, Adrian: 'Interview with John Hoyland', *Artlog*, no. 3
Packer, William: 'David Bomberg + John Hoyland', *Financial Times*, 2 October
Lucie-Smith, Edward: 'Waiting for the click ...', *Evening Standard*, 3 October
Spalding, Frances: 'John Hoyland', *Arts Review*, 12 October
Richards, Margaret: 'Multi-coloured lavishness', *Tribune*, 12 October
Januszczak, Waldemar: 'Felt through the Eye', *The Guardian*, 16 October
Griffiths, John: 'John Hoyland: Paintings 1967–1979', *The Tablet*, 20 October
Kent, Sarah: 'The Modernist Despot Refuses to Die', *Time Out*, 19–25 October
Vaughan Winter, Simon: 'The Eyes Have It – and How', *Evening News*, 6 October
Shepherd, Michael: 'Colour Magic', *The Observer*, October
MacKenzie, Andrew: 'A Colourful Champion of the Abstract', *Morning Telegraph*, Sheffield, 9 October
Spurling, John: 'Campaigns in Colour', *New Statesman*, 12 October
Roberts, John: 'Hoyland at the Serpentine', *Artscribe*, November
Fuller, Peter: 'Hoyland at the Serpentine', *Art Monthly*, no. 31
Robertson, Bryan: 'Introduction', *John Hoyland, Paintings 1967–1979*, catalogue, Arts Council, pp. 5–7
McEwen, John: 'Colour as Form', *John Hoyland, Paintings 1967–1979*, op. cit. pp. 7–8
Maloon, Terence: 'Hoyland Retrospectively', *John Hoyland, Paintings 1967–1979*, op. cit. pp. 33–35

1980 McGrath, Sandra: 'Points, Paints and Praxiteles', 7 May
McGrath, Sandra: 'Hangovers and Gunfighters', *The Australian*, 19 February
Makin, Jeffrey: 'Colour ... it's the European Flair', *The Sun*, 30 April
Fraser, Alison, 'Solid areas of hot colour', *The Australian*, 5 May
McCullach, Alan: 'Seeing it in Context ...', *The Herald*, 22 May
Sgubbi, Gianfranco: 'London', *Juliet Art Magazine*, June/October, no. 21, p. 36
Rooney, Robert: 'Hoyland Squeezes out last Desperate Drops', *Age*, 30 May
Faure Walker, James: 'John Hoyland and the Hayward Annual', *Artscribe*, no. 24, August
Lynn, Elwyn: 'Hoyland – Then and Now', *John Hoyland, Paintings Australia 1980*, catalogue, University Gallery, University of Melbourne, pp. 5–6
Marginson, R. D: 'Foreword', *John Hoyland, Paintings Australia 1980*, op. cit., p. 4
Robertson, Bryan: 'Introduction', *John Hoyland, Paintings Australia 1980*, op. cit., pp. 7–13 (reprinted from 1979 Arts Council catalogue)
McEwen, John: 'Colour as Form', *John Hoyland, Paintings Australia 1980*, op. cit., pp. 13–14 (also reprinted from 1979 Arts Council catalogue)

1981 Russell Taylor, John: 'John Hoyland', *Art and Artists*, November
McEwen, John: 'Undercurrents', *The Spectator*, 24 October
Packer, William: 'Painting of sorts', *Financial Times*, 20 October
Feaver, William: 'White Russian Hope' (includes review of Waddington Galleries exhibition), *The Observer*, 11 October
Russell Taylor, John: *The Times*, 13 October
Painter, Colin: 'John Hoyland talks to Colin Painter', *Aspects*, no. 16, Autumn
Titterington, Chris: 'John Hoyland at Waddingtons', *Artscribe*, December
Beaumont, Mary Rose: 'Waddington Galleries – John Hoyland, Kenneth Noland, David Tremlett', *Arts Review*, 23 October, pp. 472–473
John Hoyland, catalogue, Waddington Galleries, London

1982 Bisson, Roderick: 'Confused? It's a struggle', *Post*, 25 November
McEwen, John, 'Flying colours', *The Spectator*, 4 December
Vaizey, Marina: 'Art' (review of John Moores Liverpool Exhibition), *Sunday Times*, 28 November
Freke, David: 'Massaging the Medium', *Arts Alive Merseyside*, December
Riley, Joe: 'Lucky 13–It's a Winner for John!', *Liverpool Echo*, 24 November
Oliver, W. T: 'Prize abstracts', *Art & Architecture*, 6 December
Shepherd, Michael: 'The Liverpool Look', *Sunday Telegraph*, 2 January
Feaver, William: (review of the John Moores Liverpool Exhibition), *The Observer*, 12 December
Feaver, William: 'What's Time to a Pig?', *Art News*, January, volume 81, no. 1
McManus, Irene: 'John Moores Competition', *The Guardian*, 8 December
Hatton, Brian: 'The John Moores at the Walker Art Gallery, Liverpool', *Artscribe*, no. 38, December
Key, Philip: 'This Way Up and It's Art: Key Previews the John Moores Exhibition', *Post*, 25 November

1983 Van Joel, Mike: 'Hoyland at Home, *Art Line*, no. 4, February
Waddington, Leslie: (introduction) *John Hoyland*, catalogue, Waddington Galleries, London
Sweet, David: 'John Hoyland at Waddingtons', *Artscribe*, June, no. 41
Vaizey, Marina: 'Between painting and sculpture', *Sunday Times*, 22 May
McEwen, John: 'John Hoyland, new paintings', *The Spectator*, 21 May
Januszczak, Waldemar: 'Last Chance', *The Guardian*, 18 May
Allthorpe-Guyton, Marjorie: 'John Hoyland', *Arts Review*, 13 May
Alleyne, Sylvan: 'John Hoyland', *Root*, June
Billam, Michael: (introduction) *John Hoyland, Prints & Monotypes 1979–1983*, catalogue, Waddington Graphics, London
Shepherd, Michael: 'Art: The Liverpool Look', *Sunday Telegraph*, 2 January
Petherbridge, Deanna: 'A Walk through the Academy Gardens', *Art Monthly*, February
Thompson, Colin: 'The Importance of the Maclaurin Trust Collection', *The Maclaurin Collection*, brochure, Maclaurin Gallery, Rozelle, Ayr

1984 Feaver, William: 'English Expressionism' (review of exhibition at Warwick Arts Trust), *The Observer*, 13 May
Finch, Liz: 'Painting is the head, hand and the heart', John Hoyland talks to Liz Finch, *Ritz Newspaper Supplement: Inside Art*, June, pp. 4–5
Collier, Caroline: 'Hoyland Harvest', *Studio International*, no. 1005, volume 197
Beaumont, Mary Rose: 'The British Art Show', *Arts Review*, 23 November
Roberts, John: 'Morality, Postmodernism and the Pursuit of Metaphor: The British Art Show', *Artscribe*, no. 49, November/December, p. 17
McEwen, John: 'The golden age of junk art: John McEwen on Christmas Exhibitions', *Sunday Times*, 18 December
Moffat, Alexander: 'Reinventing The Real World', *The British Art Show*, catalogue, Orbis/Arts Council, London, pp. 28–31

1985 'The British Art Show', *Art Monthly*, December 1984/January 1985
Packer, William: 'Open eyes, open minds', *Financial Times*, 12 March
Vaizey, Marina: 'British art: the schools go comprehensive', *Sunday Times*, 4 November
Usherwood, Nicholas: 'Old Boys', *R. A. Magazine*, no. 9, Winter, pp. 14–16
John Hoyland, catalogue, Waddington Galleries, London

1986 Schilling, Sally-Ann: 'On Colour–John Hoyland in conversation with Sally-Ann Schilling', *The Artist*, September
Garras, Stephen: 'Sketches for a Finished Work', *The Independent*, 22 October
'London As An Art Centre', *London Illustrated News*, May, p. 64

1987 McEwen, John: 'John Hoyland: new paintings, 1986', *John Hoyland*, catalogue, Waddington Galleries, London
Graham-Dixon, Andrew: 'Canvassing the abstract voters', *The Independent*, 7 February
Januszczak, Waldemar: 'The Circles of Celebration', *The Guardian*, 19 February
Dorment, Richard: 'The abstract language of colours', *Daily Telegraph*, 11 February
Vaizey, Marina: 'Zoomin wins the glittering prize', *Sunday Times*, 15 February
McEwen, John: 'Britain's Best and Brightest', *Art in America*, July
Batchelor, David: 'John Hoyland – Waddington', *Artscribe International*, May
Burn, Gordon: 'Which One Will Win £25,000?', *Sunday Times Magazine*, 8 February, pp. 20–24
Bell, Gavin: 'Top award for casual printing', *The Times*, 11 February
Graham-Dixon, Andrew: 'John Hoyland', *The Independent*, 12 February
Januszczak, Waldemar: 'Painter nets £25,000 art prize', *The Guardian*, 11 February
Peters, Toby: 'John's little moment of glory', *City of London Recorder*, 19 February
Cumming, Hugh: 'Contemporary British Artists', *Art & Design*, February, pp. 16–48

1988 Hilton, Tim: 'Hoyland's tale of Hofmann', *The Guardian*, 5 March
Morris, Ann: 'The Experts' Expert. The discerning palette', *Observer Magazine*, 15 May, pp. 18–19
Westfall, Stephen: 'John Hoyland at Lever/Meyerson', *Art in America*, no. 1, January, p. 136

1989 Basham, Anna: 'British Painting in the 1960s and '70s – Ramsgate Library Gallery', *Arts Review*, 5 May, p. 353
Hoyland, John: 'Framing Words', *Evening Standard*, 7 December
Compton, Michael: 'John Hoyland', *Contemporary Artists*, St James' Press, London, pp. 433–434

1990 Wright, Philip: (introduction) *John Hoyland*, *Prints 1968–89*, catalogue, Austin/Desmond Fine Art, London
Gooding, Mel: *John Hoyland*, John Taylor/Lund Humphries, London

LIST OF PLATES

44 Kong Sleeps 4.10.86
acrylic on cotton duck 95 × 42 in/241.3 × 106.7 cm
The Artist/Waddington Galleries

45 Quas 23.1.86
acrylic on cotton duck 96 × 96 in/243.8 × 243.8 cm
Warwick Arts Trust, London

46 Gadal 10.11.86
acrylic on cotton duck 100 × 100 in/254 × 254 cm
Tate Gallery, London

47 Wandering Awhile 10.5.87
acrylic on cotton duck 94 × 54 in/238.8 × 137.2 cm
The Artist/Waddington Galleries

48 Swift Days, Moons and Suns 8.6.87
acrylic on cotton duck 100 × 45 in/254 × 114.3 cm
Imperial Chemical Industries PLC

49 Tracks 13.6.87
acrylic on cotton duck 100 × 100 in/254 × 254 cm
The Artist/Waddington Galleries

50 Off you Sail 28.6.87
acrylic on cotton duck 100 × 100 in/254 × 254 cm
The Artist/Waddington Galleries

51 Moon Dance 5.9.87
acrylic on cotton duck 100 × 100 in/254 × 254 cm
The Artist/Waddington Galleries

52 Helel, Fallen Angel 1.2.88
acrylic on cotton duck 100 × 100 in/254 × 254 cm
The Artist/Waddington Galleries

53 Duma 22.2.88
acrylic on cotton duck 100 × 100 in/254 × 254 cm
The Artist/Waddington Galleries

54 Tagas 2.3.88
acrylic on cotton duck 60 × 60 in/152.4 × 152.4 cm
The ROC Group, Paris

55 Drakon 7.4.88
acrylic on cotton duck 100 × 100 in/254 × 254 cm
The Artist/Waddington Galleries

56 Dynamis 24.4.88
acrylic on cotton duck 100 × 100 in/254 × 254 cm
The Artist/Waddington Galleries

57 Above the Sun 27.8.88
acrylic on cotton duck 36 × 30 in/91.4 × 76.2 cm
The Artist/Waddington Galleries

58 Sat. 15.9.88
acrylic on cotton duck 100 × 93 in/254 × 236.2 cm
The ROC Group, Paris

59 Rivers of Surprise 20.9.88
acrylic on cotton duck 60 × 50 in/152.4 × 127 cm
The ROC Group, Paris

60 Genie 24.9.88
acrylic on cotton duck 40 × 30 in/101.6 × 76.2 cm
The ROC Group, Paris

61 Talto 25.9.88
acrylic on cotton duck 60 × 50 in/152.4 × 127 cm
The ROC Group, Paris

62 Hour of Venus 17.10.88
acrylic on cotton duck 100 × 93 in/254 × 236.2 cm
The Artist/Waddington Galleries

63 Spirit of Venus 28.10.88
acrylic on cotton duck 60 × 60 in/152.4 × 152.4 cm
The ROC Group, Paris

64 Paramaribo 24.11.88
acrylic on cotton duck 100 × 60 in/254 × 152.4 cm
The ROC Group, Paris

65 Isda 7.12.88
acrylic on cotton duck 100 × 60 in/254 × 152.4 cm
The Artist/Waddington Galleries

66 Over the Edge 30.12.88
acrylic on cotton duck 28 × 20 in/71.1 × 50.8 cm
The Artist/Waddington Galleries

67 Avatar 1.1.89
acrylic on cotton duck 30 × 28 in/76.2 × 71.1 cm
The Artist/Waddington Galleries

68 Banda Oriental 22.2.89
acrylic on cotton duck 60 × 60 in/152.4 × 152.4 cm
The Artist/Waddington Galleries

69 Back to the Winter 18.3.89
acrylic on cotton duck 60 × 60 in/152.4 × 152.4 cm
The Artist/Waddington Galleries

70 La Manga 10.5.89
acrylic on cotton duck 100 × 60 in/254 × 152.4 cm
The Artist/Waddington Galleries

71 Siren 10.7.89
acrylic on cotton duck 100 × 93 in/254 × 236.2 cm
The Artist/Waddington Galleries

72 Sorcerer 1.8.89
acrylic on cotton duck 100 × 93 in/254 × 236.2 cm
The Artist/Waddington Galleries

73 Mirth of Snakes 13.8.89
acrylic on cotton duck 60 × 50 in/152.4 × 127 cm
The Artist/Waddington Galleries

74 Aerial Animal 15.8.89
acrylic on cotton duck 60 × 50 in/152.4 × 127 cm
The Artist/Waddington Galleries

75 Hating and Dreaming 12.9.89
acrylic on cotton duck 100 × 93 in/254 × 236.2 cm
The Artist/Waddington Galleries

76 Red Snake 13.9.89
acrylic on cotton duck 30 × 30 in/76.2 × 76.2 cm
The Artist/Waddington Galleries

77 Youwarkee 25.9.89
acrylic on cotton duck 100 × 93 in/254 × 236.2 cm
The Artist/Waddington Galleries

78 Inhabited Place 5.10.89
acrylic on cotton duck 100 × 93 in/254 × 236.2 cm
The Artist/Waddington Galleries

79 Lamia 28.10.89
acrylic on cotton duck 100 × 93 in/254 × 236.2 cm
The Artist/Waddington Galleries

80 Ocean Man 30.10.89
acrylic on cotton duck 60 × 60 in/152.4 × 152.4 cm
Private Collection

1
Abstract Composition 1958
oil on hardboard
50×37in/127×94cm

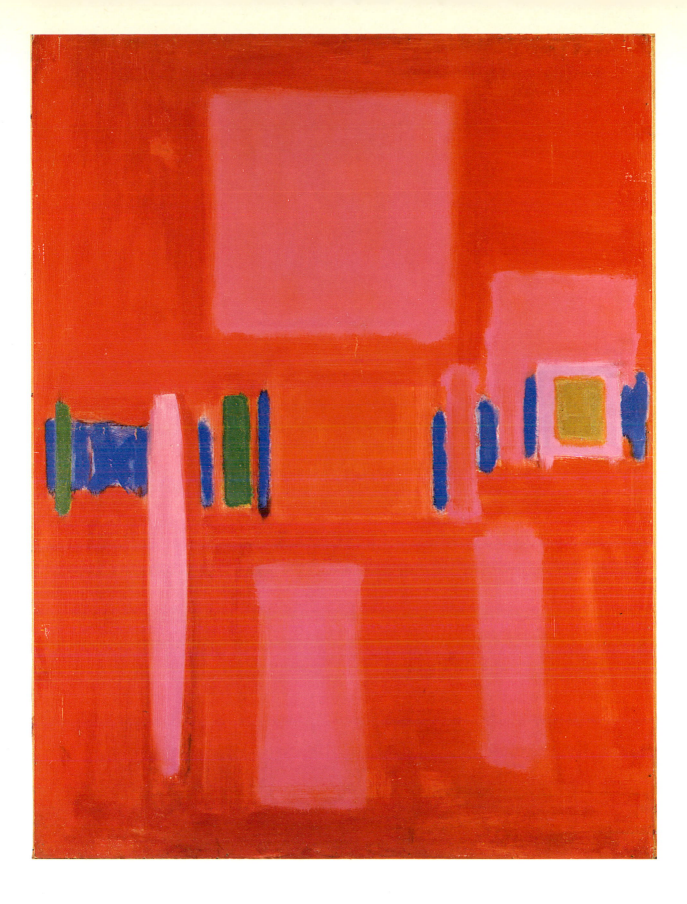

2
Painting November/December 1960
oil on canvas
60×54in/152.4×137.2cm

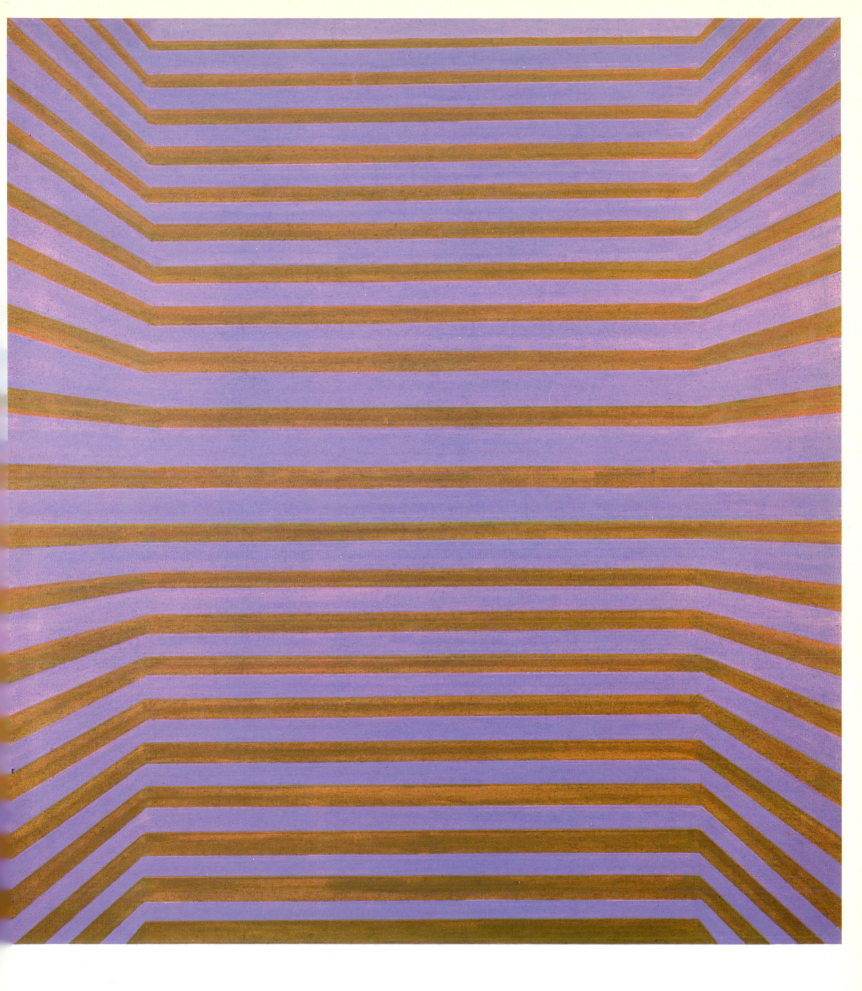

3
10.11.61 No.42
oil on cotton duck
68×68in/172.7×172.7cm

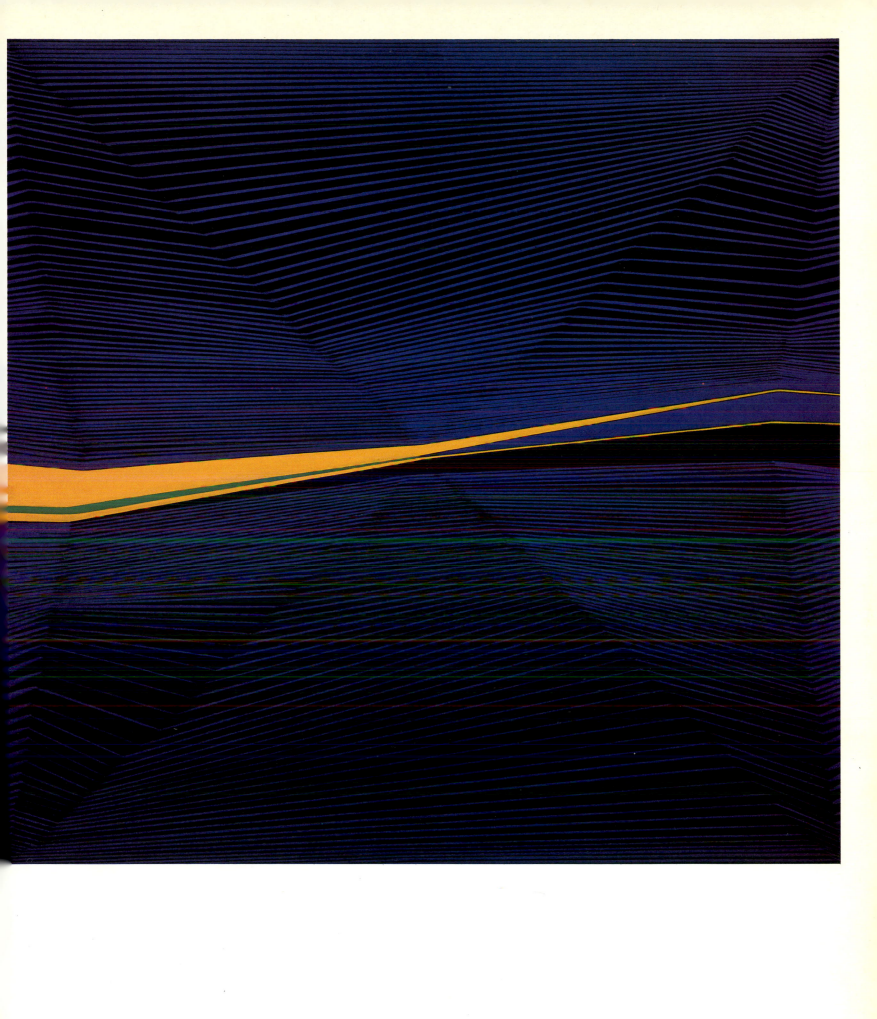

4
27.3.62 No.25
oil on cotton duck
100×78in/254×198.1cm

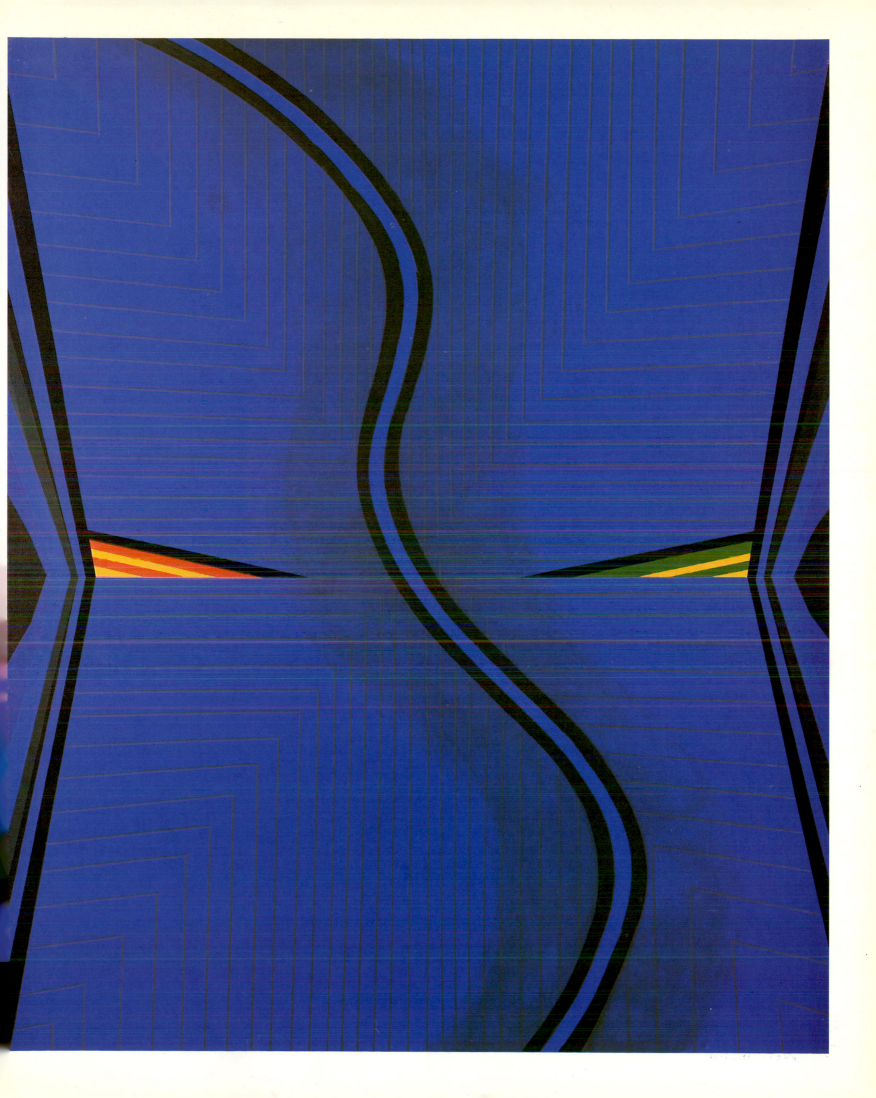

5
22.6.63
acrylic on cotton duck
68×68in/172.7×172.7cm

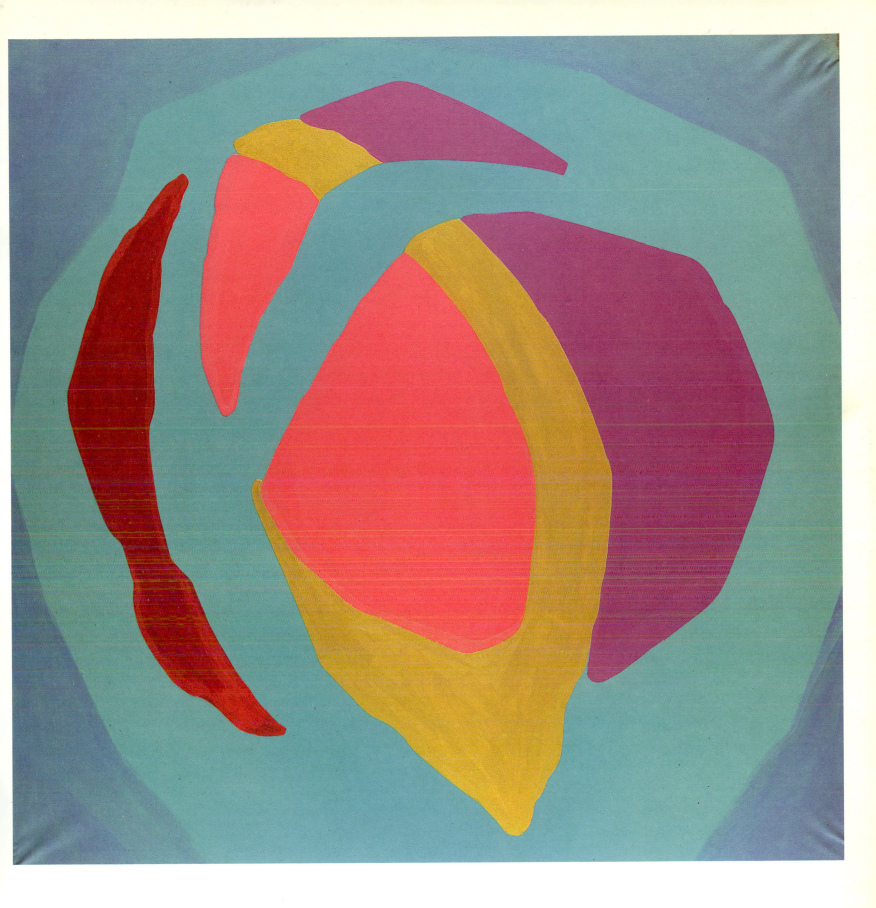

6
28.12.63
acrylic on cotton duck
84×84in/213.4×213.4cm

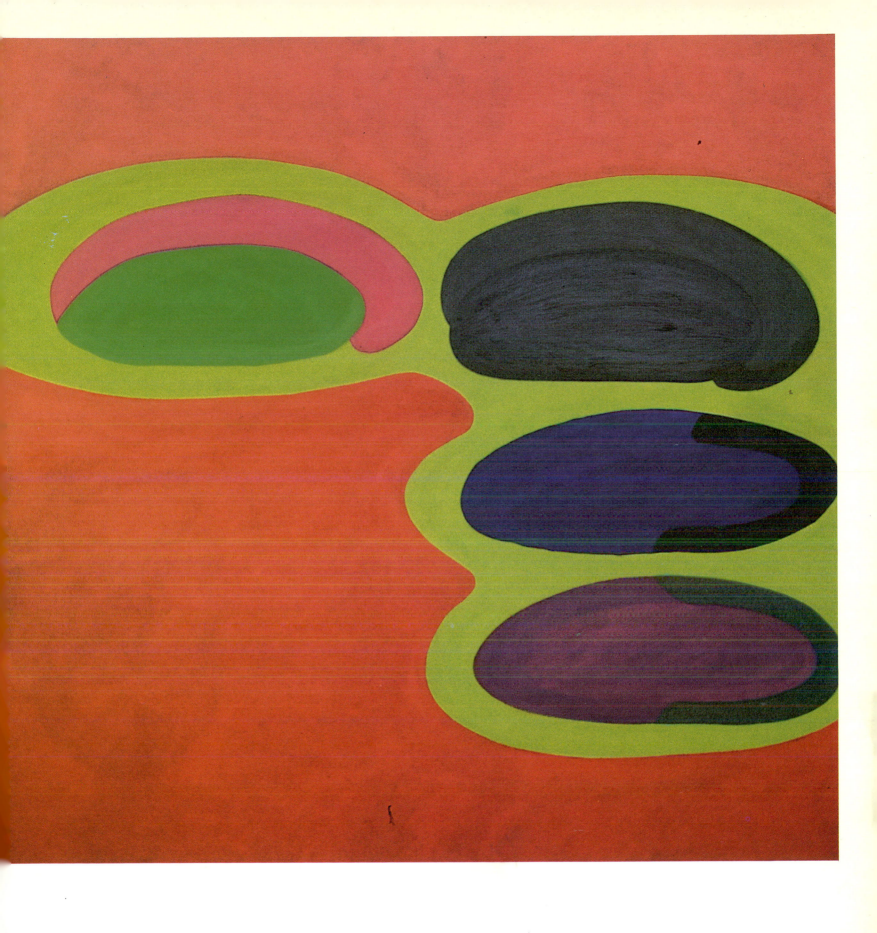

7
30.8.64
acrylic on cotton duck
78×126in/198.1×320cm

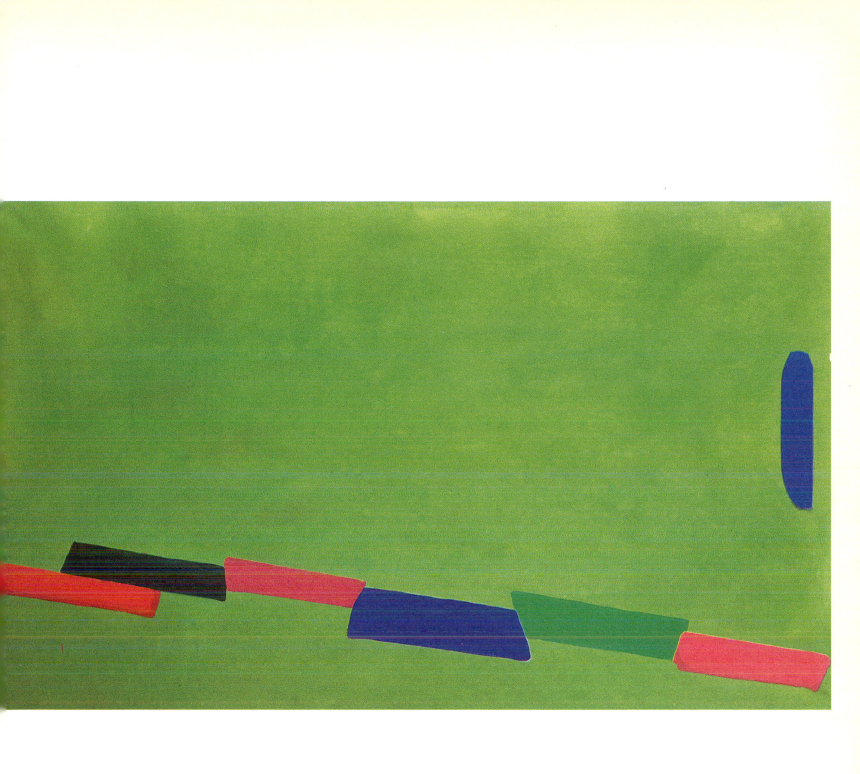

8
12.8.65
Red with Violet, Green and Orange
acrylic on cotton duck
66×100in/167.6×254cm

9
2.1.66
acrylic on cotton duck
84×144in/213.4×365.8cm

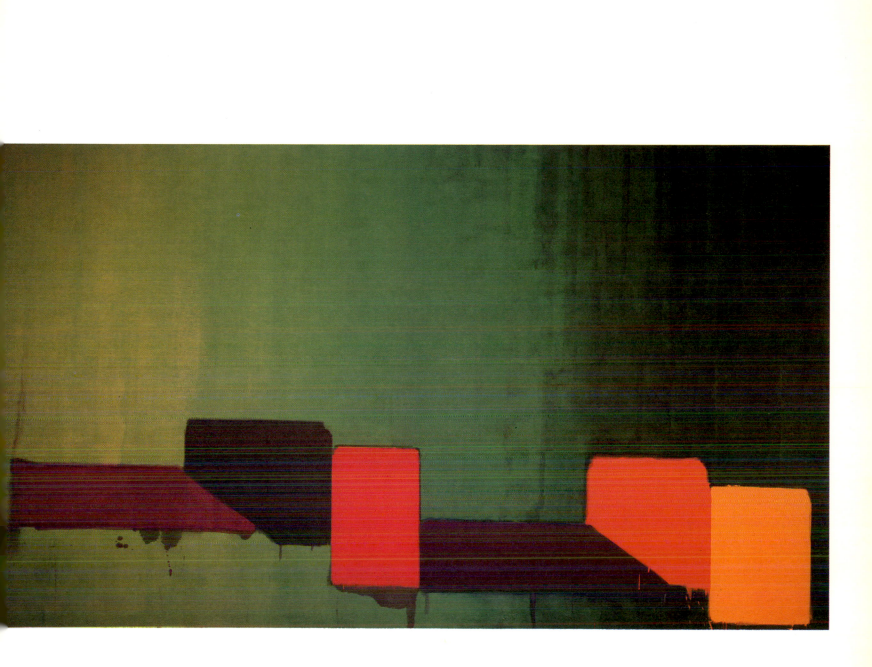

10
14.5.66
acrylic on cotton duck
36×72in/91.4×182.9cm

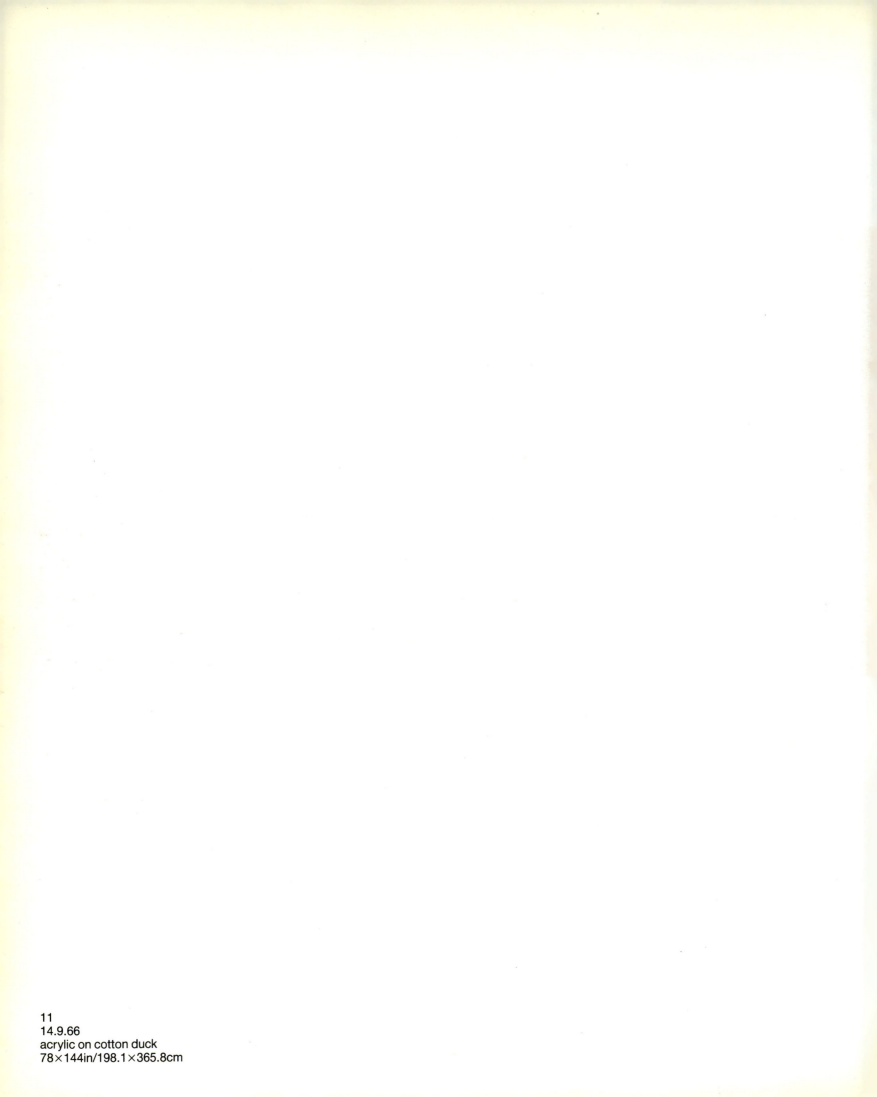

11
14.9.66
acrylic on cotton duck
78×144in/198.1×365.8cm

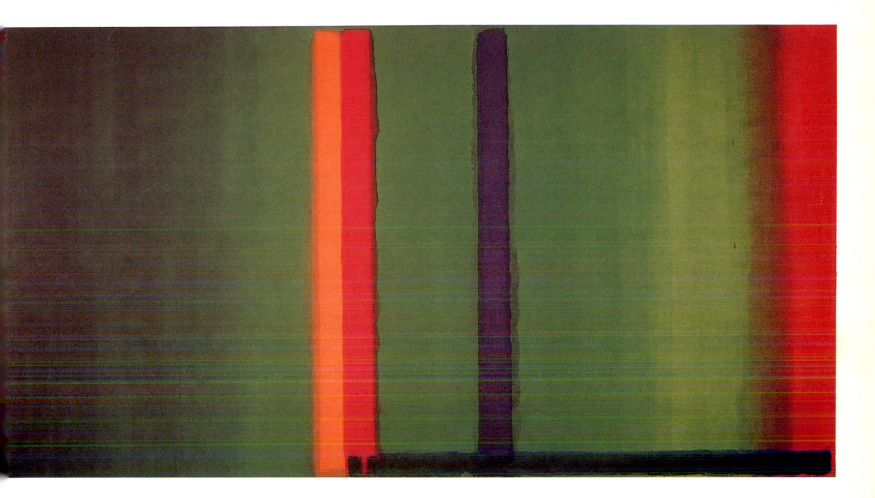

12
3.2.67
acrylic on cotton duck
78×144in/198.1×365.8cm

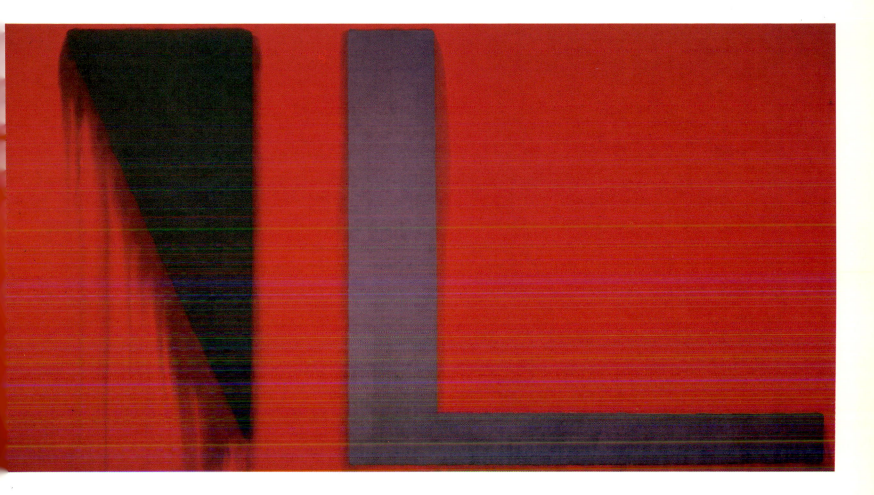

13
9.11.68
acrylic on cotton duck
84×144in/213.4×365.8cm

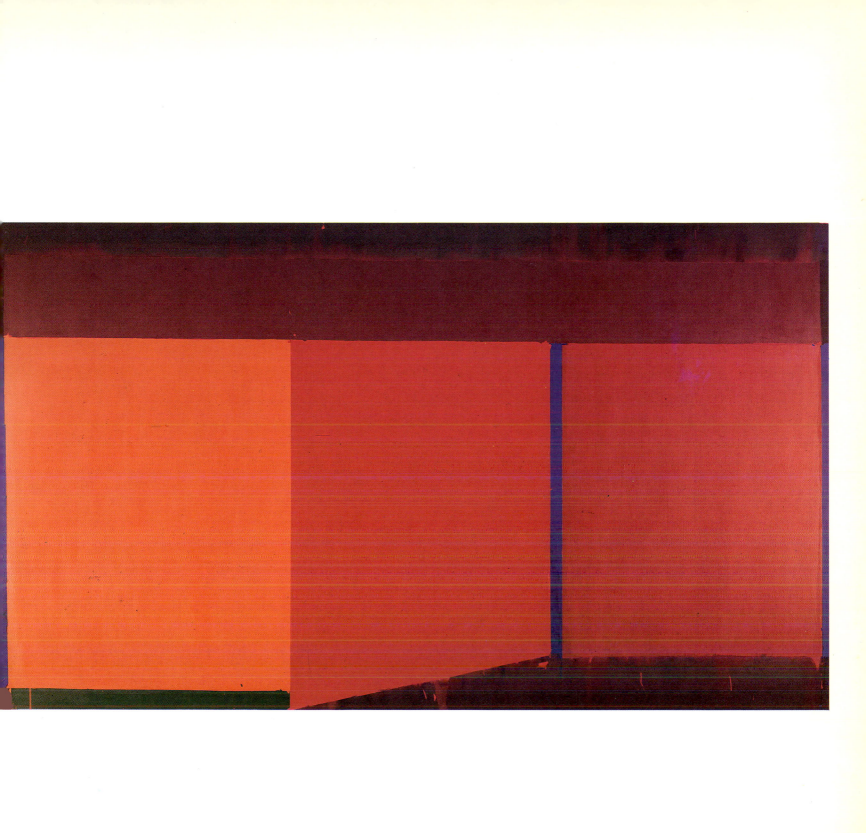

14
12.12.68
acrylic on hessian
84×72in/213.4×182.9cm

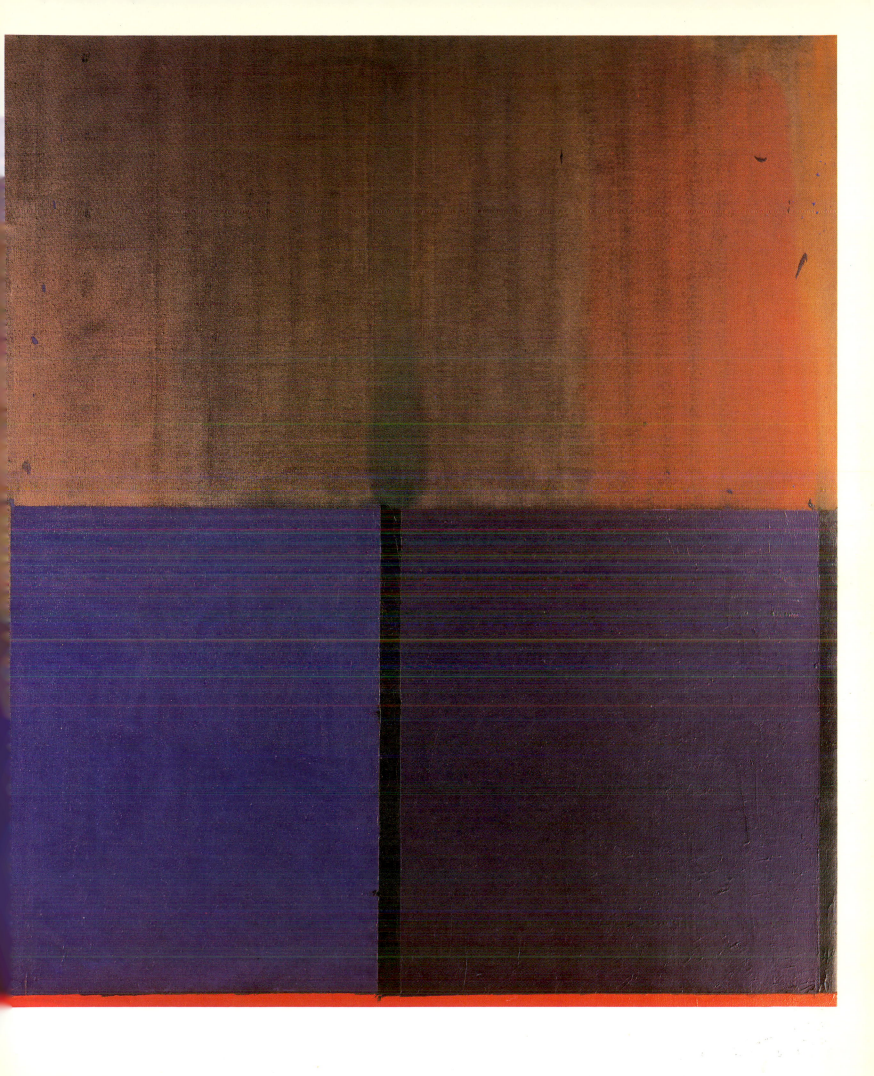

15
7.8.69
acrylic on cotton duck
78×144in/198.1×365.8cm

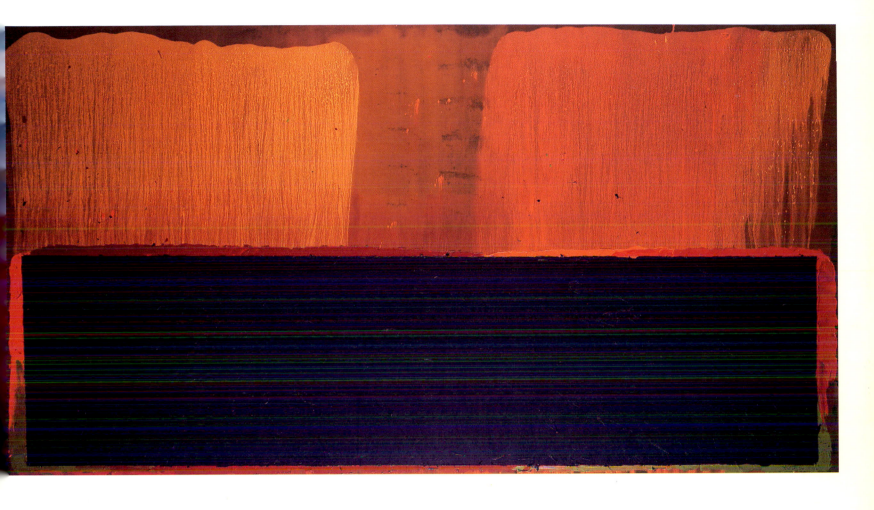

16
6.11.69
acrylic on cotton duck
78×144in/198.1×365.8cm

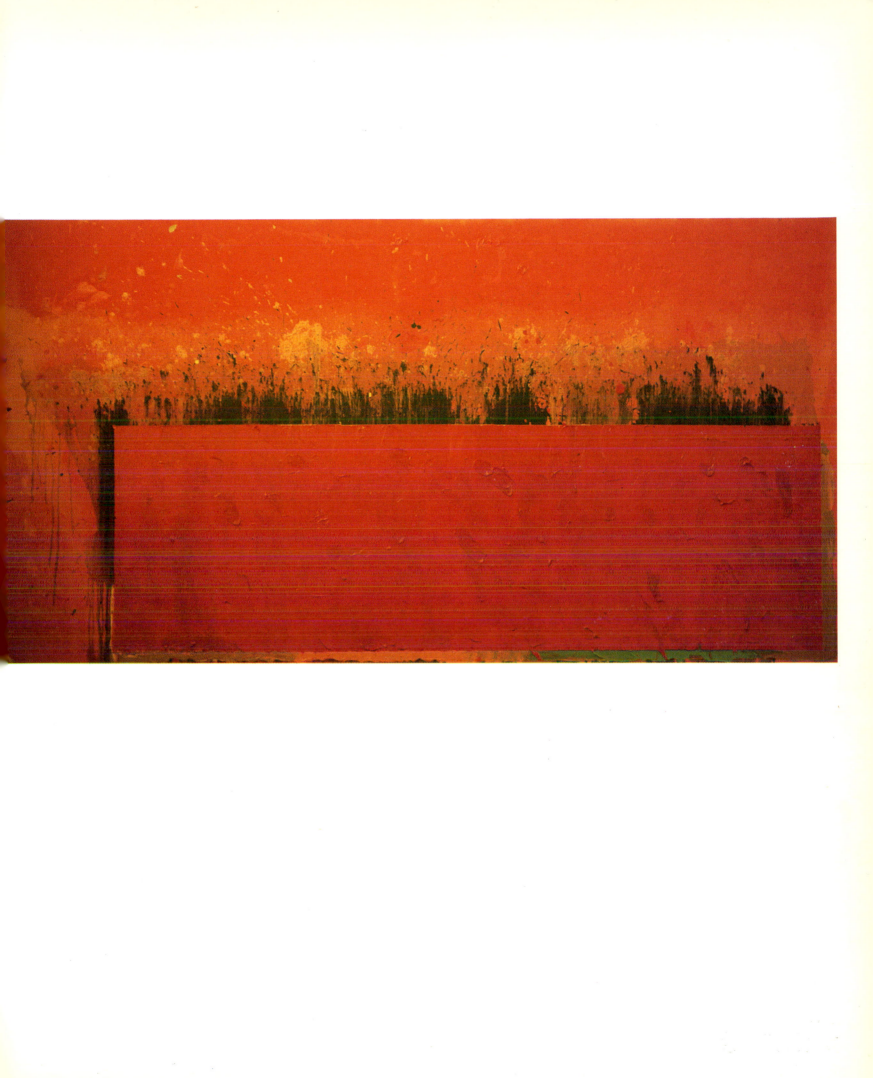

17
5.9.70
acrylic on cotton duck
108×60in/274.3×152.4cm

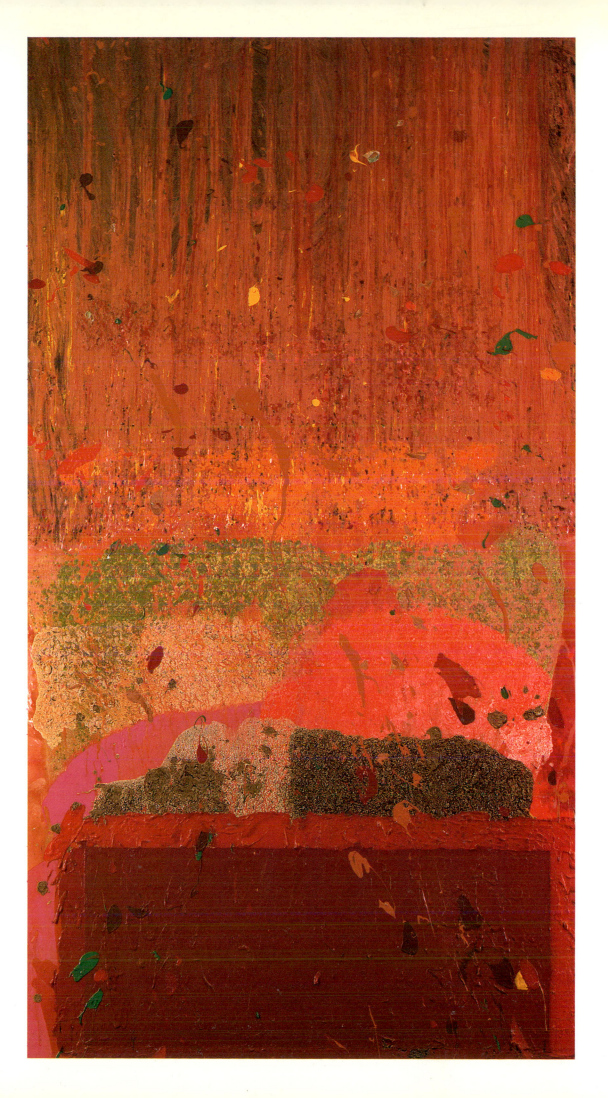

18
8.10.70
acrylic on cotton duck
96×60in/243.8×152.4cm

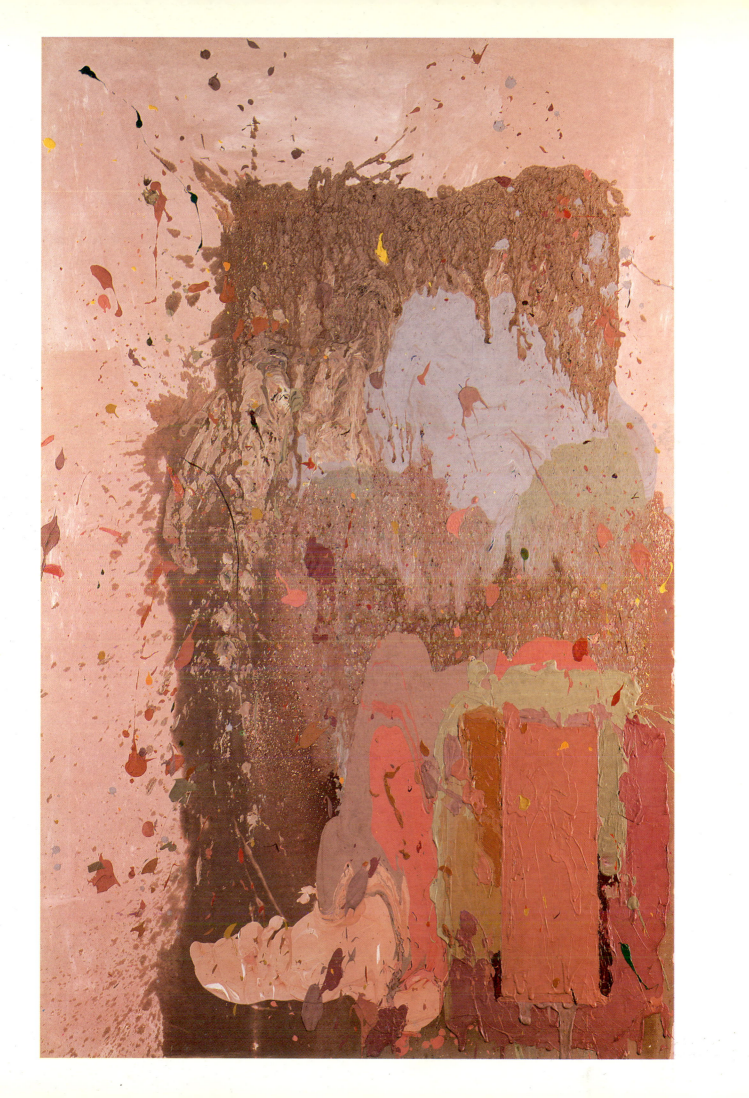

19
8.2.71
acrylic on cotton duck
96×72in/243.8×182.9cm

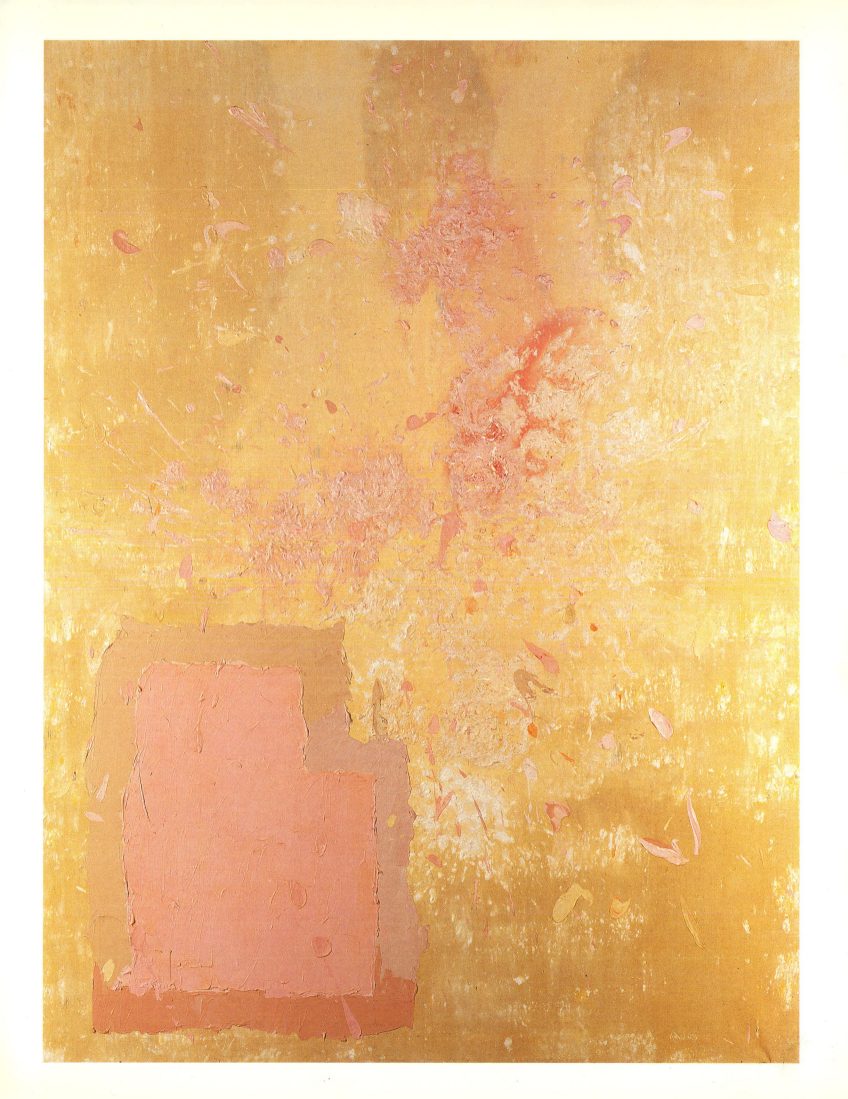

20
Rabat 30.8.72
acrylic on cotton duck
72×60in/182.9×152.4cm

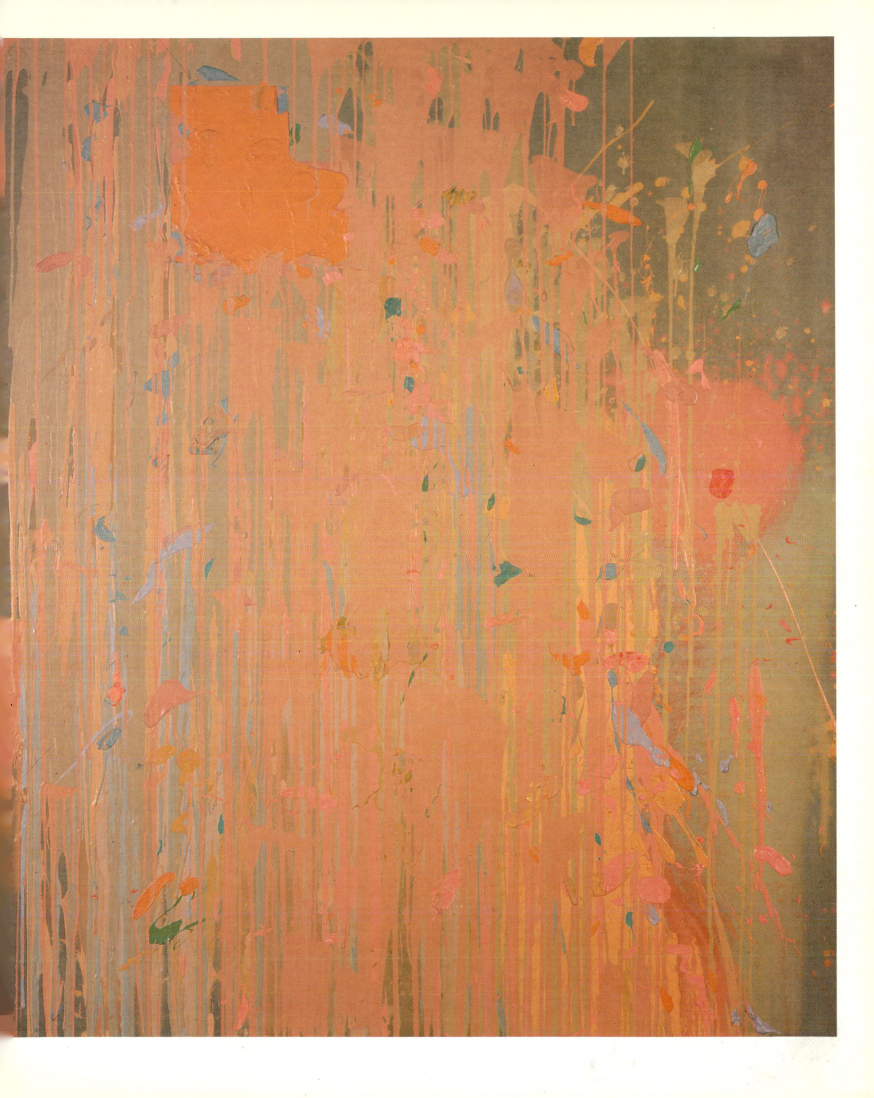

21
27.4.73
acrylic on cotton duck
72×60in/182.9×152.4cm

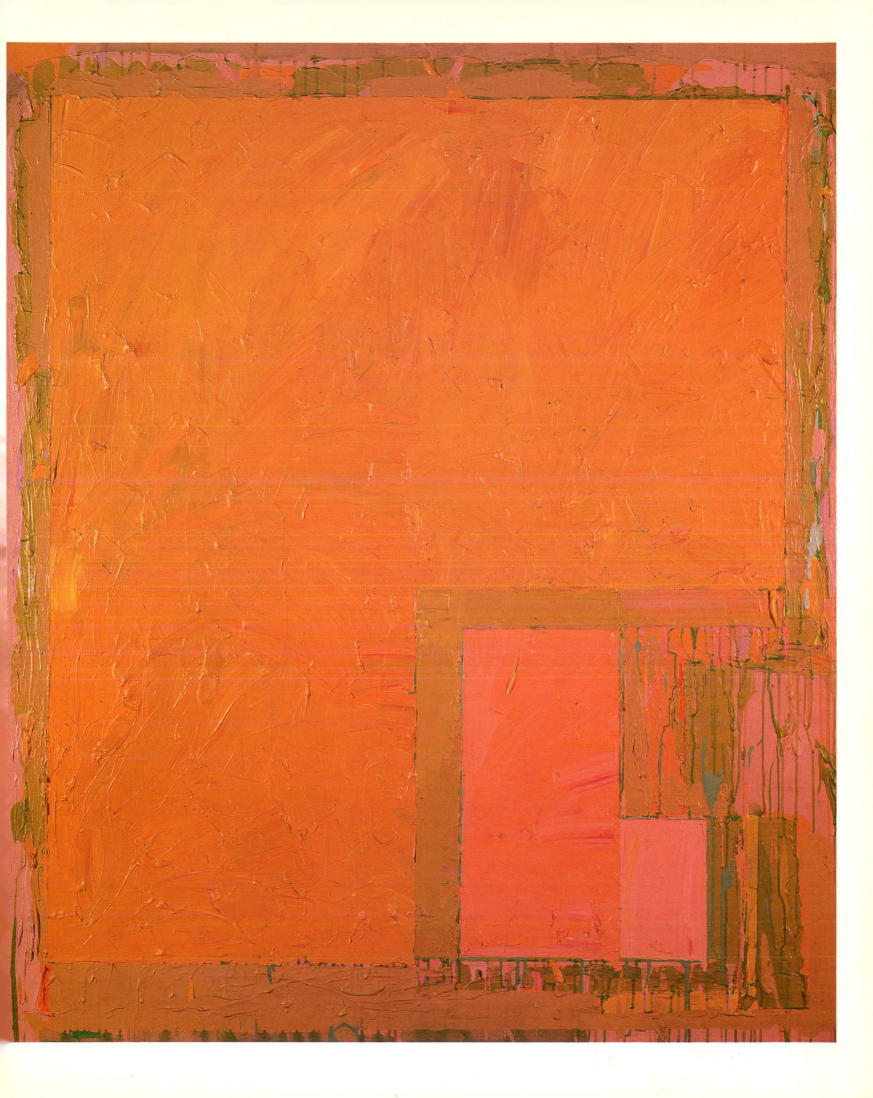

22
4.6.73
acrylic on cotton duck
72×66in/182.9×167.6cm

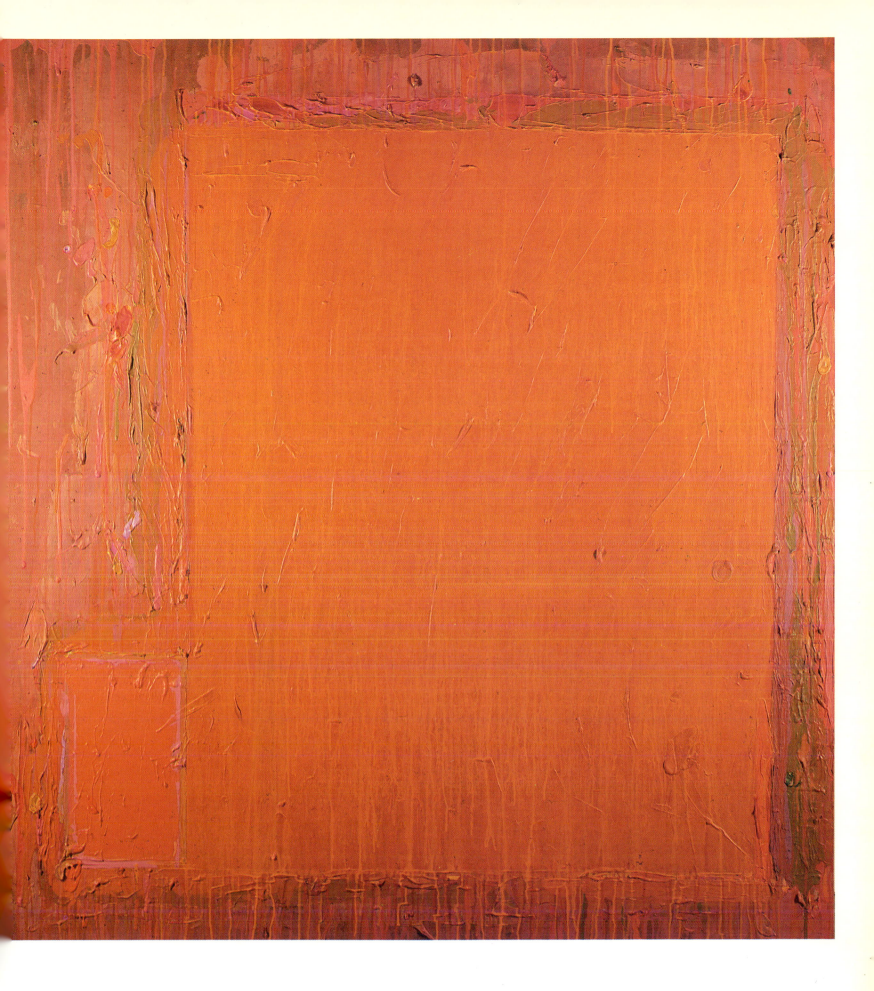

23
22.8.74
acrylic on cotton duck
80×60in/203.2×152.4cm

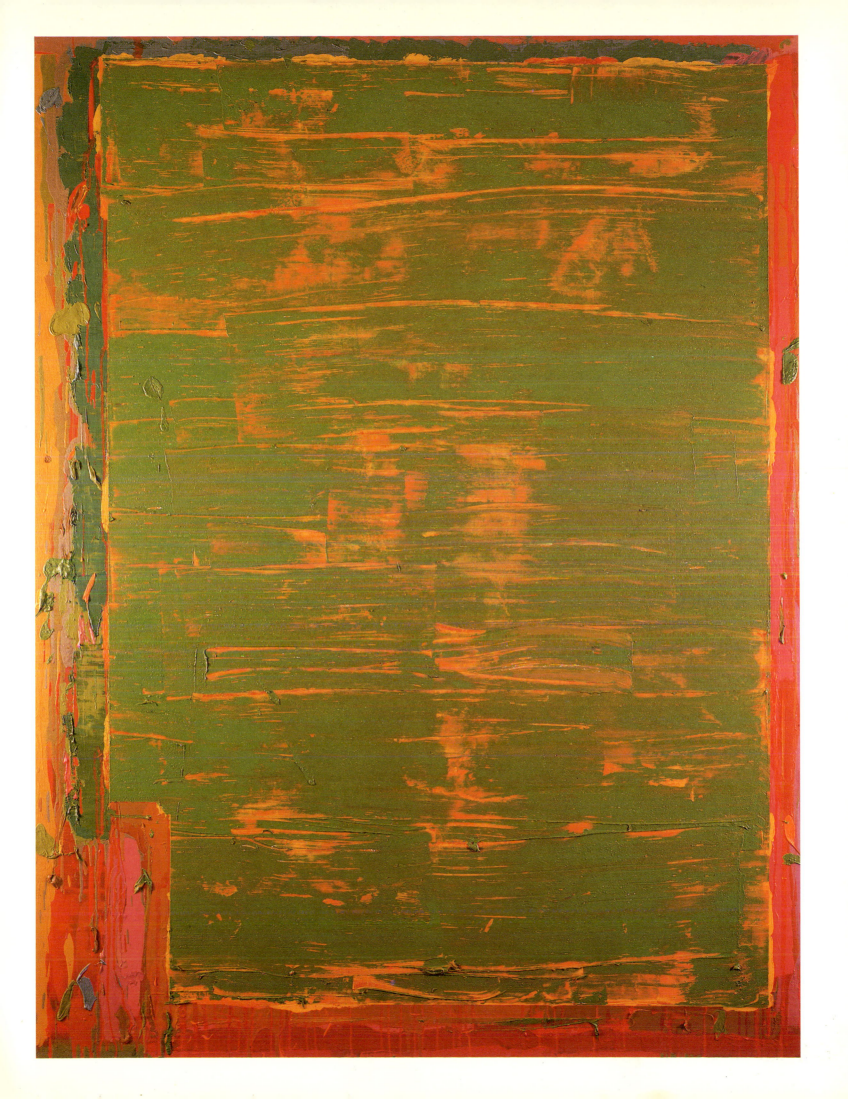

24
10.8.75
acrylic on cotton duck
48×26in/121.9×66cm

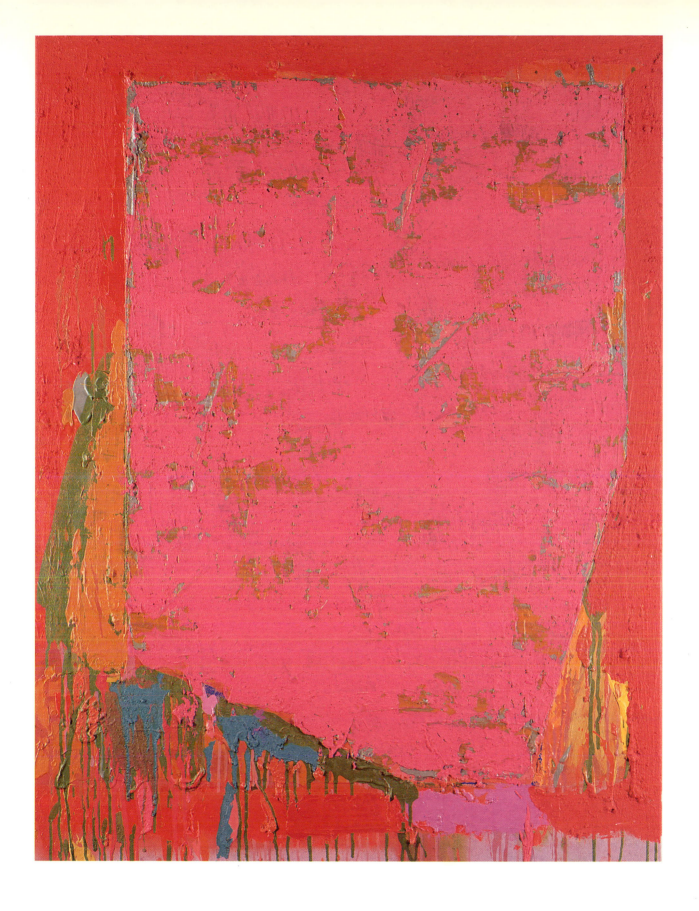

25
Verge 12.10.76
acrylic on cotton duck
75×51in/190×129.8cm

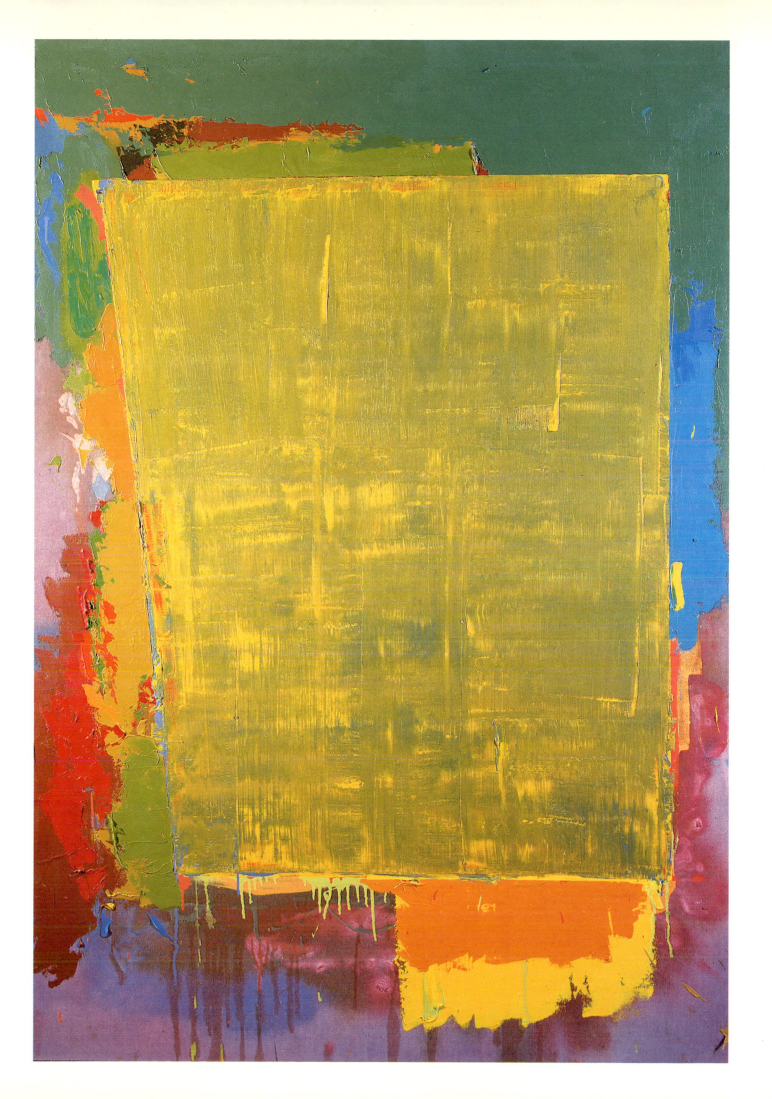

26
Saracen 30.3.77
acrylic on cotton duck
96×90in/243.8×228.6cm

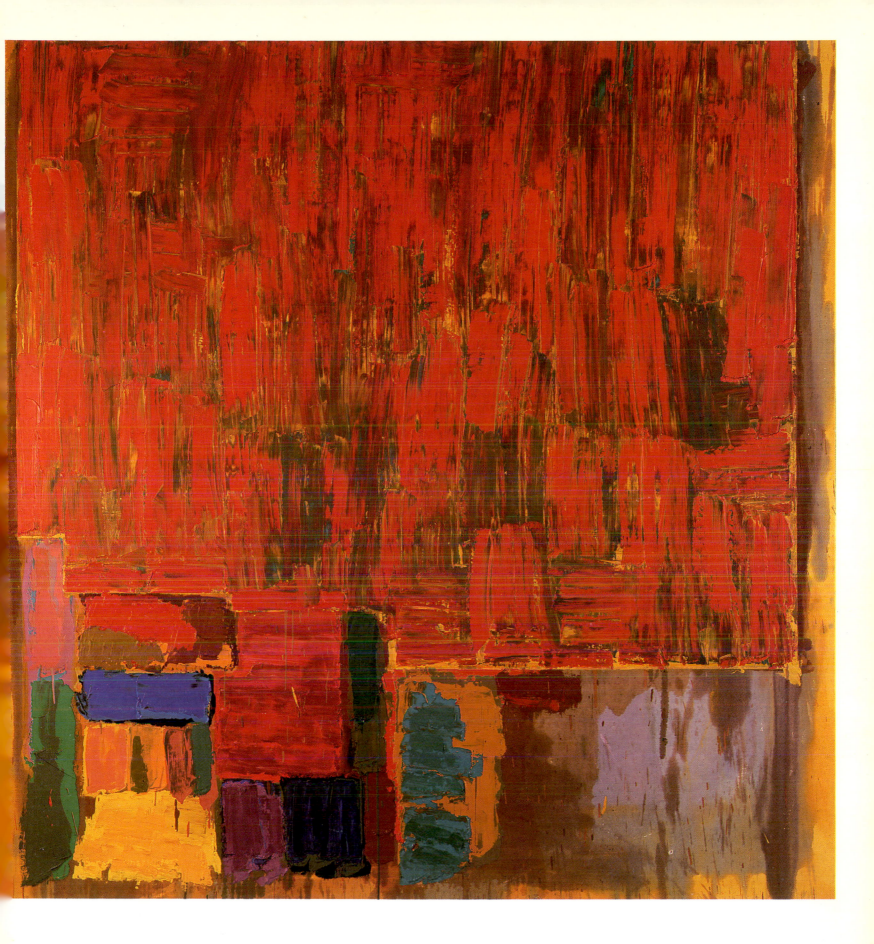

27
Wotan 21.7.77
acrylic on cotton duck
96×90in/243.8×228.6cm

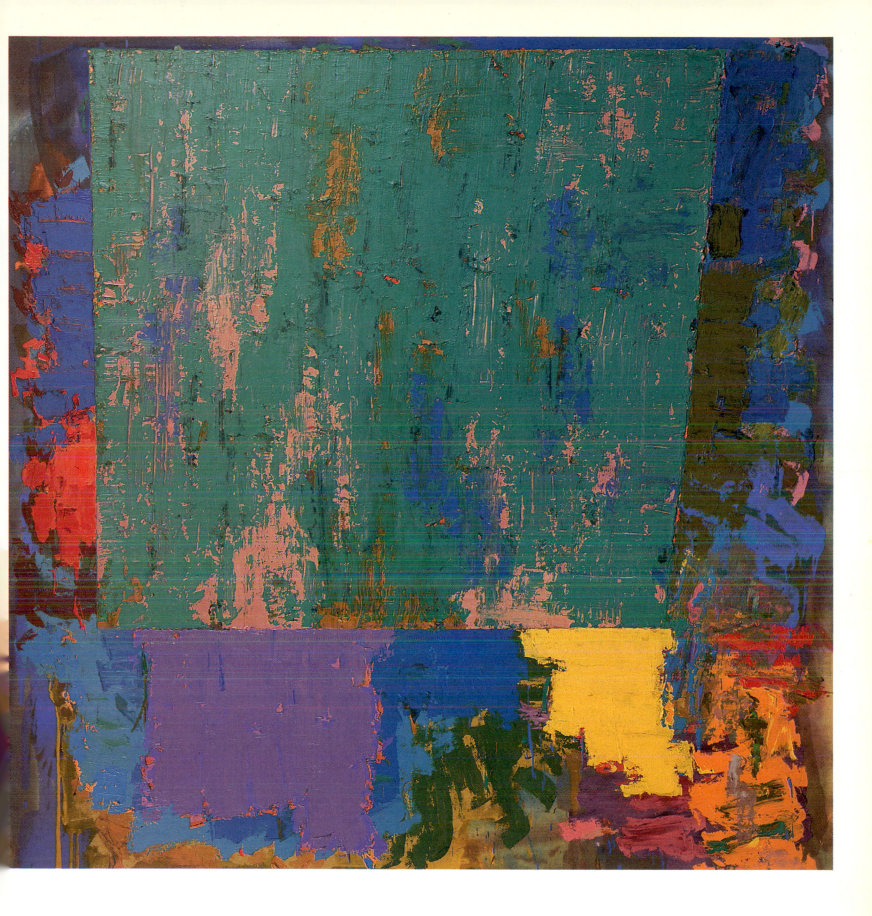

28
Devilaya 28.12.77
acrylic on cotton duck
96×90in/243.8×228.6cm

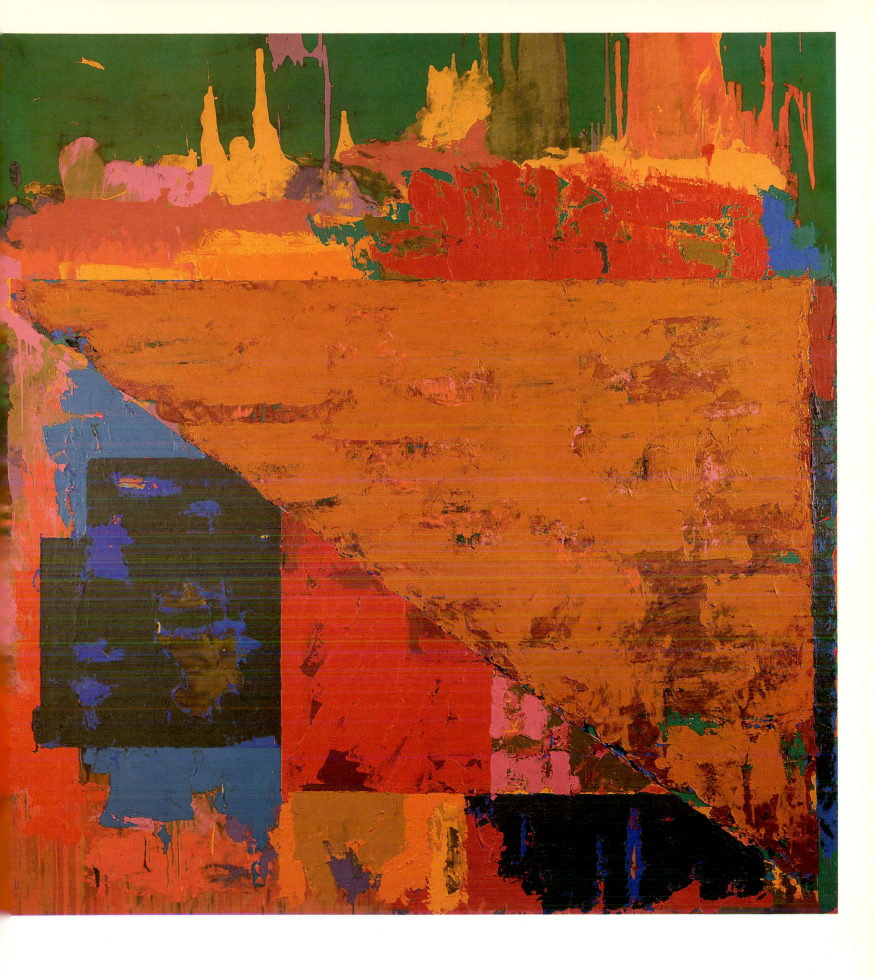

29
Pact 31.5.78
acrylic on cotton duck
60×50in/152.4×127cm

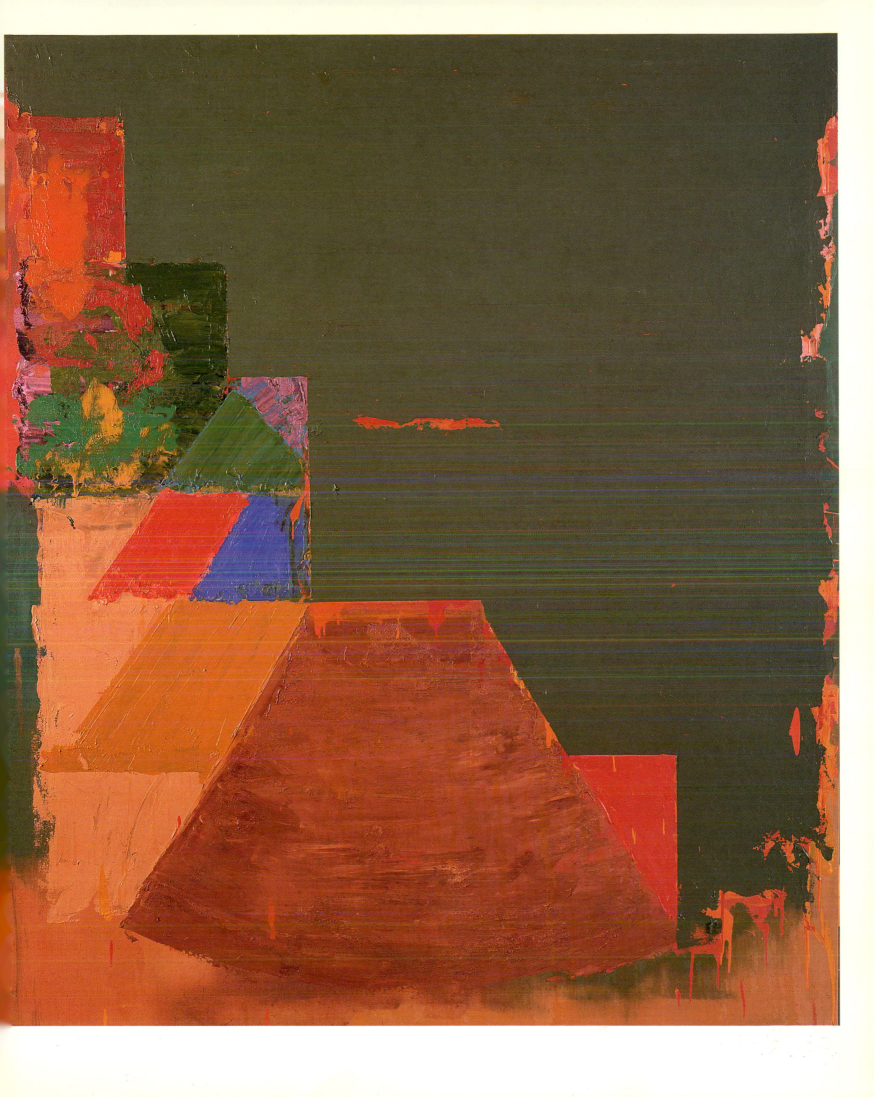

30
North Sound 15.9.79
acrylic on cotton duck
90×96in/228.6×243.8cm

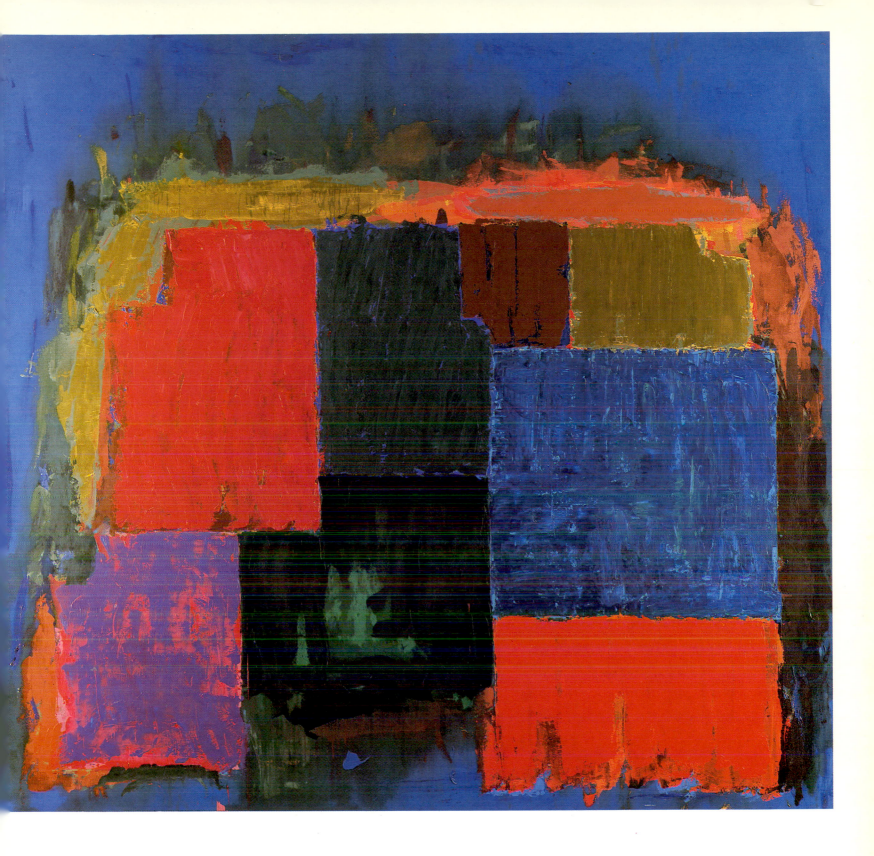

31
Voyeurs Voyage 21.1.81
acrylic on cotton duck
90×100in/228.6×254cm

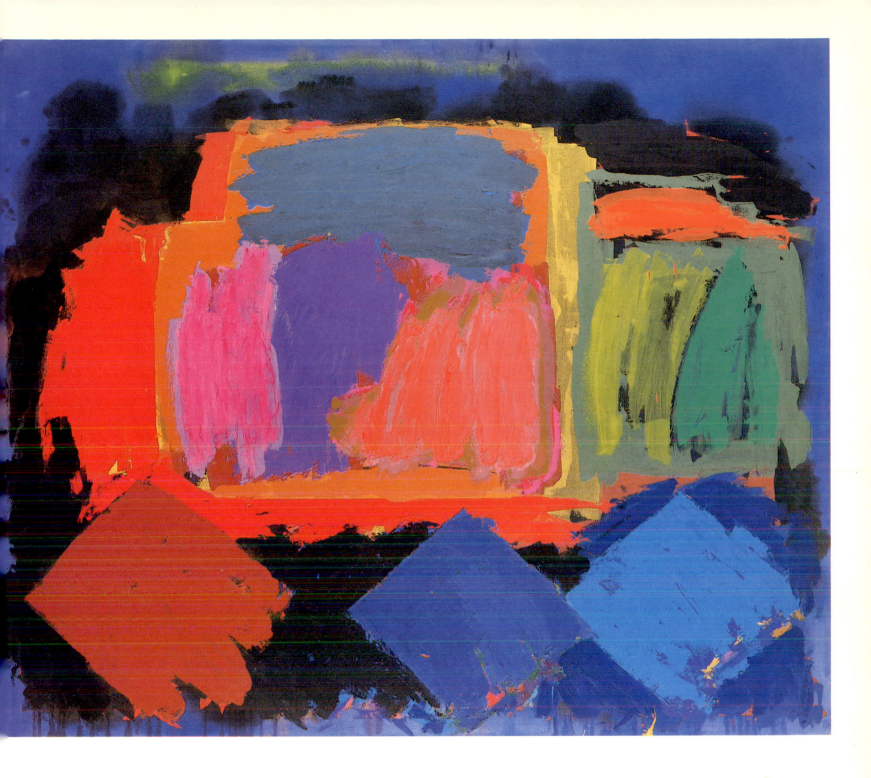

32
Tiger Walk 3.4.81
acrylic on cotton duck
90×96in/228.6×243.8cm

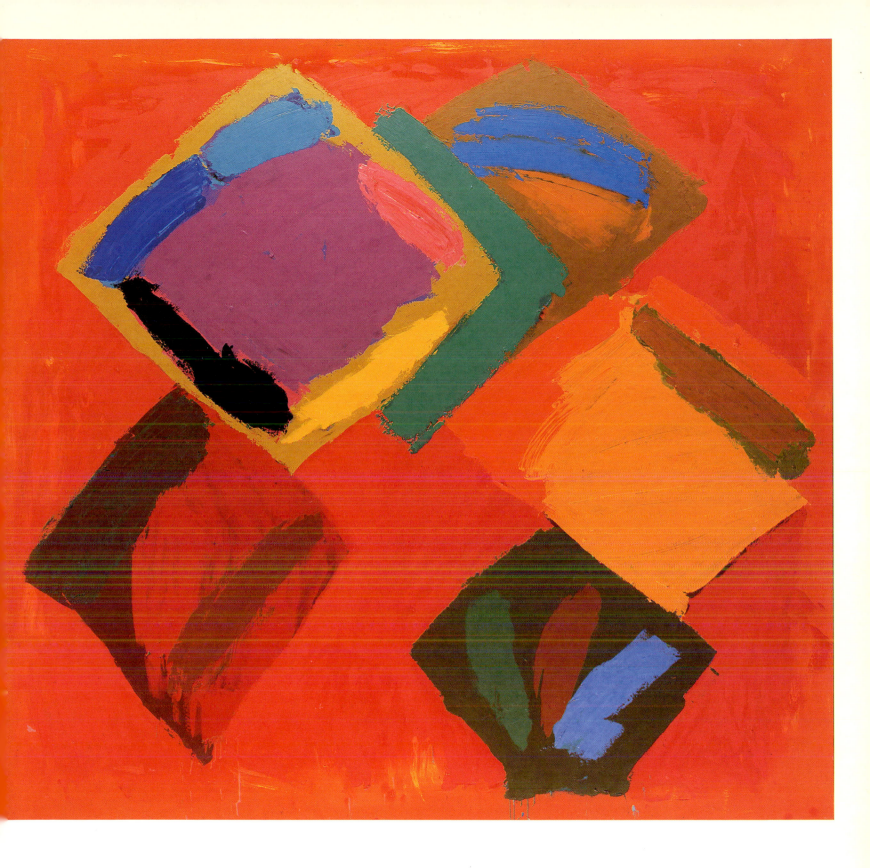

33
Singwara 19.7.81
acrylic on cotton duck
72×60in/182.9×152.4cm

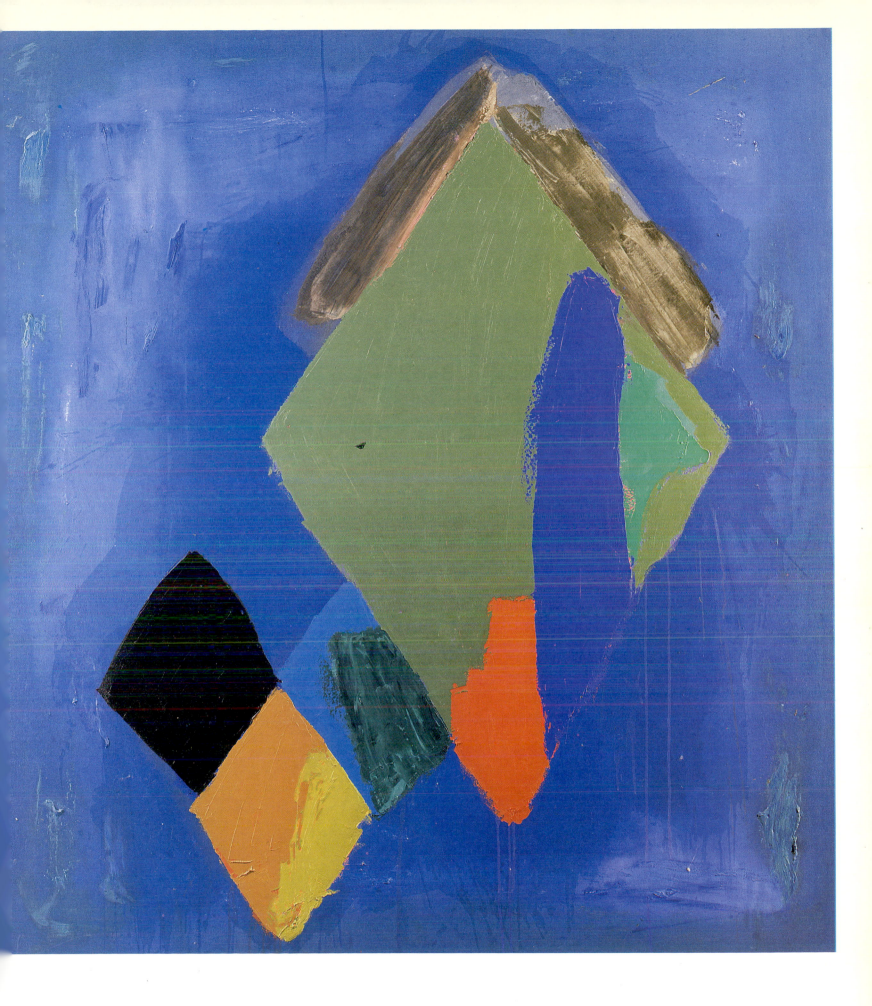

34
Hoochy-Coochy 10.2.82
acrylic on cotton duck
100×90in/254×228.6cm

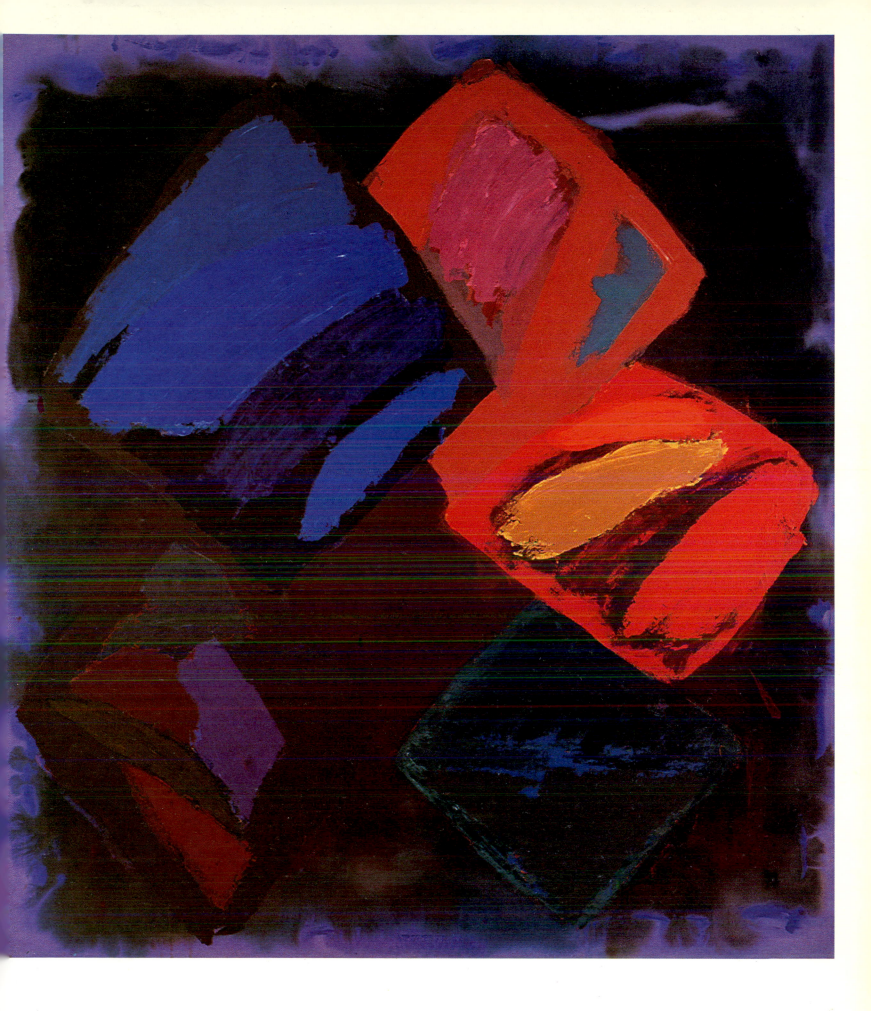

35
Broken Bride 13.6.82
acrylic on cotton duck
100×90in/254×228.6cm

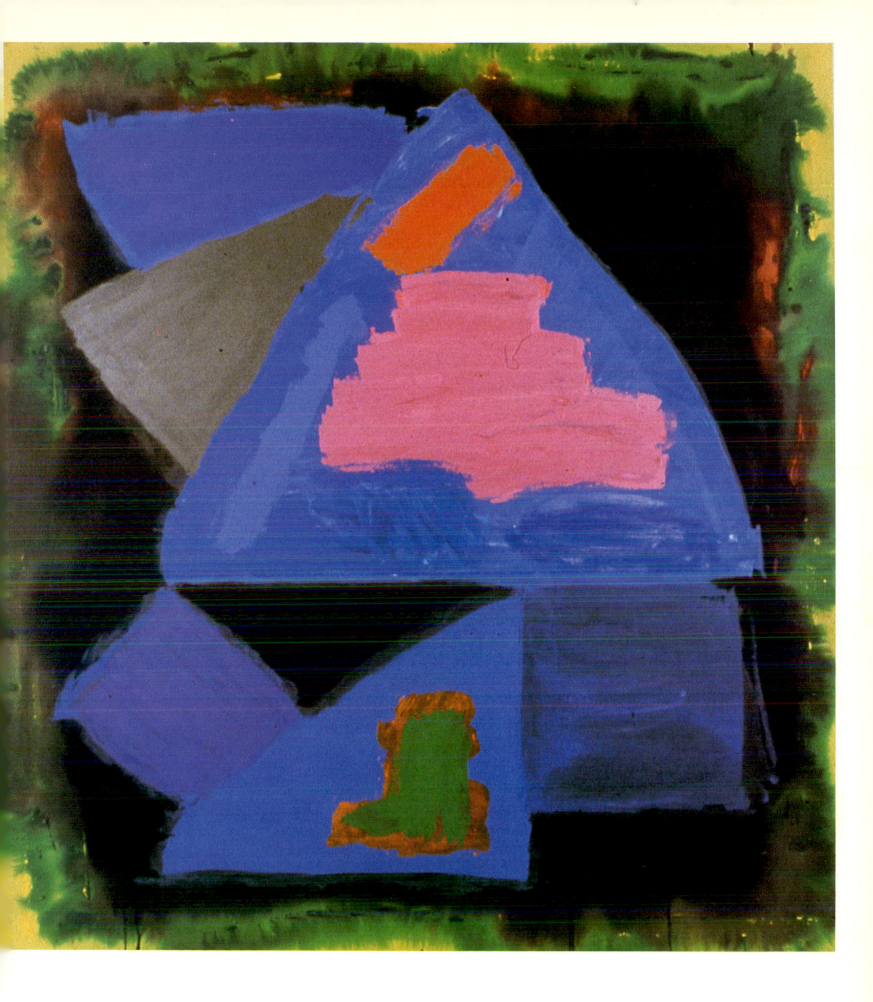

36
Kilkenny Cats 7.12.82
acrylic on cotton duck
90×84in/228.6×213.4cm

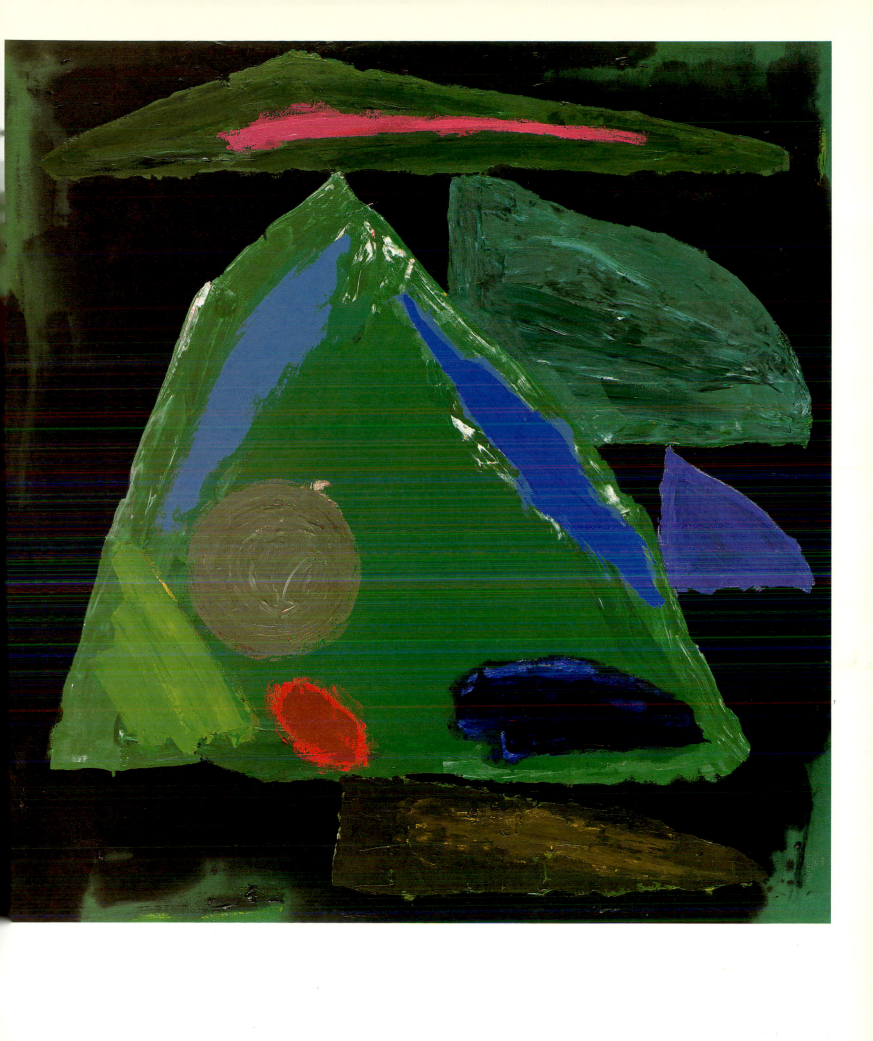

37
Maverick Days 20.1.83
acrylic on cotton duck
90×84in/228.6×213.4cm

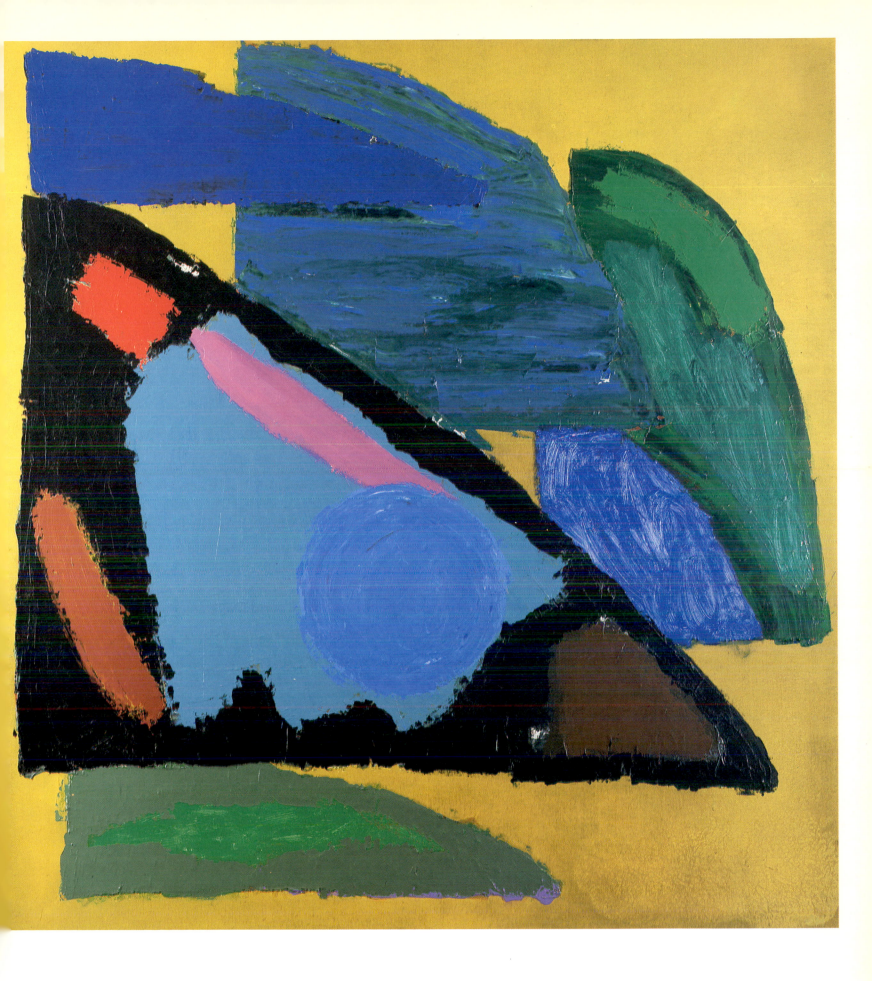

38
Turn Turn 30.8.83
acrylic on cotton duck
100×90in/254×228.6cm

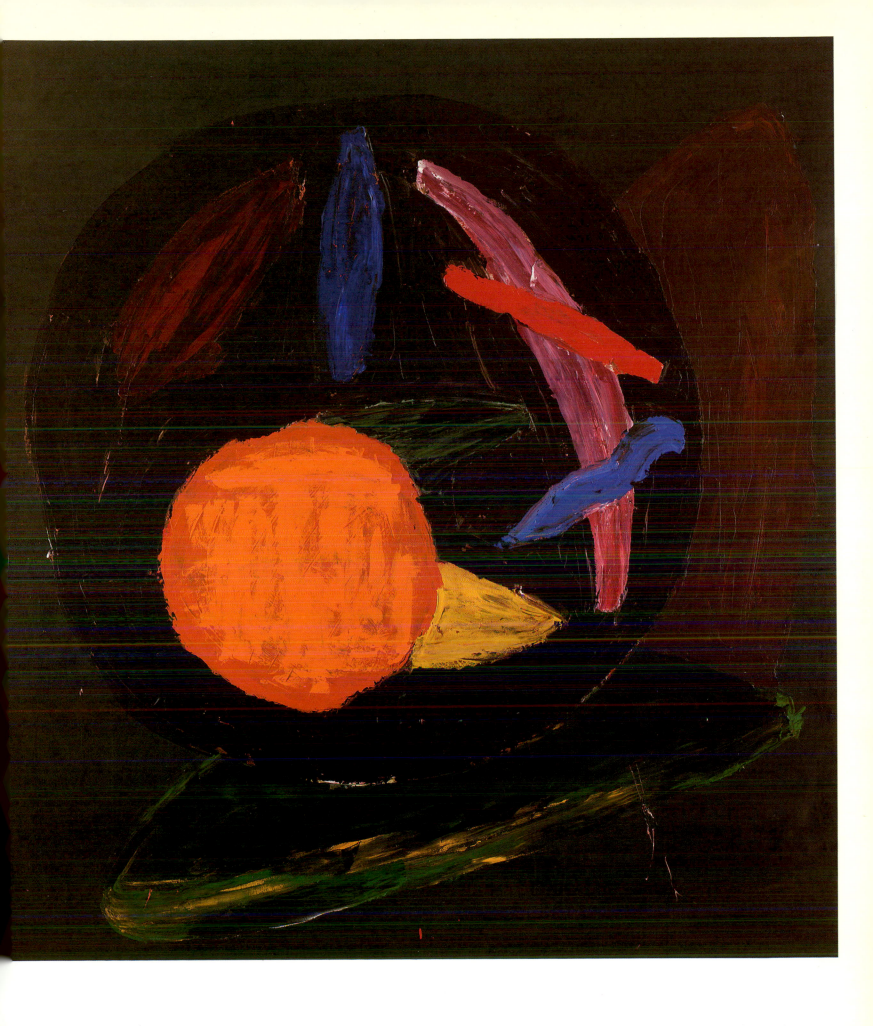

39
Somewhere Before 14.4.84
acrylic on cotton duck
96×90in/243.8×228.6cm

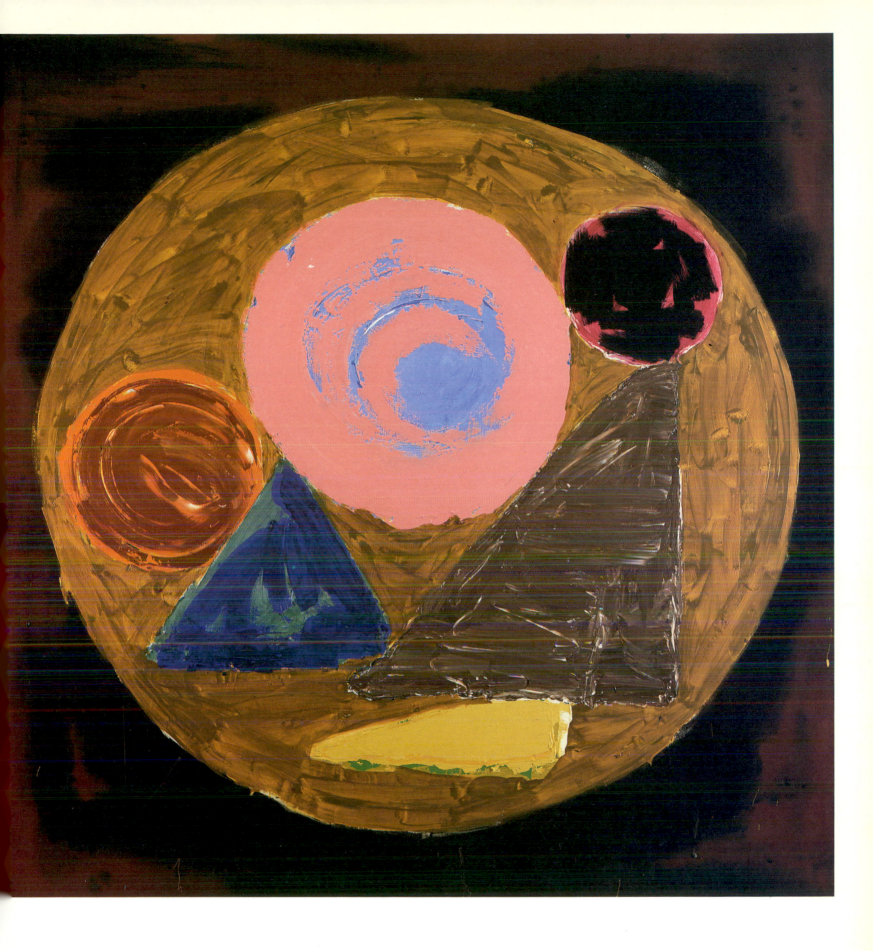

40
Street of Kisses 4.1.85
acrylic on cotton duck
60×54in/152.4×137.6cm

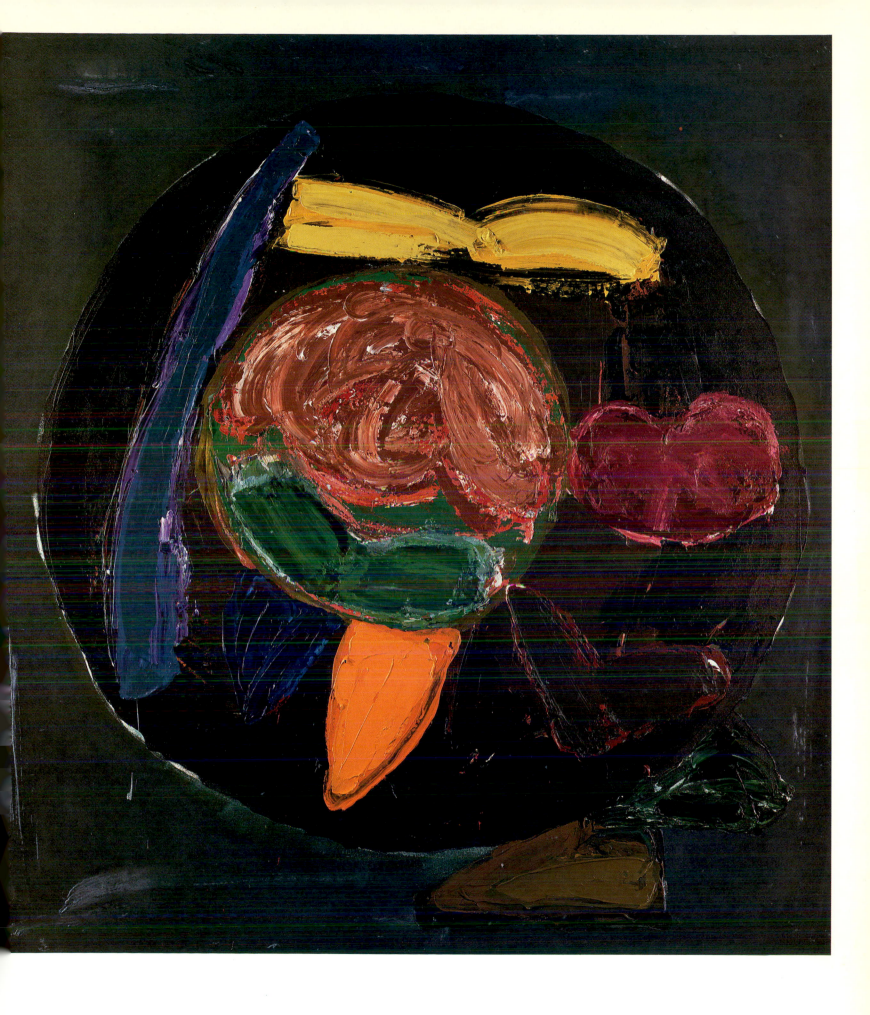

41
The Ark 16.2.85
acrylic on cotton duck
96×96in/243.8×243.8cm

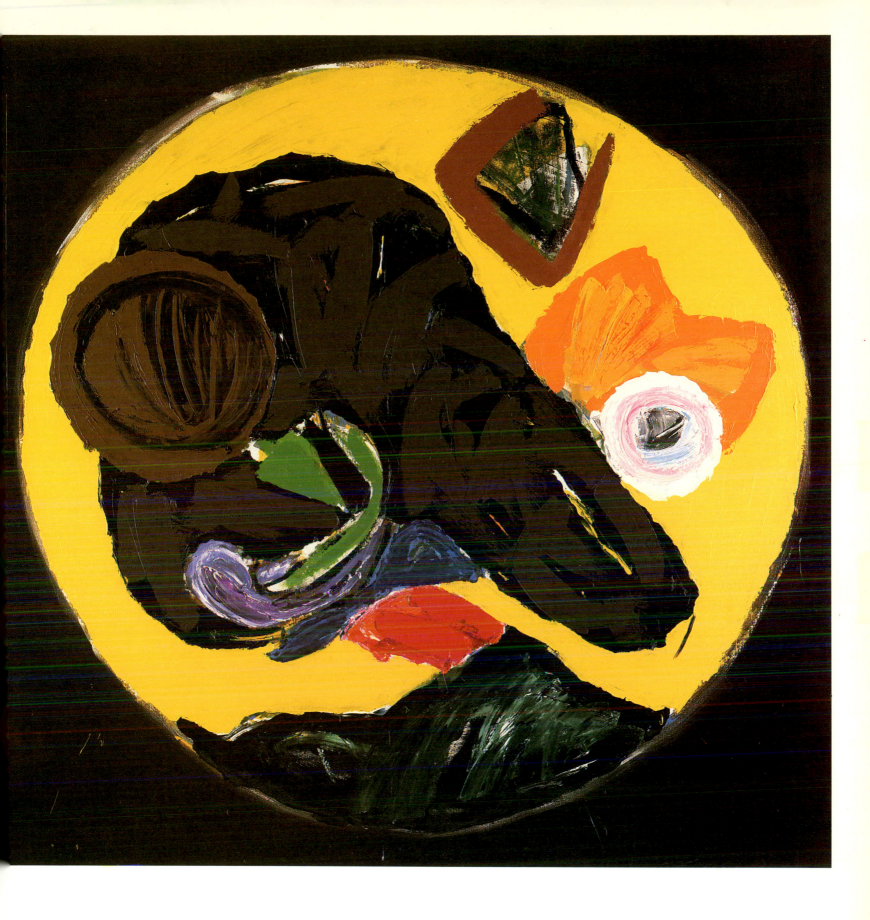

42
Burning 16.6.85
acrylic on cotton duck
96×96in/243.8×243.8cm

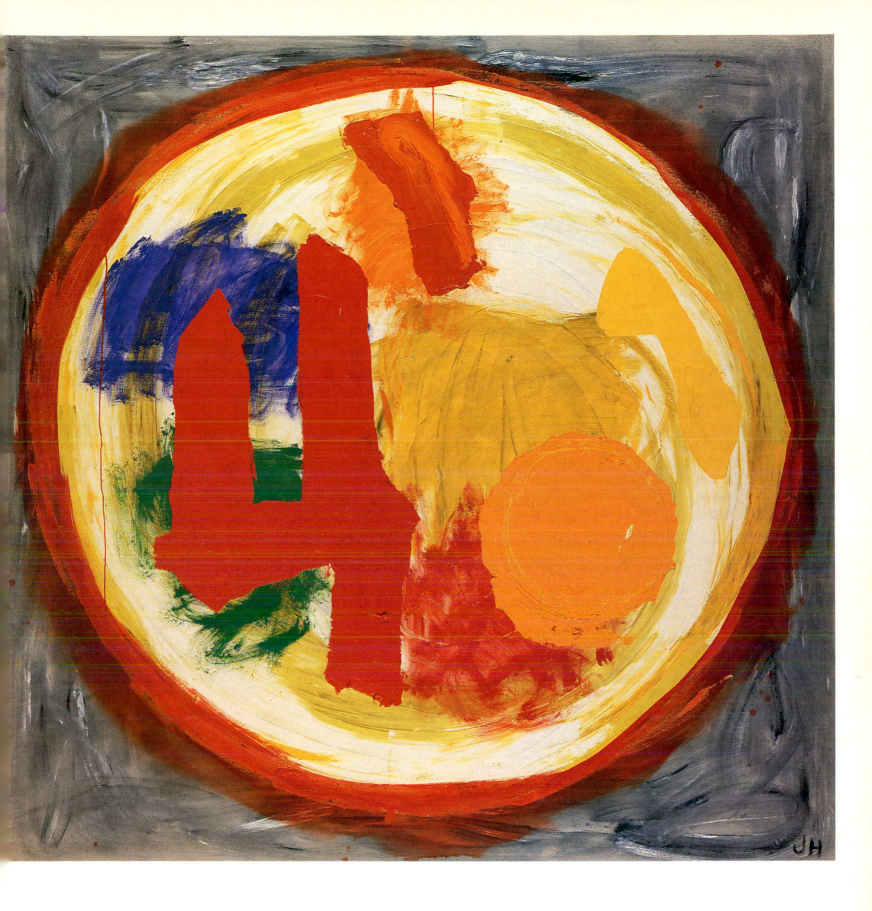

43
Kumari 28.7.86
acrylic on cotton duck
100×100in/254×254cm

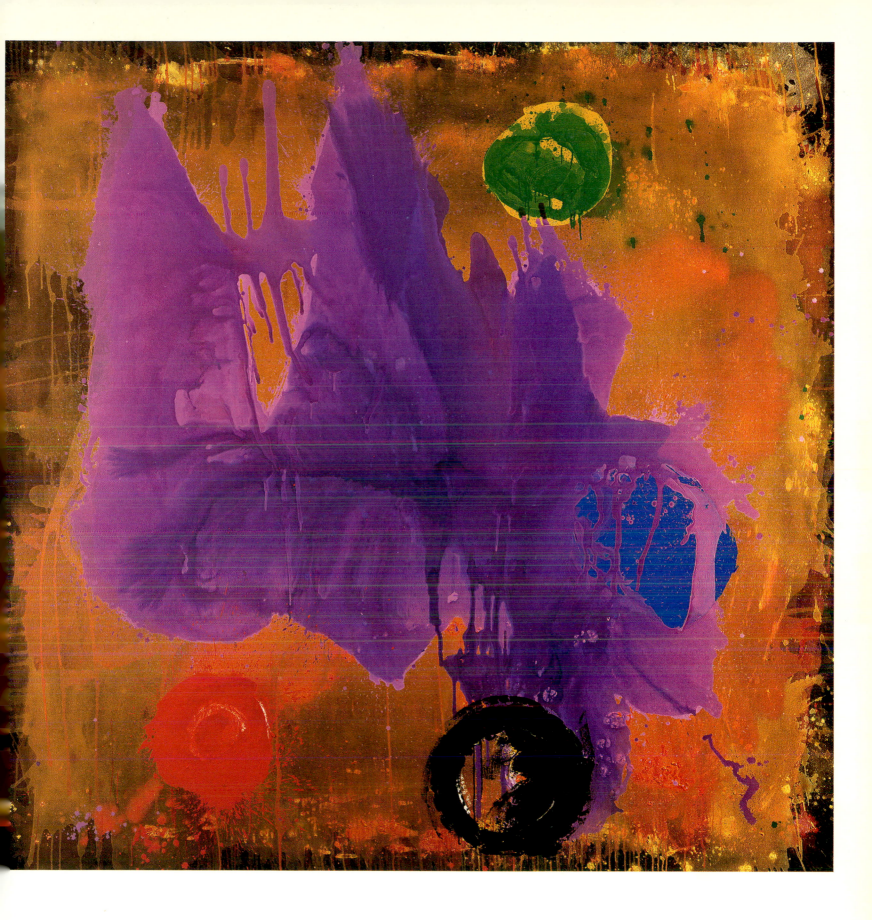

44
Kong Sleeps 4.10.85
acrylic on cotton duck
95×42in/241.3×106.7cm

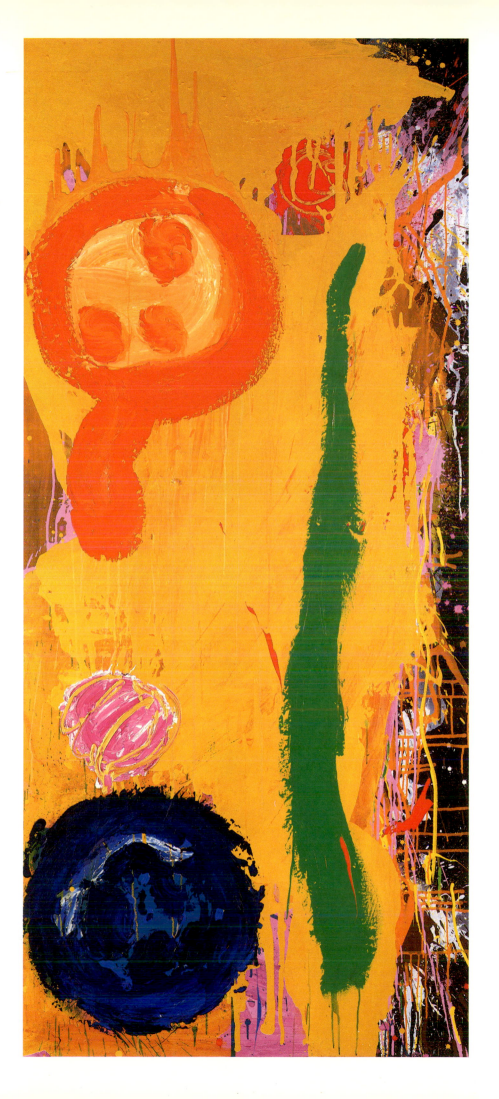

45
Quas 23.1.86
acrylic on cotton duck
96×96in/243.8×243.8cm

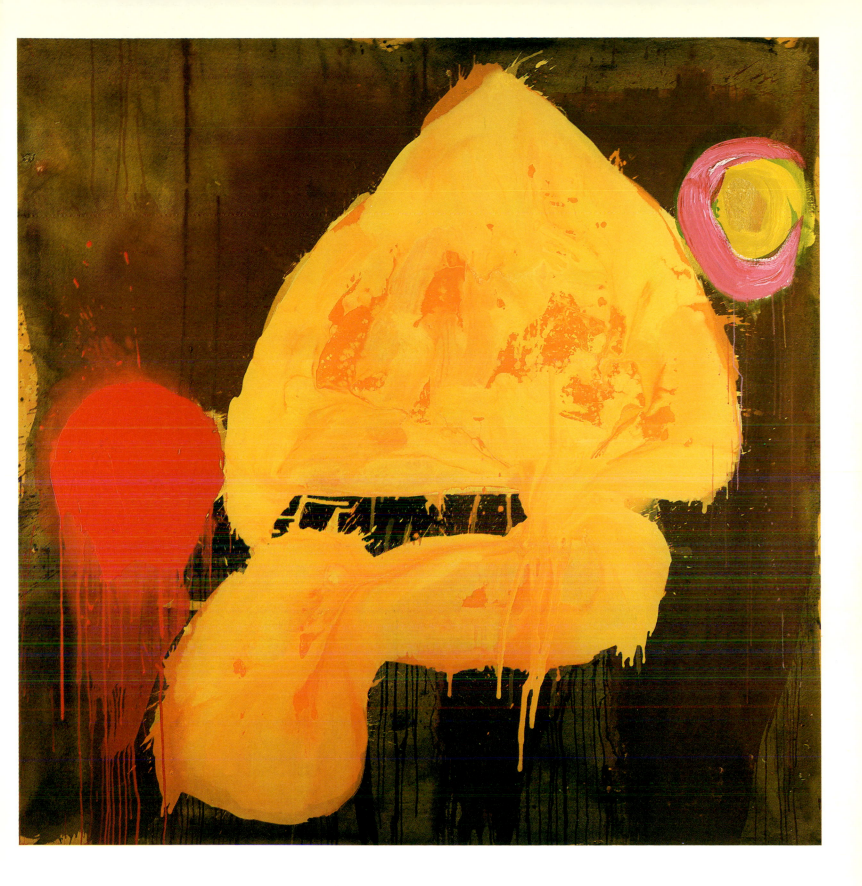

46
Gadal 10.11.86
acrylic on cotton duck
100×100in/254×254cm

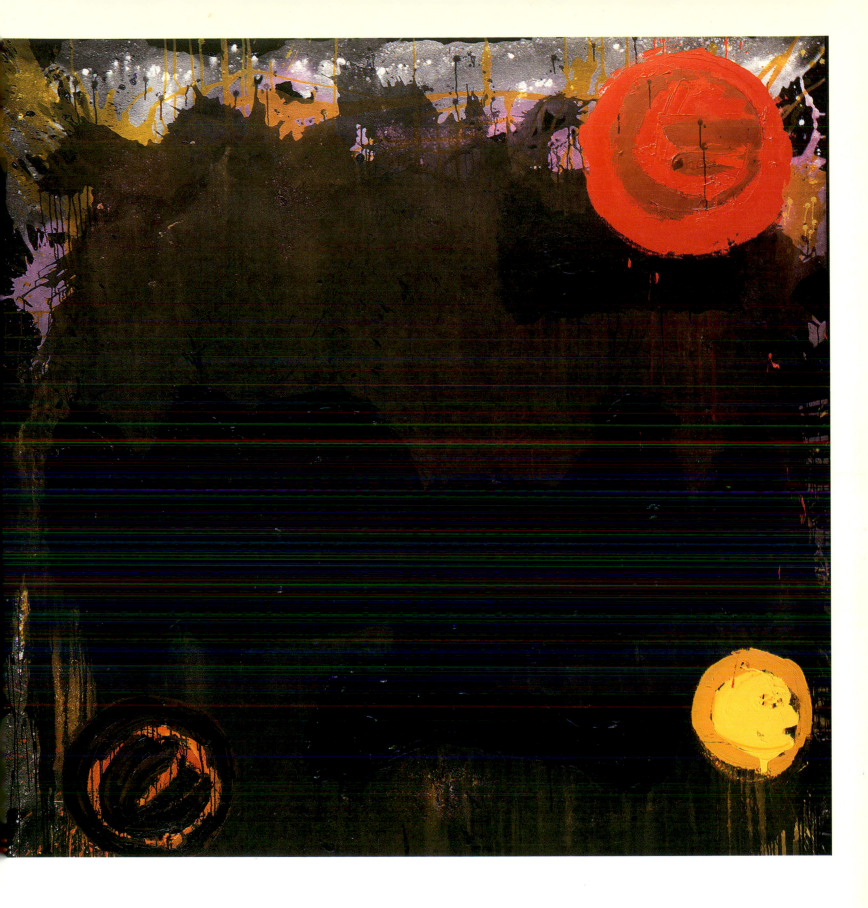

47
Wandering Awhile 10.5.87
acrylic on cotton duck
94×54in/238.8×137.2cm

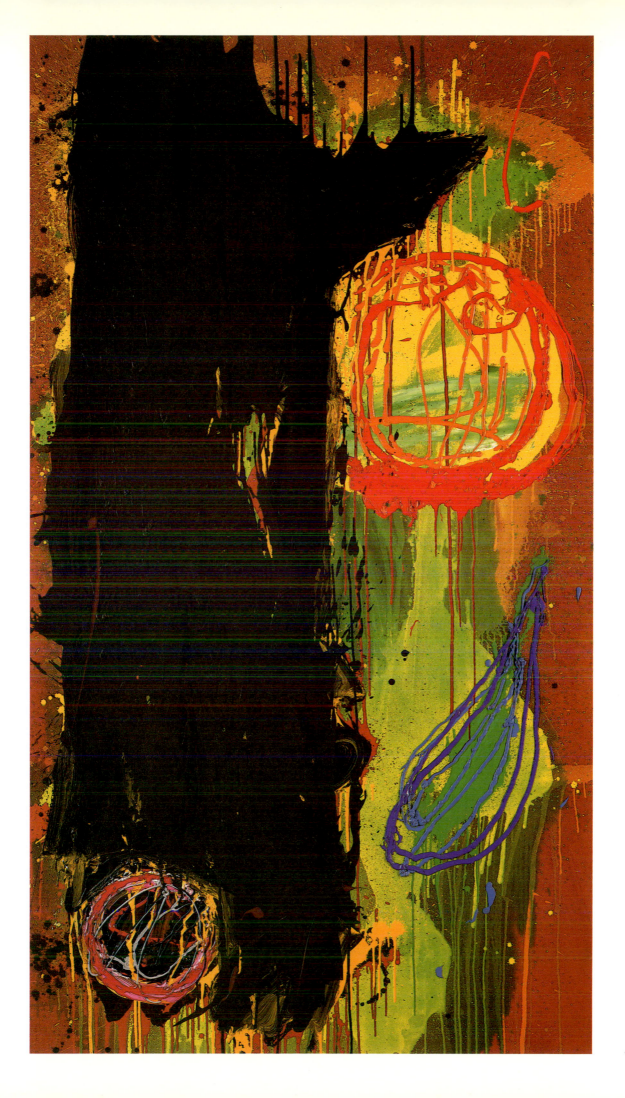

48
Swift Days, Moons and Suns 8.6.87
acrylic on cotton duck
100×45in/254×114.3cm

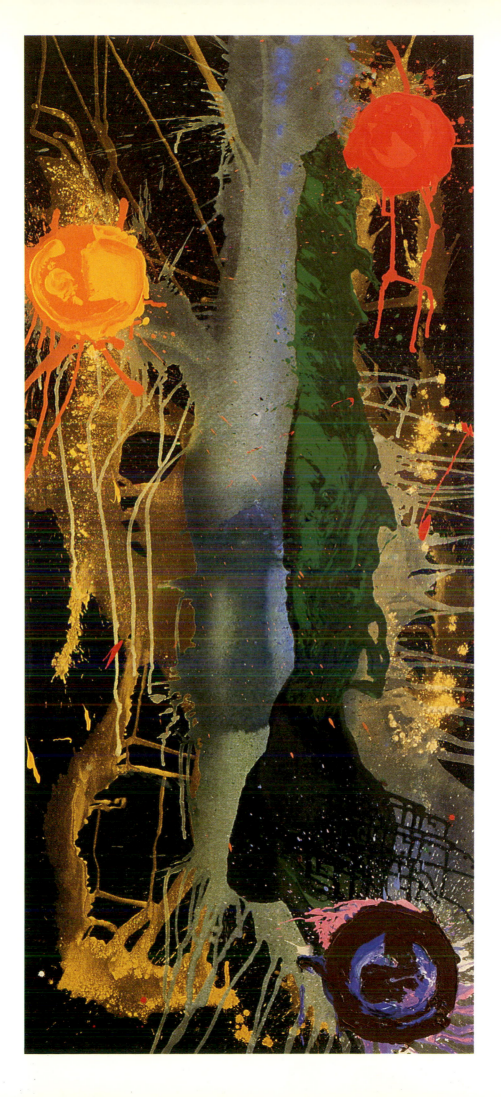

49
Tracks 13.6.87
acrylic on cotton duck
100×100in/254×254cm

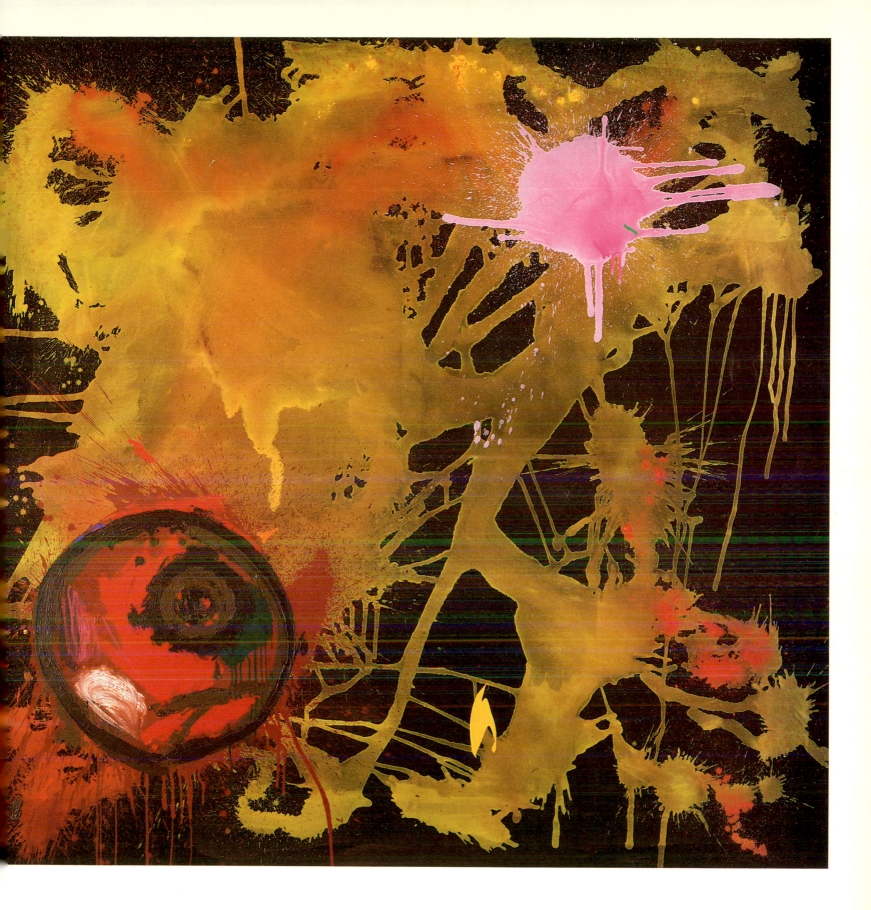

50
Off you Sail 28.6.87
acrylic on cotton duck
100×100in/254×254cm

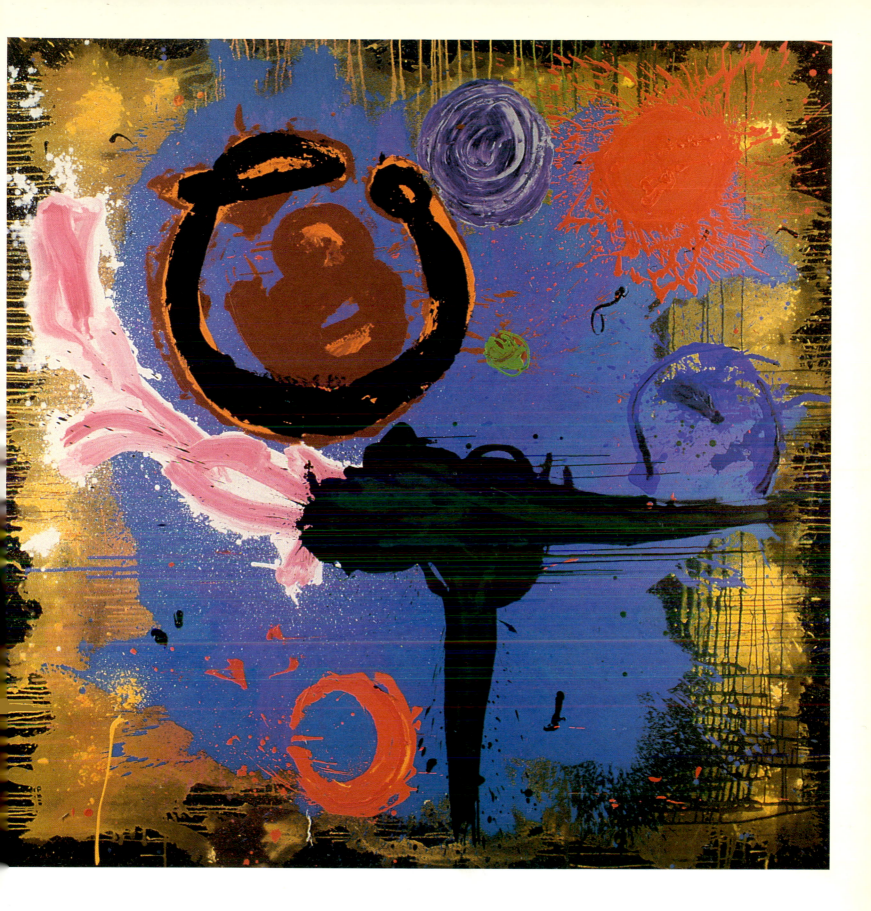

51
Moon Dance 5.9.87
acrylic on cotton duck
100×100in/254×254cm

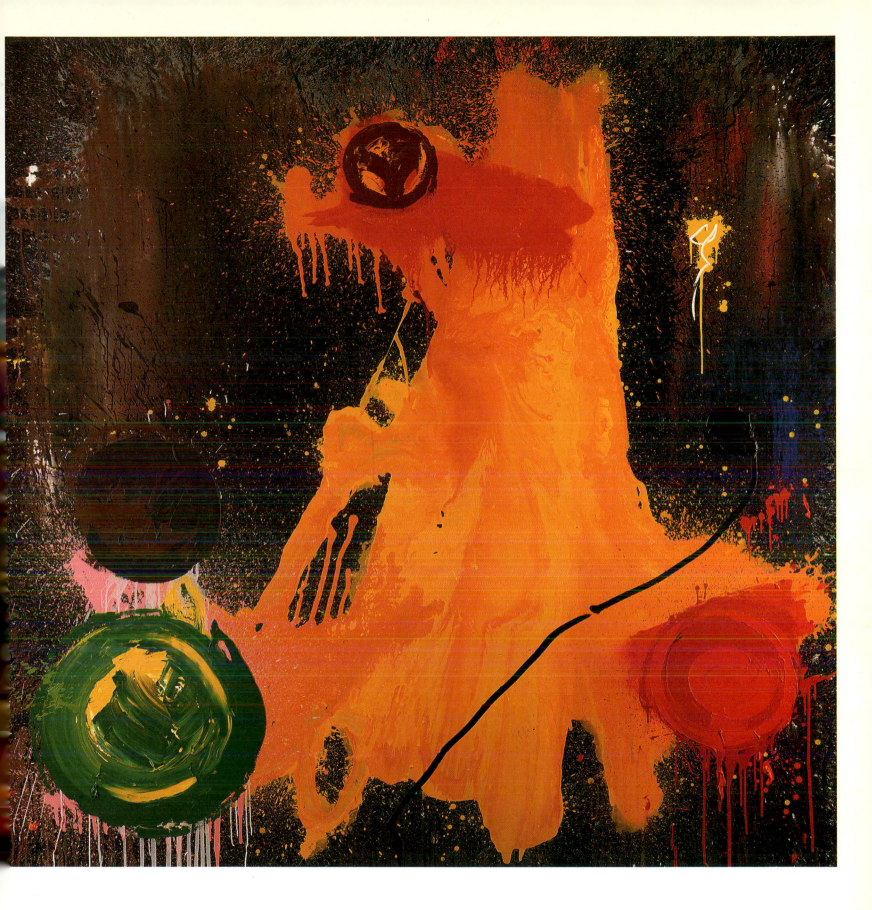

52
Helel, Fallen Angel 1.2.88
acrylic on cotton duck
100×100in/254×254cm

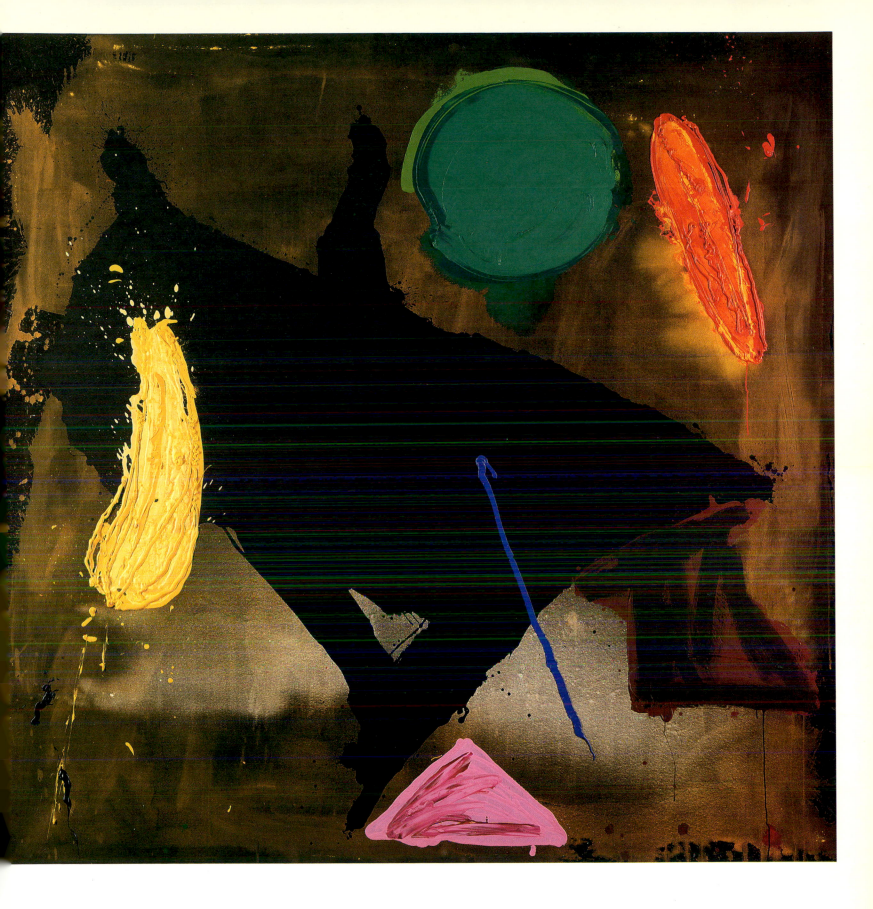

53
Duma 22.2.88
acrylic on cotton duck
100×100in/254×254cm

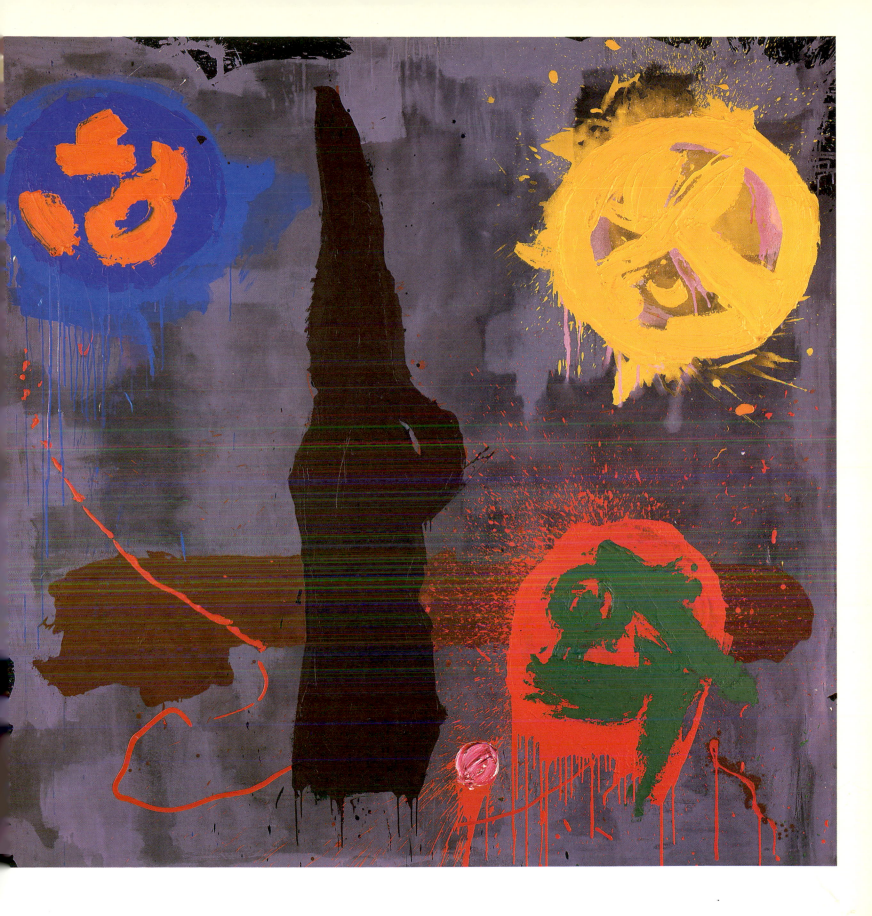

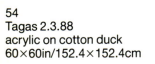

54
Tagas 2.3.88
acrylic on cotton duck
60×60in/152.4×152.4cm

55
Drakon 7.4.88
acrylic on cotton duck
100×100in/254×254cm

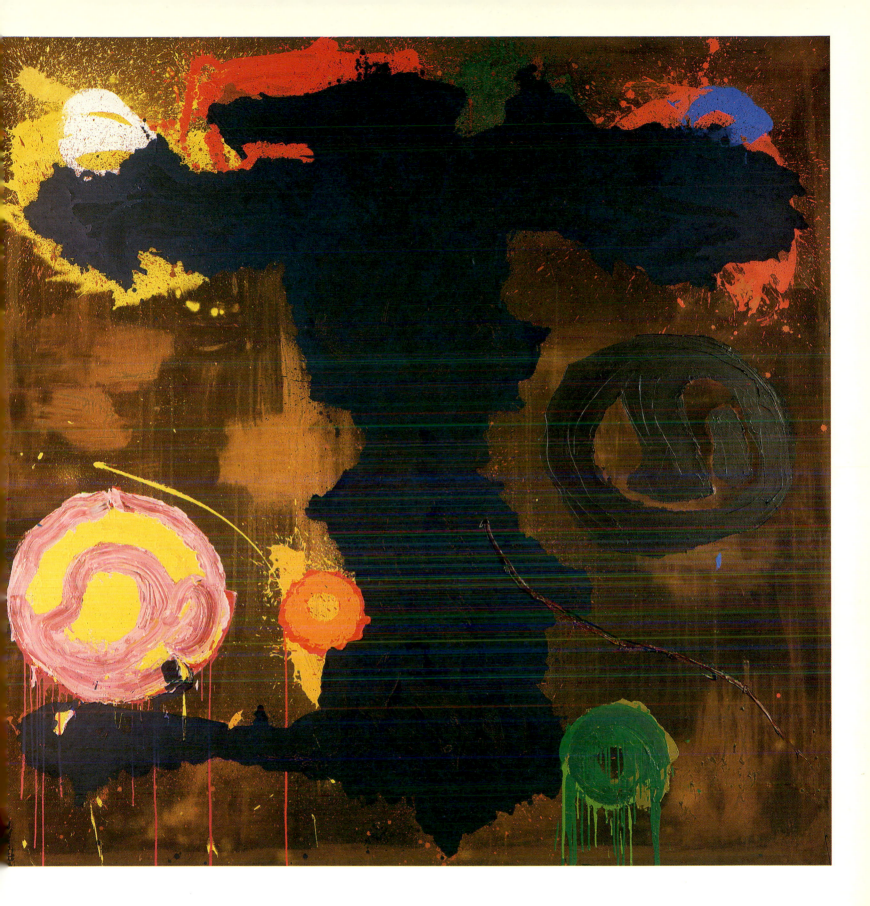

56
Dynamis 24.4.88
acrylic on cotton duck
100×100in/254×254cm

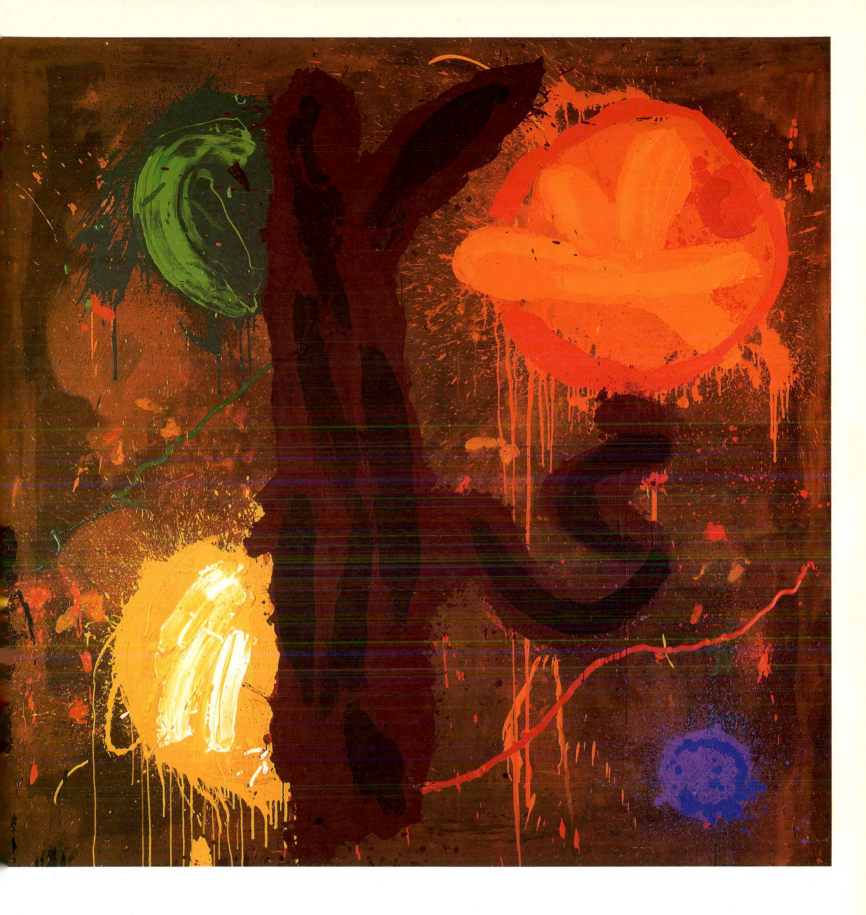

57
Above the Sun 27.8.88
acrylic on cotton duck
36×30in/91.4×76.2cm

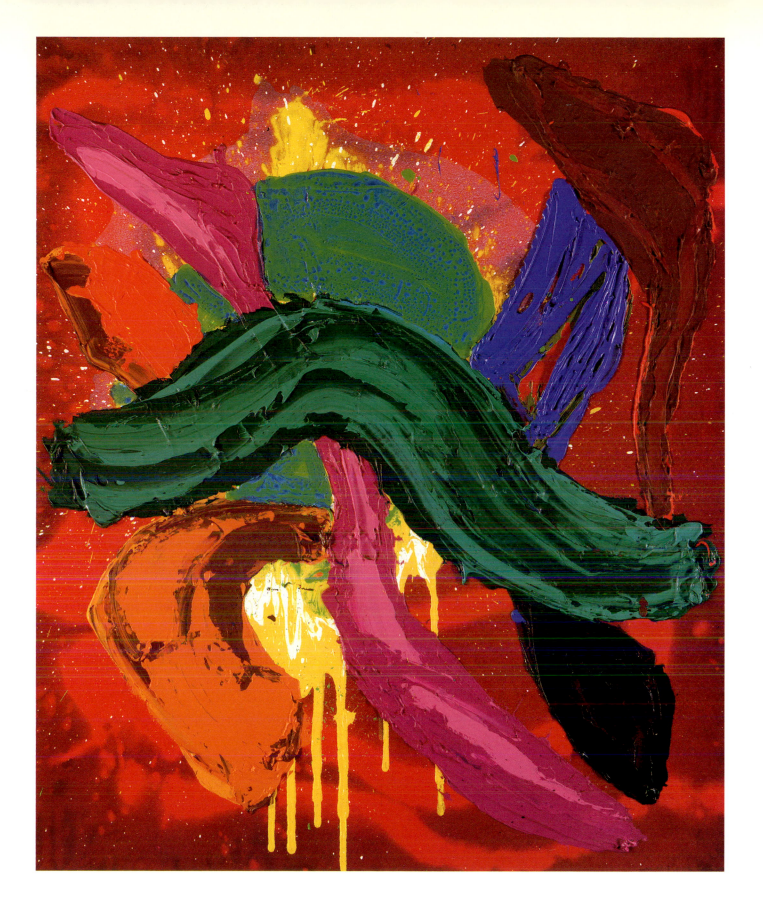

58
Sat. 15.9.88
acrylic on cotton duck
100×93in/254×236.2cm

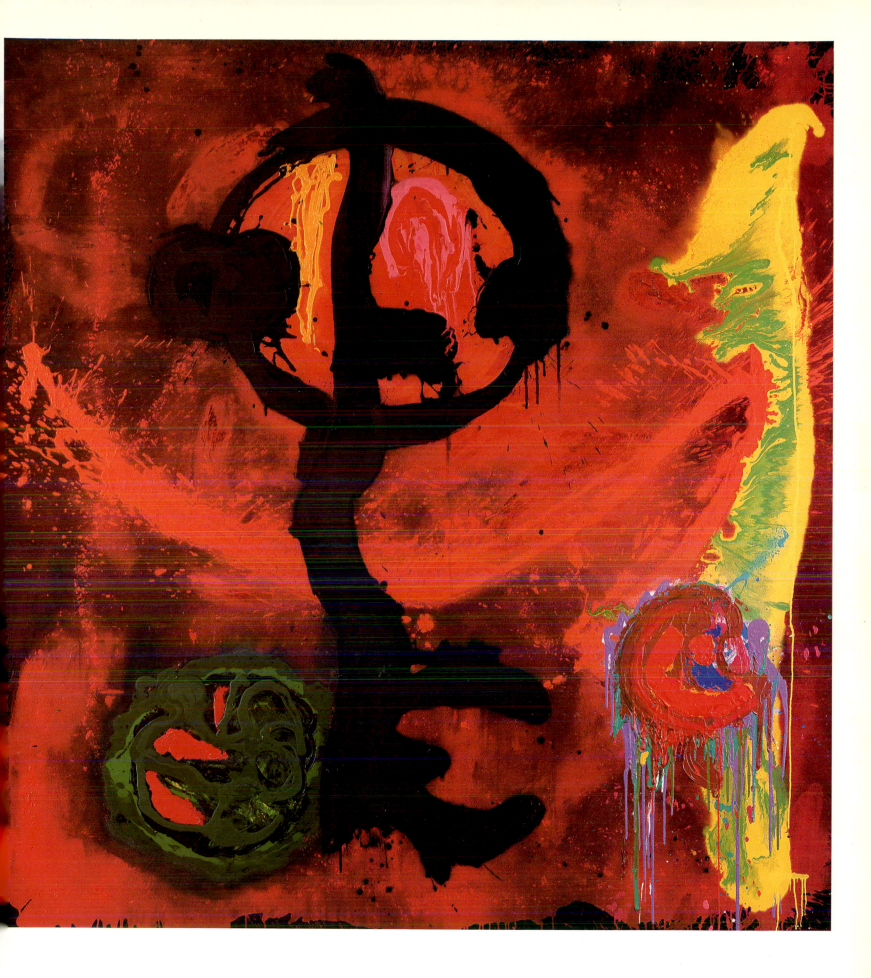

59
Rivers of Surprise 20.9.88
acrylic on cotton duck
60×50in/152.4×127cm

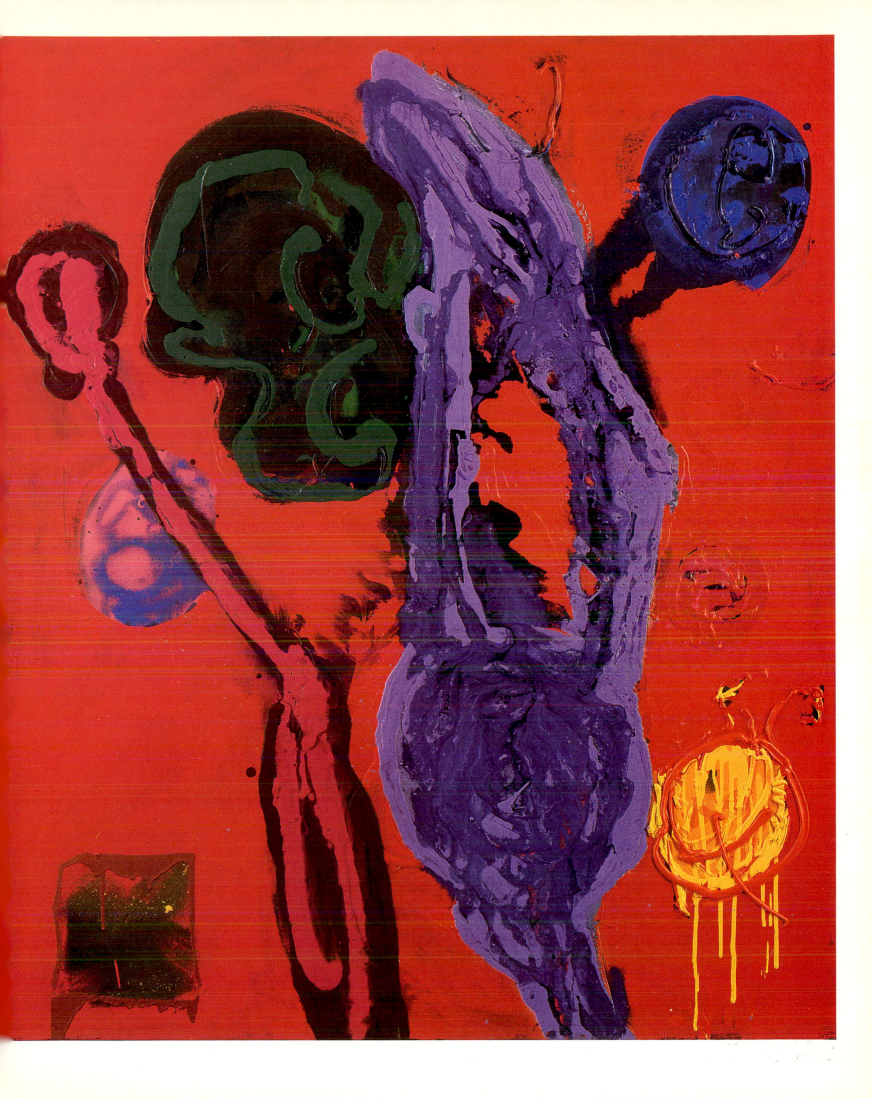

60
Genie 24.9.88
acrylic on cotton duck
40×30in/101.6×76.2cm

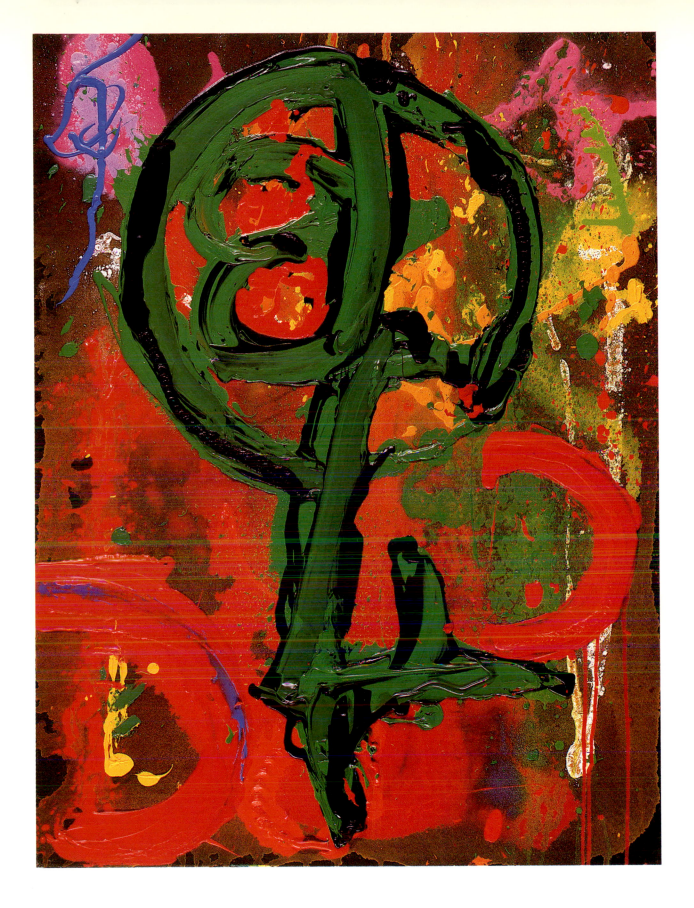

61
Talto 25.9.88
acrylic on cotton duck
60×50in/152.4×127cm

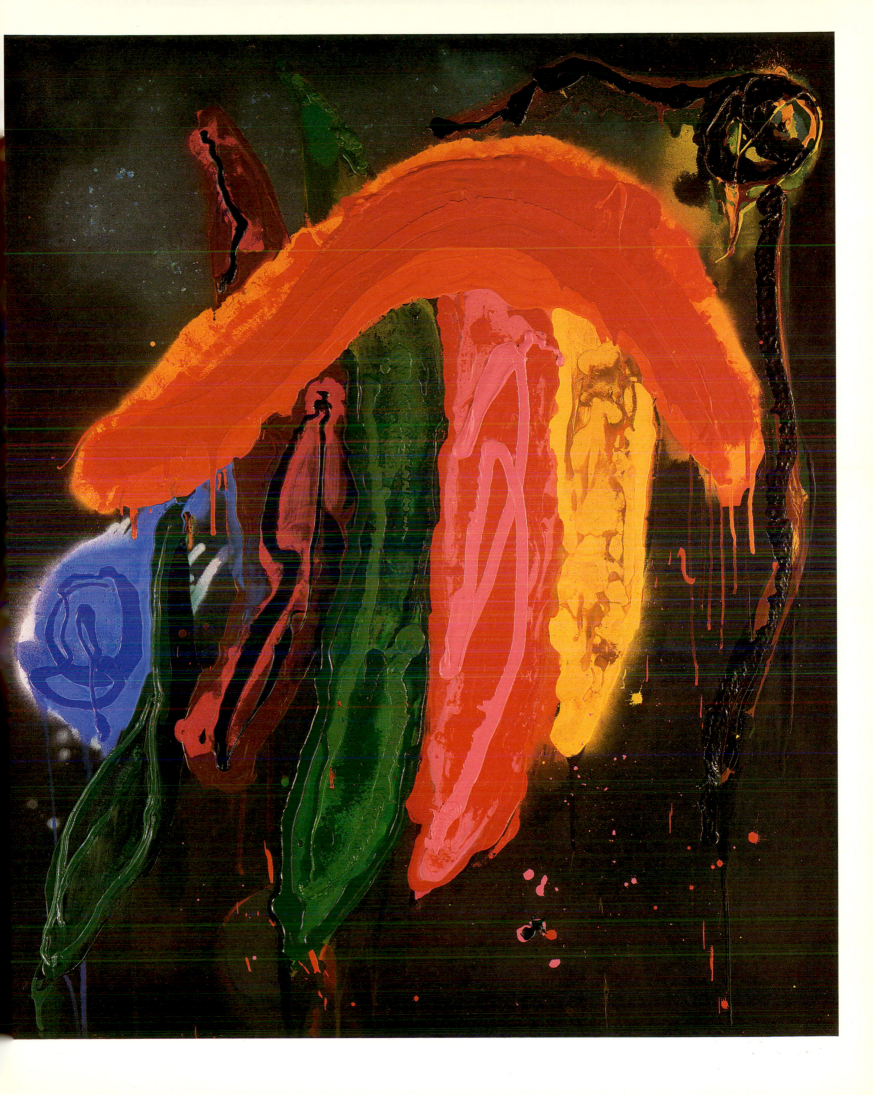

62
Hour of Venus 17. 10. 88
acrylic on cotton duck
100×93in/254×236.2cm

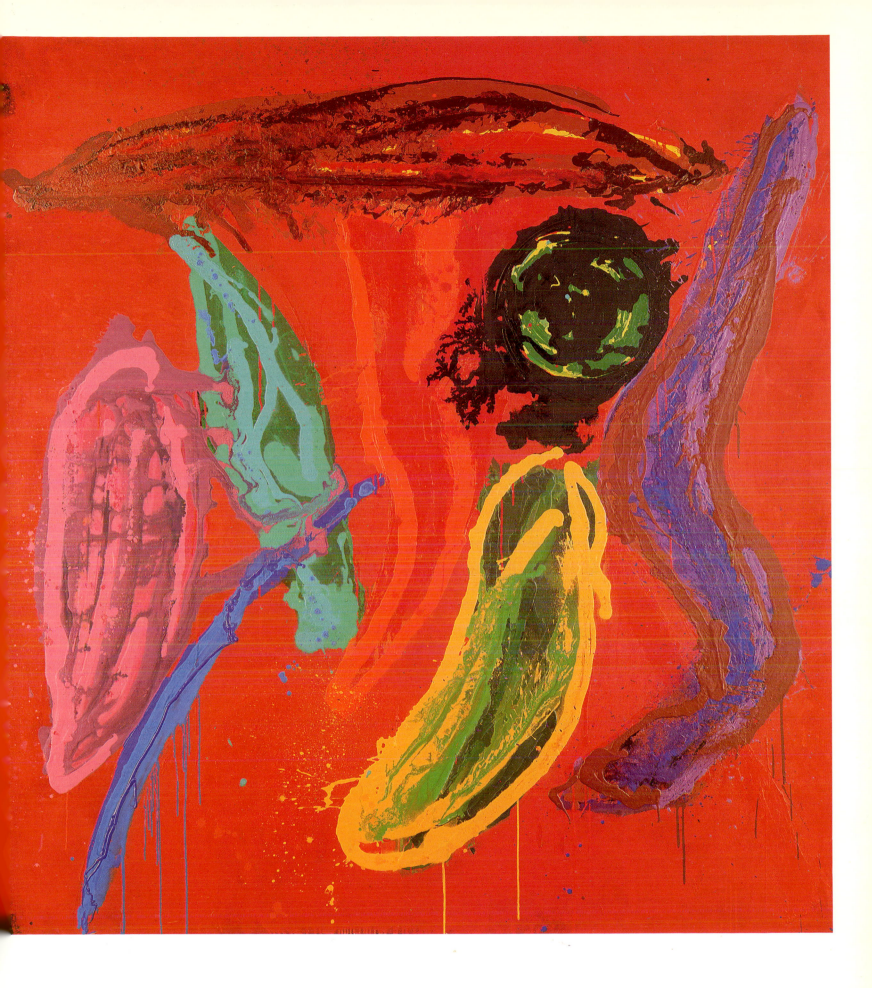

63
Spirit of Venus 28.10.88
acrylic on cotton duck
60×60in/152.4×152.4cm

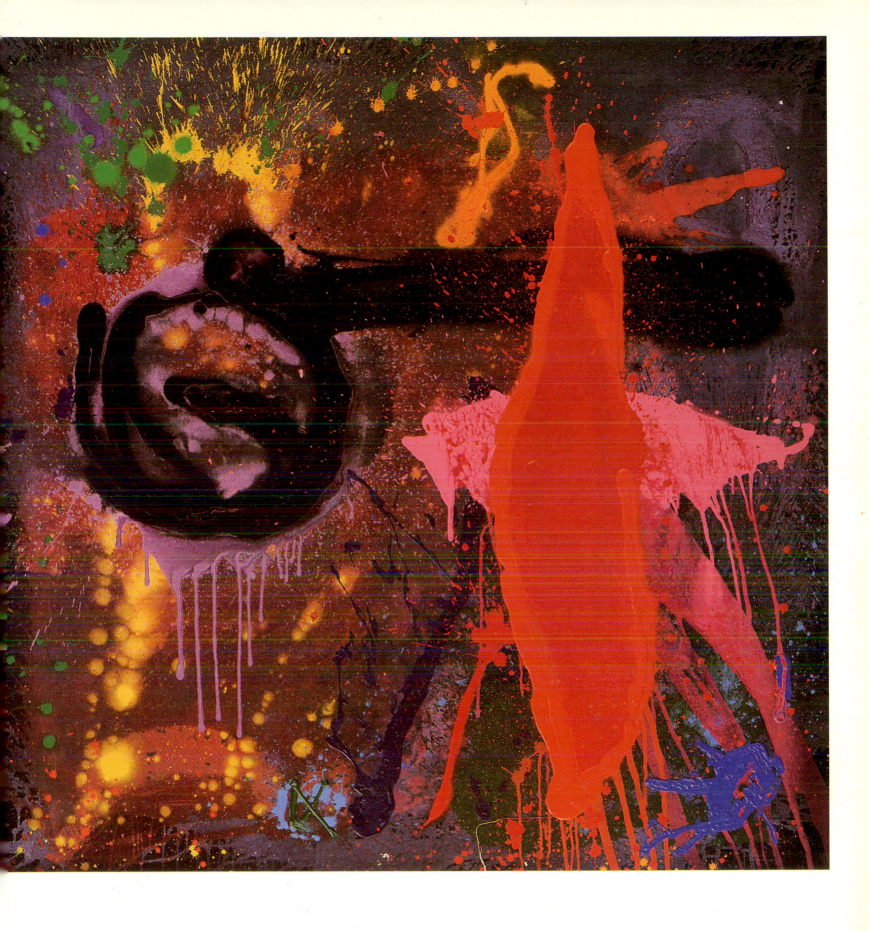

64
Paramaribo 24.11.88
acrylic on cotton duck
100×60in/254×152.4cm

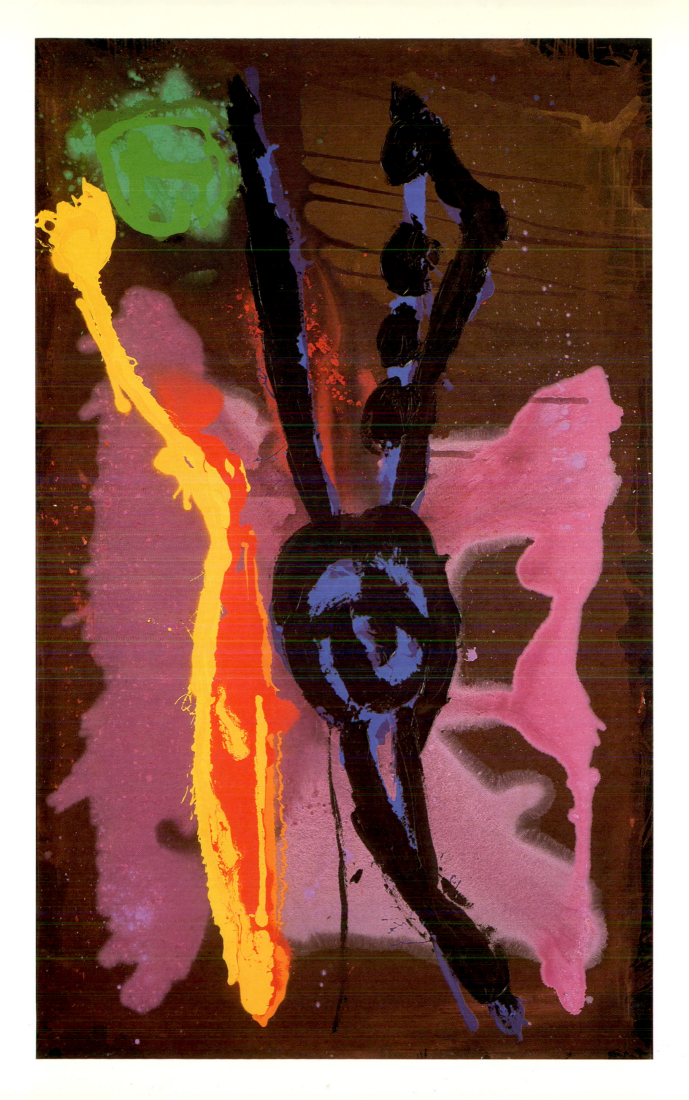

65
lsda 7.12.88
acrylic on cotton duck
100×60in/254×152.4cm

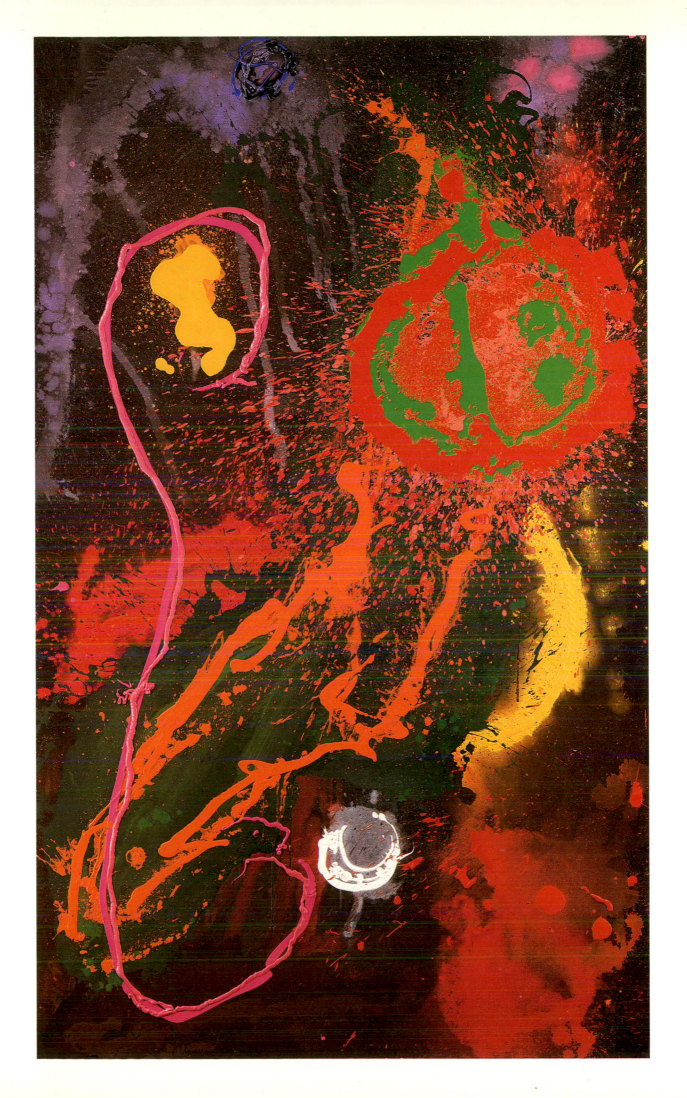

66
Over the Edge 30.12.88
acrylic on cotton duck
28×20in/71.1×50.8cm

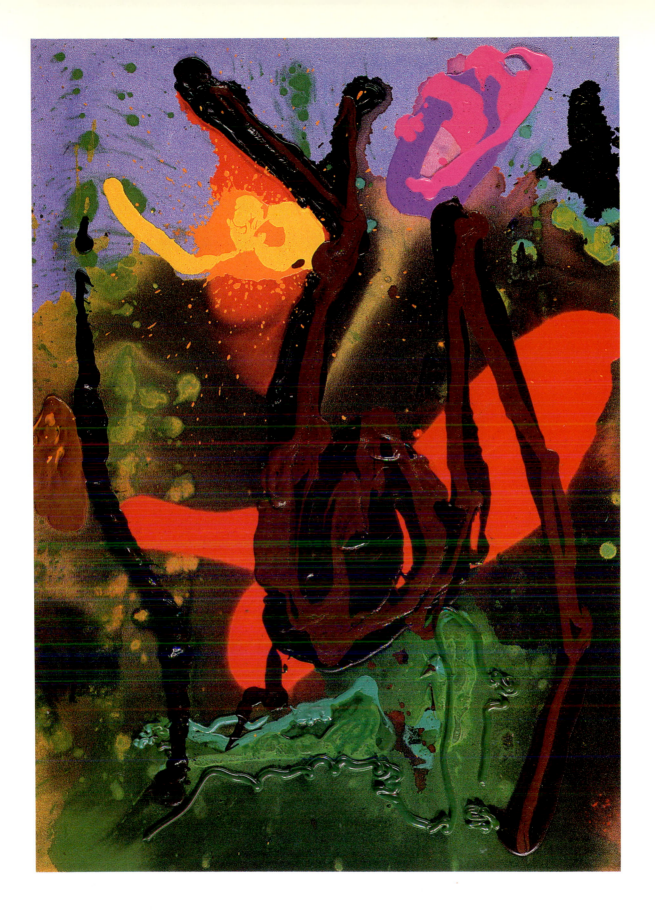

67
Avatar 1.1.89
acrylic on cotton duck
30×28in/76.2×71.1cm

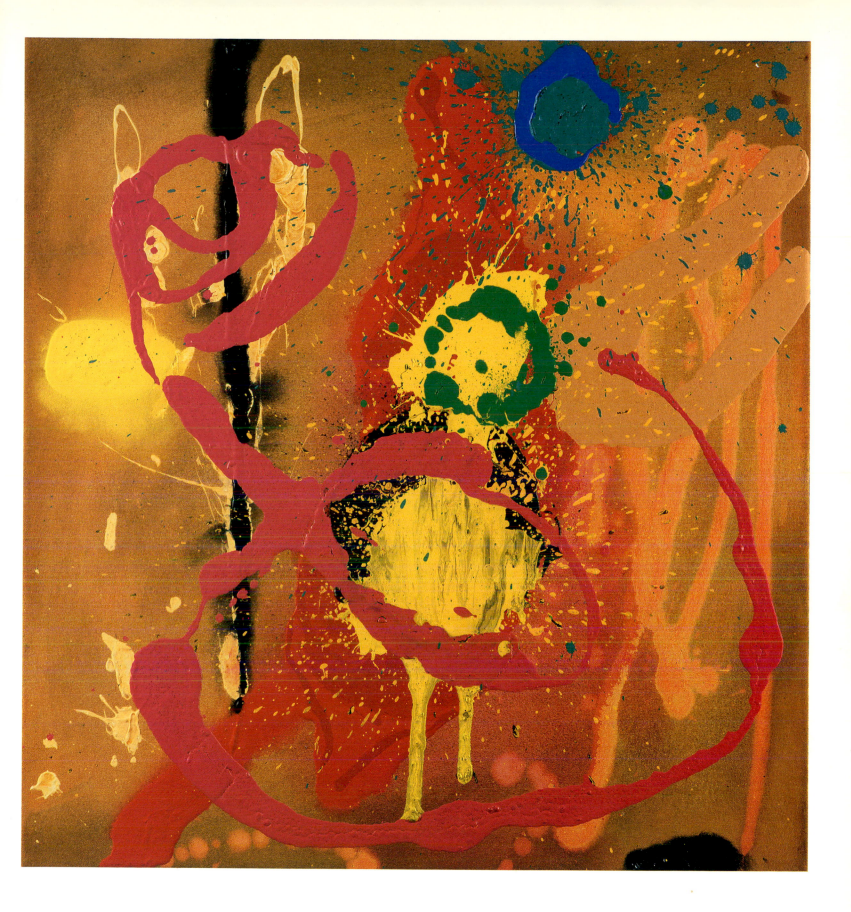

68
Banda Oriental 22.2.89
acrylic on cotton duck
60×60in/152.4×152.4cm

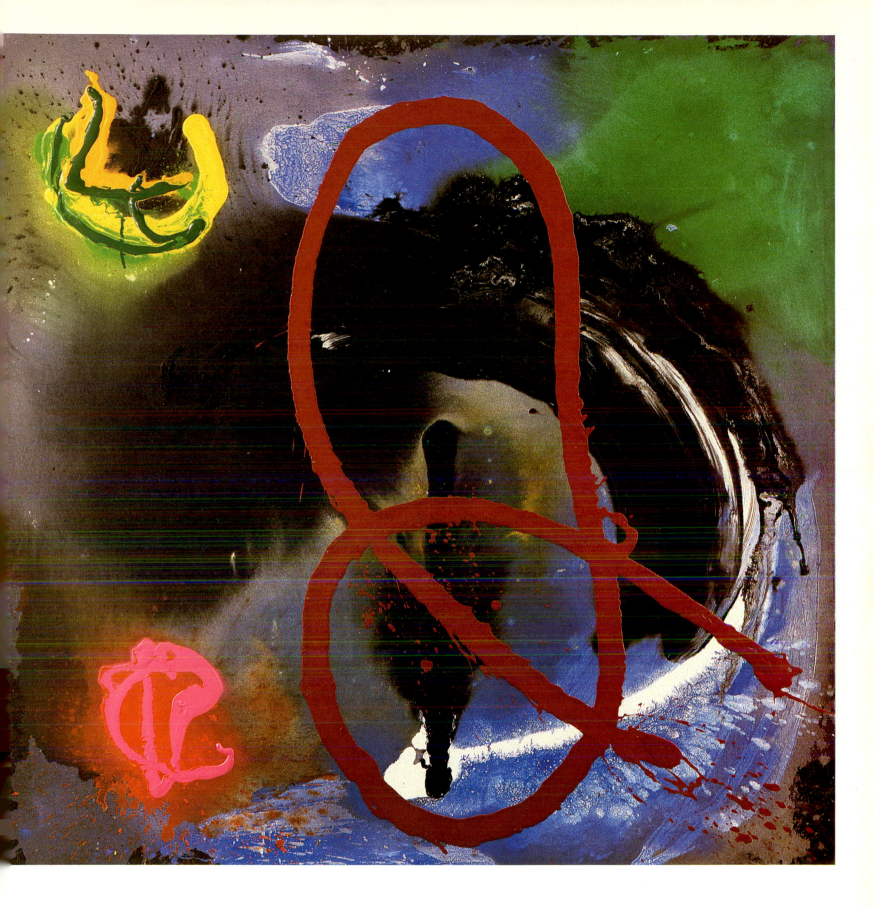

69
Back to the Winter 18.3.89
acrylic on cotton duck
60×60in/152.4×152.4cm

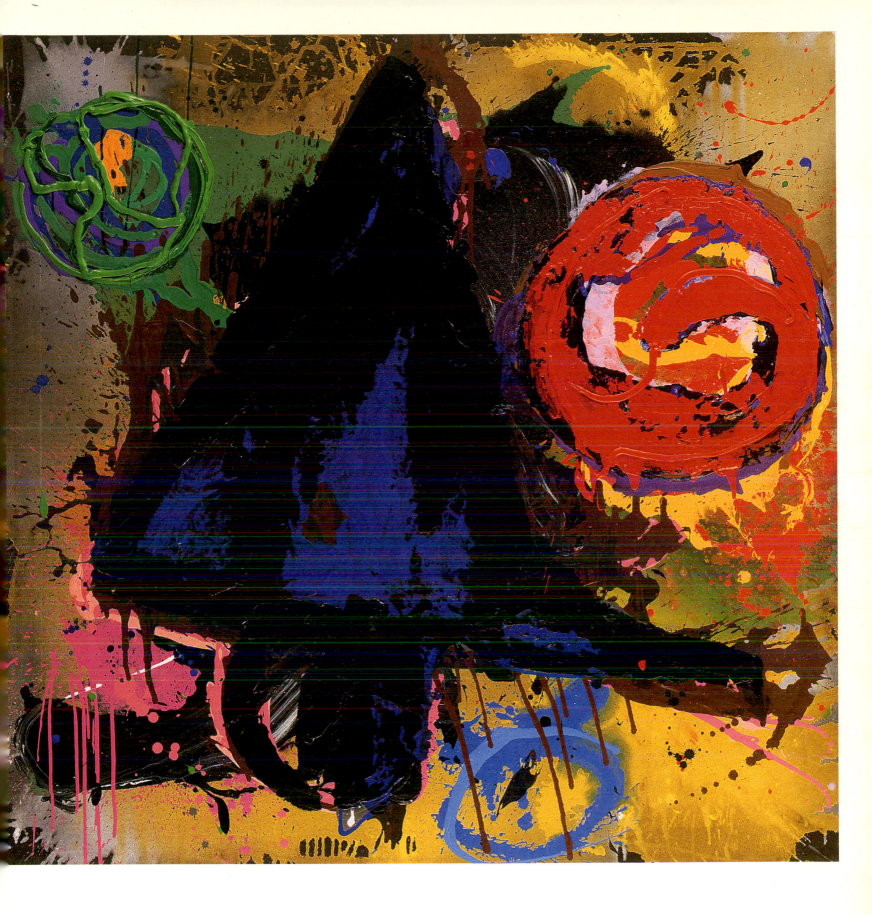

70
La Manga 10.5.89
acrylic on cotton duck
100×60in/254×152.4cm

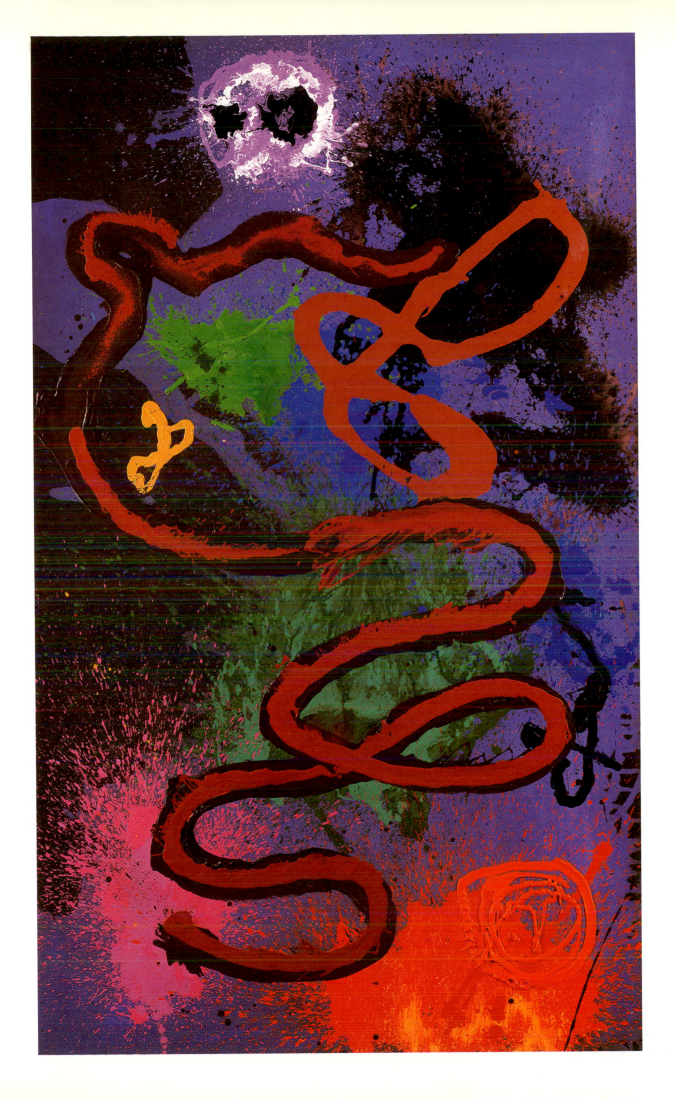

71
Siren 10.7.89
acrylic on cotton duck
100×93in/254×236.2cm

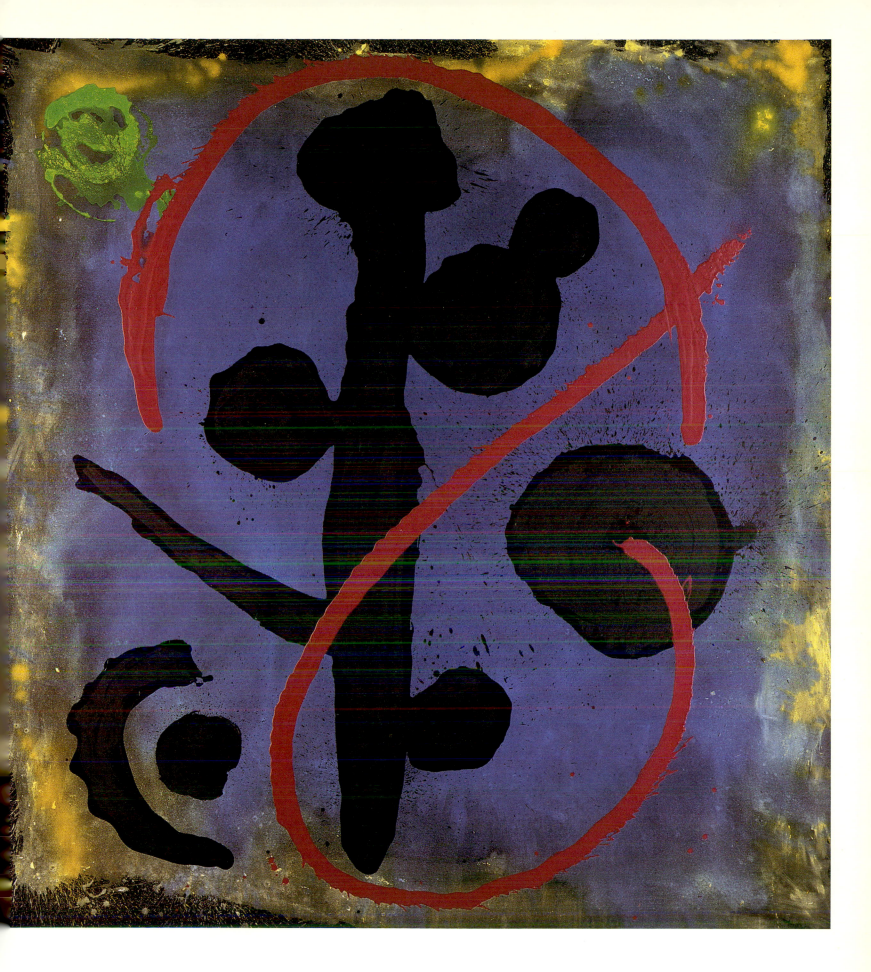

Sorcerer 1.8.89
acrylic on cotton duck
100×93in/254×236.2cm

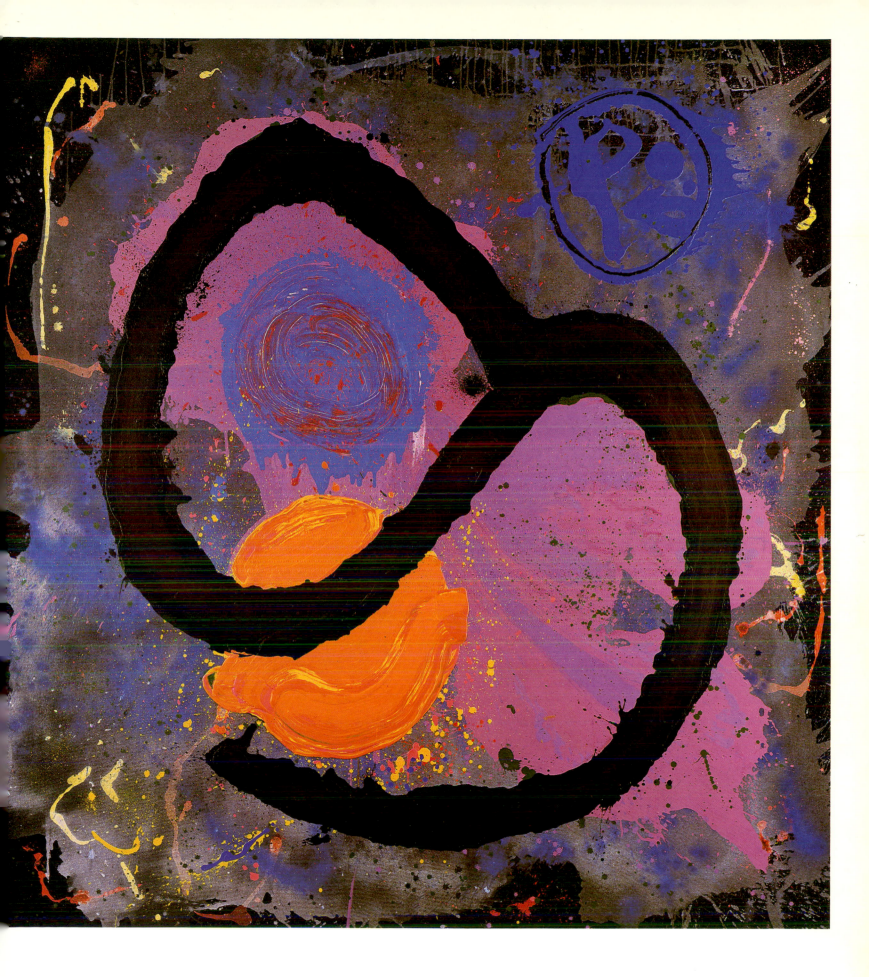

73
Mirth of Snakes 13.8.89
acrylic on cotton duck
60×50in/152.4×127cm

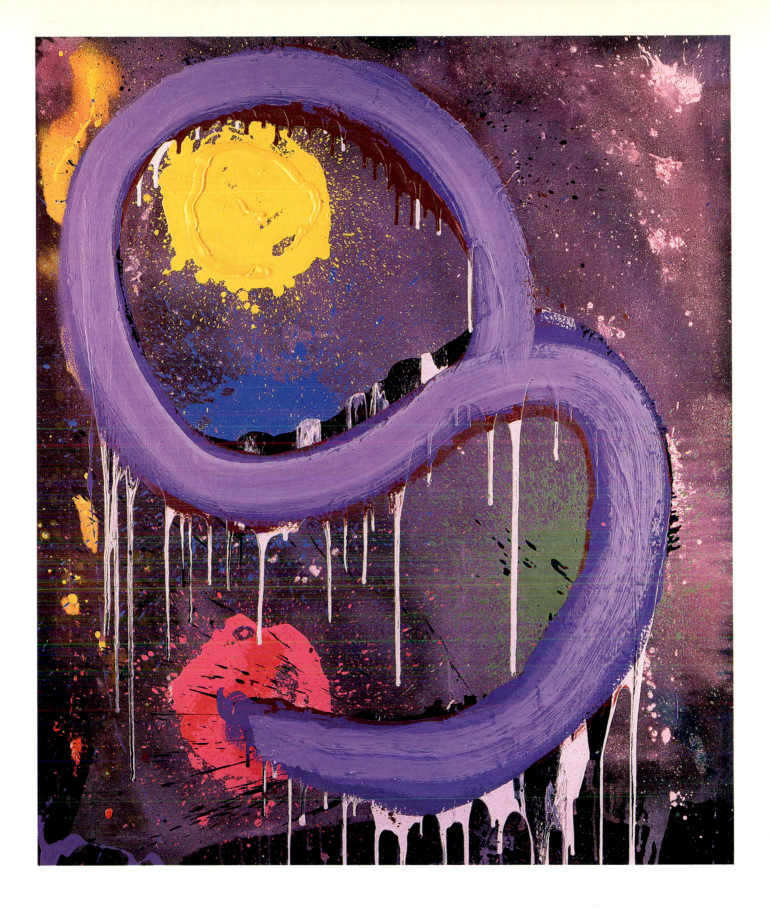

74
Aerial Animal 15.8.89
acrylic on cotton duck
60×50in/152.4×127cm

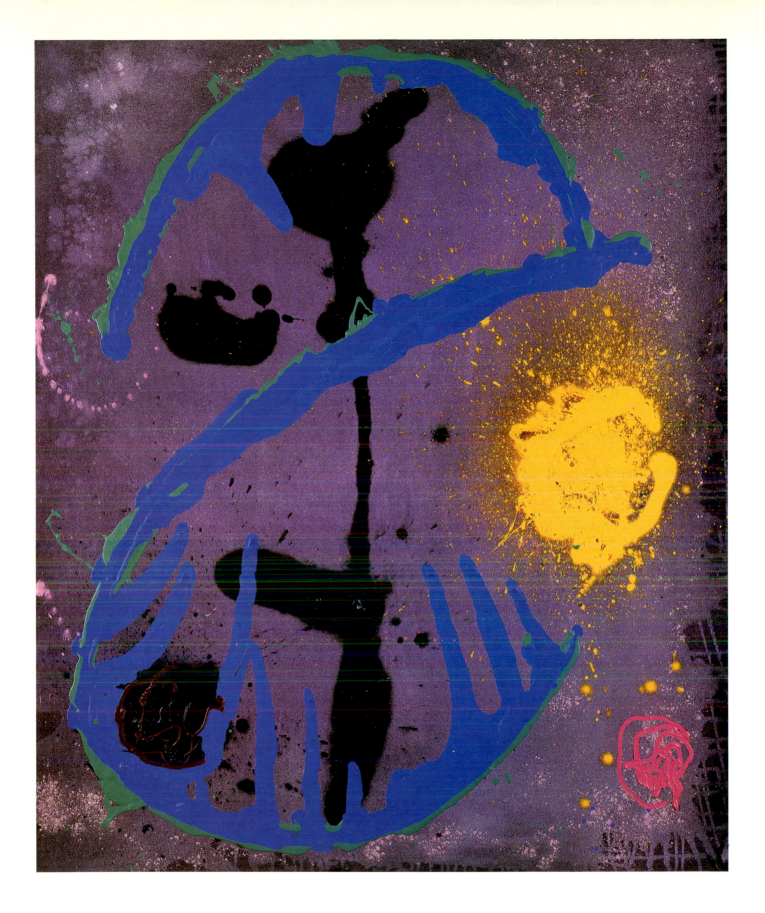

75
Hating and Dreaming 12.9.89
acrylic on cotton duck
100×93in/254×236.2cm

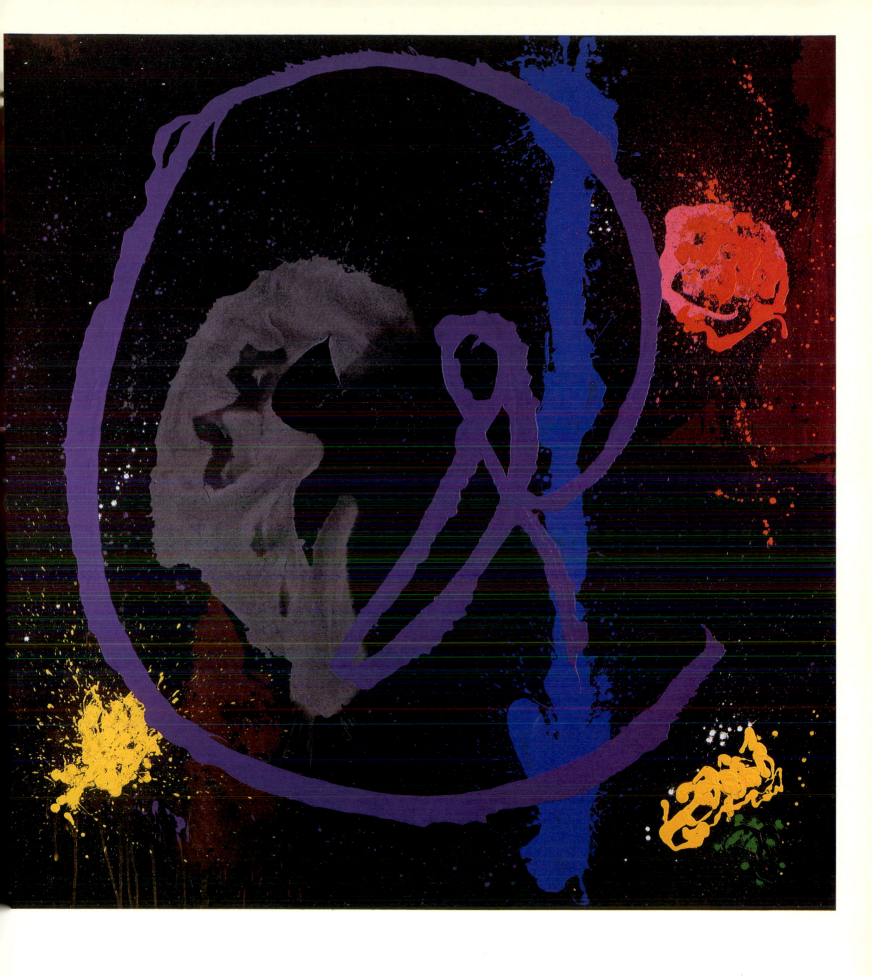

76
Red Snake 13.9.89
acrylic on cotton duck
30×30in/76.2×76.2cm

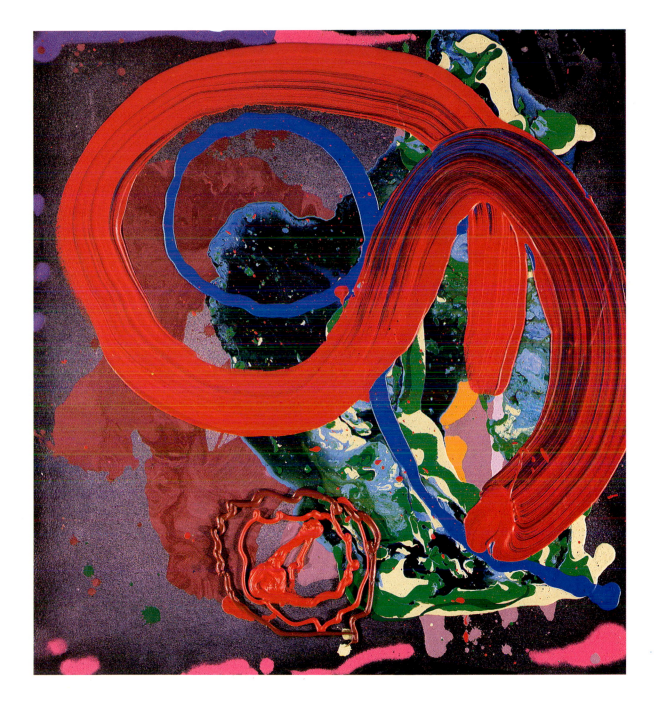

77
Youwarkee 25.9.89
acrylic on cotton duck
100×93in/254×236.2cm

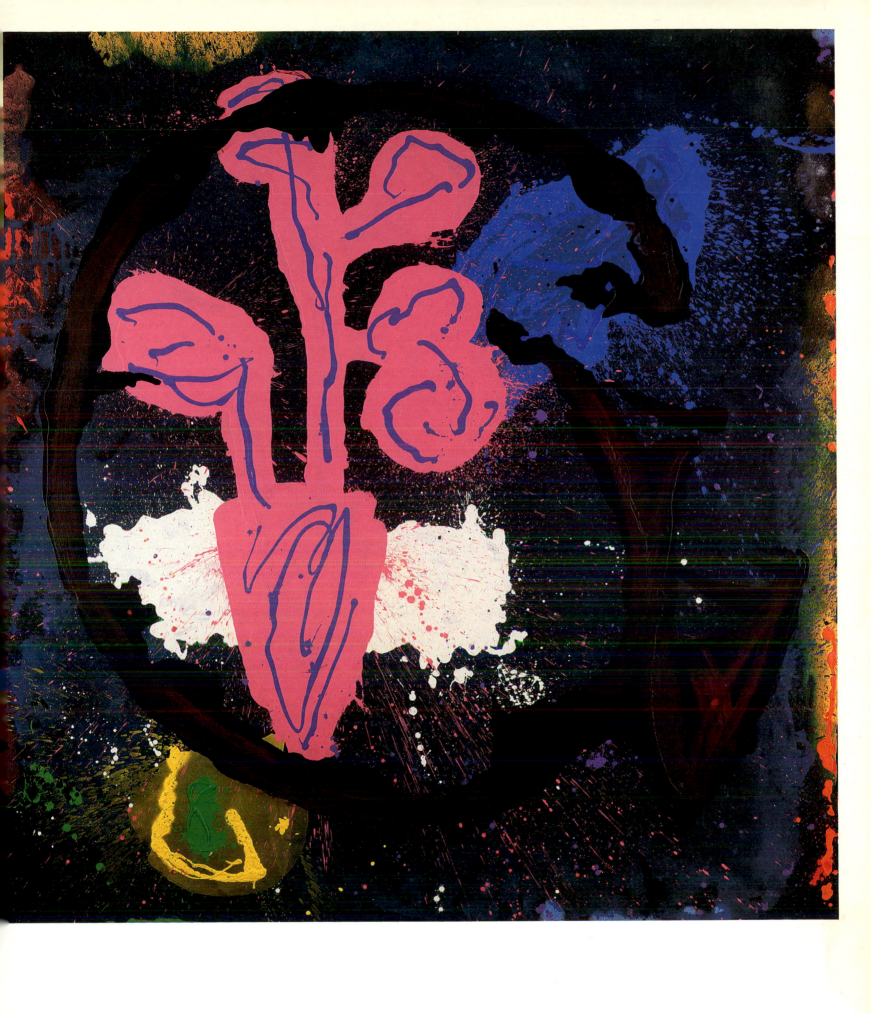

78
Inhabited Place 5.10.89
acrylic on cotton duck
100×93in/254×236.2cm

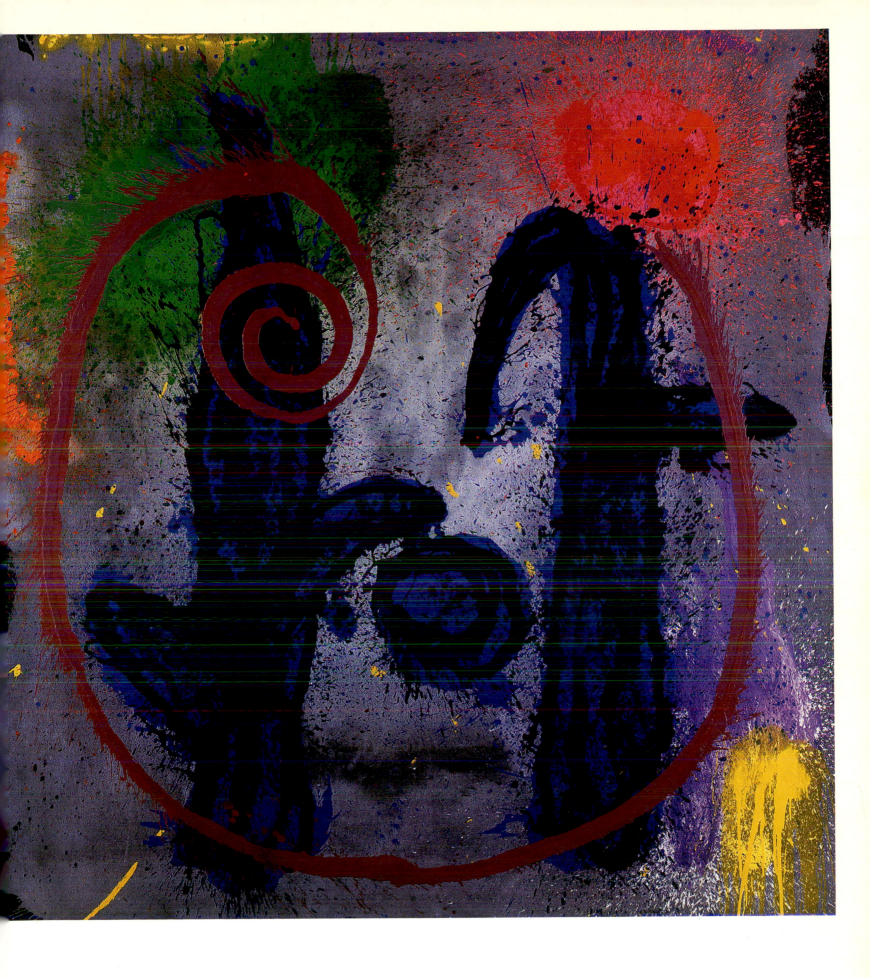

79
Lamia 28.10.89
acrylic on cotton duck
100×93in/254×236.2cm

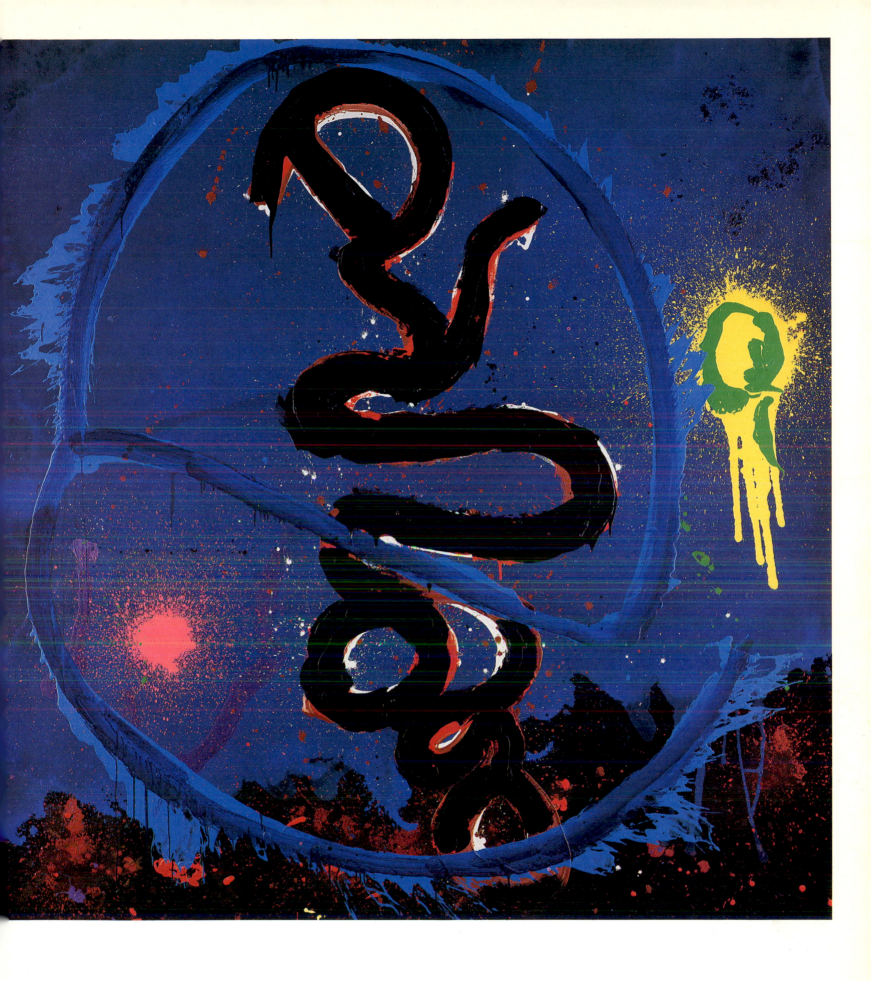

80
Ocean Man 30.10.89
acrylic on cotton duck
60×60in/152.4×152.4cm

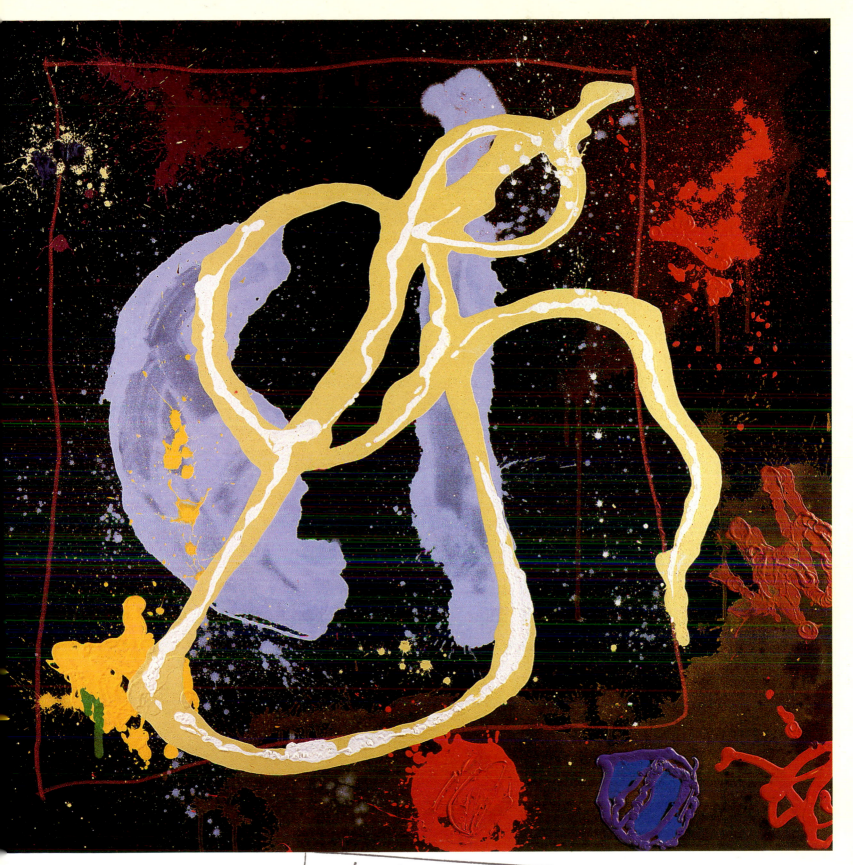

Lanchester Library

WITHDRAWN